for tomoko

THE GRAPHIC DESIGN OF JONATHAN BARNBROOK

BARNBROOK

BIBLE

THE GRAPHIC DESIGN

of

JONATHAN BARNBROOK

WITH CONTRIBUTIONS BY

KALLE LASN

EMILY KING

TEAL TRIGGS

ALICE TWEMLOW

(AND THREE PARAGRAPHS BY DAVID BOWIE)

editor: edward booth-clibborn | design: barnbrook design | main text © 2007 jonathan barnbrook | text editor: julia booth-clibborn | design's absurd hero © 2007 alice twemlow | dancing in the face of the apocalypse © 2007 teal triggs | i want to spend and spend © 2007 emily king | designing without dead time © 2007 kalle lasn | david bowie text © 2007 david bowie | first published in 2007 by room for living publishing, an imprint of booth-clibborn editions united kingdom | © 2007 booth-clibborn editions | barnbrook design are jonathan barnbrook, pedro inoue, elle kawano and marcus mccallion | all rights reserved. no part of this publication may be reproduced or transmitted in any form or by any means, or stored in any retrieval system of any nature without prior written permission of the copyright holders, except for permitted fair dealing under the copyright, designs and patents act 1988 | the information in this book is based on material supplied to booth-clibborn editions by the authors and participants. while every effort has been made to ensure accuracy, booth-clibborn editions does not under any circumstances accept responsibility for any errors or omissions. | please note we have made all reasonable efforts to reach copyright owners of images used in this book. we are prepared to pay fair and reasonable fees for any usage made without compensation or agreement. | a cataloguing-in-publication record for this book is available from the publisher | isbn 1-86154-239-7 | printed and bound in hong kong | www.barnbrook.net | www.booth-clibborn.com |

ConTents

BARNBROOK BIBLE?

WHAT THE

F**K?

WHO does this guy think he is?

JESUS CHRIST?

HOLD ON!

I AM NOT PROCLAIMING MYSELF THE NEW MESSIAH OR GOD'S GIFT TO DESIGN.

If God sent a graphic designer to save us, there would be no universal salvation but we would have some 'really cool typography' to sell us more stuff in the meantime. NO, the title *Barnbrook Bible* is about this book being a statement and explanation of my beliefs and design philosophy. Er… I don't know if that sounds a little too forthright. Maybe that's because designers don't usually have that much to say—it's actually easy to be one without believing in anything whatsoever.

So… let's start the whole thing on a positive note by saying what ISN'T in this book (ha, ha):

TIPS FOR 'GETTING AHEAD IN THE INDUSTRY' OR 'MAKING GREAT PRESENTATIONS'	A LACK OF EXPLANATION HIDDEN BEHIND COMPLEX OR ACADEMIC LANGUAGE	THE WORK OF SOMEONE WHO DOES *nice stuff* BUT IS A BIT OF A BASTARD TO WORK WITH
I hate the idea that design is talked about as an 'industry'. If you are a committed designer, there is no separation from your beliefs, your work and how you present them. There is no 'big plan' other than being true to yourself. This means that you should be sincere in the reasons for creating your work, if not it will be inauthentic and you will be quickly found out.	Many designers hide behind complex language or worse offer no explanation saying,"If you don't get it, you don't get it," this is just woolly thinking or arrogance. Knowing 'why' helps you and those still learning. You can still produce work that is open-ended but you should have the critical faculties to understand and explain that process.	I am not saying, "hey I am a fantastic guy," just that you do not have to be difficult to produce good work. Your personality and the way you handle people are part of the problem-solving process. That doesn't mean that you have to be a yes man, just don't think of it like a war. Acting like a jerk means that you ARE a jerk, not some 'great creative individual.'

So having explained what ISN'T in this book, maybe I should actually say WHAT IS:

For me it is confirmation that graphic design is a valid form of expression which can facilitate social and cultural change, that it is possible to survive without compromising principles first formulated at college. Um… for some I imagine it's going to provide further proof that the world is collapsing under the weight of illegibility. For others, it's going to be a *pretty little picture book* with all of the studio's work in one tidy place. The less scrupulous will photocopy and show it as a 'style' to clients for arbitrary use on projects (*bah!*). A more worthwhile route would be to read the explanations and absorb the underlying philosophy (*but hey, don't worry about it*).

FINALLY SINCE THIS A 'BIBLE', IT'S IMPORTANT TO HAVE 'HERESY'. GOOD IDEAS ARE THE LIFEBLOOD OF DESIGN BUT SO IS SUBVERSION. I HOPE THAT A FEW WHO READ THIS BOOK WILL THINK I AM WRONG AND BE TEMPTED TO DO THEIR OWN THING IN THEIR OWN F***ING WAY.

II.

DESIGN'S ABSURD HERO

BY

ALICE TWEMLOW

In his 1942 essay THE MYTH OF SISYPHUS, Albert Camus conducts a philosophical exploration of the absurd using the analogy of Sisyphus who, in Greek mythology, was condemned to forever repeat the same meaningless task of pushing a rock up a mountain, only to see it roll down again. Camus is interested in whether or not Sisyphus knows and understands his fate, leading the reader to extrapolate that consciousness of the futility of our actions, in a world devoid of meaning and God, inevitably requires suicide. Camus concludes his essay, however, with an image of Sisyphus at the foot of his underworld mountain that is unmistakably hopeful. "This universe henceforth without a master seems to him neither sterile nor futile," Camus writes. "Each atom of that stone, each mineral flake of that night-filled mountain, in itself forms a world. The struggle itself toward the heights is enough to fill a man's heart. One must imagine Sisyphus happy."

A PHOTOGRAPH OF

JONATHAN BARNBROOK, taken when his hair was longer, shows him holding a gun to his head. His face is screwed up, his eyes are shut tight, and all his sinews are tensed in expectation of the explosion. The photo, used in magazines and in brochures and websites announcing his speaking engagements, references one of the principal themes in Barnbrook's work – the utter pointlessness of the world's many tragedies and the utter pointlessness of his typographic responses to them. Rather than being stultifying, however, the absurdity of this paradox becomes the energy source for Barnbrook's finest works. The font titled *Manson*, for example, is a tightly wound and P.78 unnerving exposition on beauty. It references the centuries-old tradition of stone carving, elements of classical architecture and letterforms found in Mediæval manuscripts, but also the headstones of desolate North London cemeteries, the cross-hairs used in aiming a firearm, and the nihilistic horror of one of the most infamous serial killers of the twentieth century. The beauty of this typeface relies on its dark underbelly of ugliness and violence. In fact, many of his fonts emanate from violent conflict – murder in the case of *Manson*, the violence of language in *Newspeak*, *Tourette*, and *Expletive*, and P.174 P.188 P.182 warfare in *Patriot*, *Exocet*, and *Shock & Awe*. Their P.65 P.58 P.186 power comes from the counterpoised forces of hopefulness and dark pessimism kept in the eternal limbo of that moment before the explosion.

Barnbrook graduated from the Royal College of Art in 1990. Britain was in a major economic recession, unemployment was on the rise again, coalition forces had invaded Iraq and, even though Margaret Thatcher had resigned, the Conservatives' decade-long grip on power looked set to continue. A lot of the big design firms, who had appeared so stable in the 1980s, were suffering; they certainly weren't offering jobs. Many young designers moved abroad.

Even more challenging than the lack of a design economy was the absence of a meaningful design ideology to rally around. The excesses of postmodernism had energized Barnbrook but, once they fizzled, he felt directionless. "For two months I couldn't do anything," he recalls. Some of his contemporaries found a new focus in Dutch graphic design. They were introduced to Gert Dumbar in the late 1980s when he was head of graphic design at the RCA and, with little to inspire in Britain's marketing-driven design landscape, they continued to look to Studio Dumbar's posters for the Zeebelt Theatre, for example, which featured the deft manipulation of free-floating typography and elaborately staged mise-en-scène photography. Barnbrook, on the other hand, wanted to stay in London. What interested him – more than the possibilities that Holland offered – was to look directly at the country he was actually living in and to retrieve some of its native design vocabularies.

Barnbrook grew up in Luton, a town thirty miles to the north of London, once the site of a vibrant hat-making industry, then the Vauxhall Motors car plant and today best-known for its airport, an unexceptional gateway to budget holidays in Europe. Luton was voted the worst place to live in Britain in 2004 and, despite Barnbrook's loyal support for the oft-relegated Luton Town FC, he has little to say in the town's defence. He describes his family as "modern" and "lacking in history," by which he means

typeface and iconic red and blue symbol still in use, was emblematic to Barnbrook of the richness of the cultural and historical continuities to be found in England. He identified other examples in the architecture and sombre stone-carved typography associated with memorialising which he saw in London's grand cemeteries.

Literature provided Barnbrook with another cue for what he calls "spiritual reassurance." At the age of

> "The font titled Manson, for example, is a tightly wound and unnerving exposition on beauty. It references the centuries-old tradition of stone carving, elements of classical architecture and letterforms found in Mediæval manuscripts, but also the headstones of desolate North London cemeteries, the cross-hairs used in aiming a firearm, and the nihilistic horror of one of the most infamous serial killers of the twentieth century. The beauty of this typeface relies on its dark underbelly of ugliness and violence."

that, because it split up several times—including when he was three and his Mother left his Father—that there are no photographs of family members from more than thirty years ago. When Barnbrook went to study graphic design at Central St. Martins in London, therefore, he wasn't as concerned as his classmates may have been with searching for something new. What he wanted to do was to forge a connection with the past, with qualities such as permanence and excellence, the evidence of which he saw all around him in the architecture and the architectural typography of London. The London Underground, for example, with its original station architecture still visible, and Edward Johnston's

fifteen, in an English O-level class, he was given Dylan Thomas's *Under Milk Wood*. "I'd never read a book that related to me so well before," Barnbrook recalls. He revelled in Thomas's use of double meanings to suggest the simultaneous existence of euphoria and darkness in someone's soul, a dichotomy he also heard in Joy Division albums such as *Closer* which he was listening to at the time.

It was a novel about spiritual crisis rather than reassurance, however, which inspired his most innovative student work at St. Martins. Using only one classical typeface family, *Garamond*, and a limited range of colours he set passages

and phrases from the Hermann Hesse novel *Steppenwolf* in compositions that articulate the

P. 24

architectural plan of a cathedral and the rhythms of a page of illuminated manuscript. His previous attempts at fulfilling student briefs had been unsuccessful; he tended to do what he thought the tutor was after and to save his personal take on the subject for some future hypothetical outlet. Creating the self-directed *Steppenwolf* pieces, therefore, marked a significant shift in Barnbrook's thinking and established a direction for much of his future work. The series signalled his newfound confidence in typography as an integral rather than ancillary part of graphic design. It also confirmed his appreciation of the bond between typography and language. Like the rest of Barnbrook's work that would follow, the *Steppenwolf* series was driven by a double-edged motivation. On the one hand was an utopian mission to create a better society – in this case, "I wanted to show this text to the world because I thought it was important" – and on the other was a personal need to fill that looming gap in his family history with something so monumental and beautiful that it would make him "seem like a person who had some worth."

It took Barnbrook a couple of attempts to gain admittance to a degree course. He blames his initial rejection on the fact that he didn't have life drawing in his portfolio. Encouraged by an art teacher who'd spotted his immaculate copies of band logos, he'd specialised early and done a diploma in graphic design, rather than following the more usual route of a foundation course. He also thinks it was because

he needed to loosen up. "I was so uptight. My work didn't have a sense of humour." A year on an HND course at Croydon brought out Barnbrook's absurdist streak. Indeed, by the time he got to his interview at Central St. Martins, in a self-conscious gesture that his interviewers graciously overlooked, he was sporting a dead fish in his jacket's top pocket.

Andy Altmann and David Ellis had just established their firm, the Why Not Associates, when, in 1988, they attended Barnbrook's degree show at Central St. Martins. They clearly remember their first encounter with his work. "It was typography as I had never quite seen it before," says Altmann. "Full of classical reference but utterly modern and ultimately beautiful. Even the imagery he had used in combination with the typography was unusual. I was desperate to know how he had produced such amazing work."

Even though the Why Nots could not persuade him to take a full-time job with them when he graduated from the RCA, they did let Barnbrook borrow their studio at night. After a couple of years of studio squatting, and aided (somewhat ironically, given his antipathy to Thatcherism) by the Enterprise Allowance Scheme, he was able to establish a studio on one of Soho's seediest backstreets, the same one he uses today. Unlike prior generations of type and graphic designers, all the equipment he needed was an Apple Mac computer.

Barnbrook wanted to make significant or "extreme" work – and for him, that meant work that told the truth. To do so, he had to tell the truth about himself – about a personality that contained anger, bitterness and

DEATH
SHOWN
LIVE

melancholy. The images he made in response to the Gulf War, and then was able to use as part of his book design for *Illustration Now*, were the first pieces of work P.46 in which he was able to resolve the need to be a good designer—he enjoys the problem-solving aspect of design—with the need to be honest.

Once he saw how he could use his type and his graphic design to interrogate the deeper issues of our existence on this planet such as death, religion, government, capitalism and war, there was no turning back. The search for beauty and immortality that had shaped his student years was mostly subsumed by a desire to point up the ills in society and in particular the insidious structural links between corporate and political power. Barnbrook began to use his work to fathom the raw and angry core of things; he seemed impelled to do so.

My first encounter with Barnbrook was a few years later in 1995. I was at the RCA and was helping organize an exhibition about the history of the college. I sent him a letter asking to show some of his work. "Dear Jonny," I wrote. "Where on earth had I heard that it was okay to call him Jonny?" His response came thundering back. And even though everyone else I know refers to him as Jon or Jonny, I have been careful, ever since, to use all three syllables of his name. Today he is more relaxed about it but, at that point, being precise about how he interfaced with the world was of utmost importance to him. This concern is evident in his immaculately wrought type specimens. Because success came to Barnbrook so early in his career—no sooner than he was out of college, he began to be feted by design magazines, to win awards and be offered major advertising commissions—he quickly understood that his work would be used out of context in wildly various

and sometimes utterly inappropriate situations. The historical references to stone carving and dark meanings that he thought were built into the very structure of a font like *Manson* were apparently all too easy to shrug off, as its use as a visual soundbite for 'Gothic' in the titles of Disney's *The Hunchback of Notre Dame* demonstrated.

Most designers see a font, once purchased, as just one of many tools at their disposal. Not neutral exactly—all typefaces contain residue of their makers' intentions—but malleable enough to be re-cast in service of a designer's project. For someone as artistically controlling as Barnbrook, this was a tough realization. He responded by initiating The Cult of Virus, an elaborate type specimen, P.130 printed in 1997 after almost a year of work, which provided specific graphic contexts for his fonts that he hoped would communicate the thinking that went into them. He wanted designers who bought the fonts to understand both what he was about, and what they were buying into.

By naming his fonts so specifically and by building such detailed worlds around them, they began to exist substantially as designed entities—art objects even—that contained their own auras and resonances. The logical by-product of this was that the fonts became impenetrable and other designers felt inadequate to the task of using them. The Why Nots, for example, have only tried a couple of times. "They are so about him that they are very difficult to use without appearing like a piece of his work," Altmann explains. Similarly, the Austrian art director Martin Tiefenthaler who has bought almost all of Barnbrook's fonts, says, "For me his fonts are pieces of art. I do not use them but leave it to Jonathan to use them in his works."

This is not to say that with his typographic cultism, Barnbrook was, or is, in opposition to design. Unlike some type designers, who produce typefaces from the margins, deliver them to the design community and then retreat, Barnbrook has worked in and amongst graphic design from the beginning. He even says he's amused, or at least interested, when designers use his fonts in unlikely ways. When the neo-Nazi organisation *Aryan Nations* used *Exocet* for their website, Barnbrook assumed it was because his references to Greek and Roman ideals of beauty could also be harnessed to a racist mission. Also contained in the font, however, and built into the very structure of the letterforms, are unambiguous references

to violence—its gunsight at the centre of the 'O,' its missile-derived moniker, for example. Barnbrook wanted to suggest the close ties between violence and language, but it's easy to see how such a subtle message might be lost in translation.

Ultimately, then, the designer who uses his fonts the most and the most successfully is Barnbrook himself. Like a self-sufficient farmer he home-grows all the components he will need to design something. And it's the process of making that is the most important and satisfying thing to him. Ideologically, that process is larger than design but, at the same time, it's also all about design.

WHILE THE LANGUAGE OF DESIGN HAS ALWAYS BEEN CENTRAL TO BARNBROOK'S WORK, he's adjusted its pitch over the years. Earlier in his career, he mainly used techniques such as collage and image juxtaposition and, in doing so, tapped into a lineage of political designers dating back to the early 20th century. Then, in a body of work generated for exhibitions in Tokyo and Seoul in 2003 and 2004, he began to experiment with more concise imagery–warped pictograms in particular. By focusing on the emblems of ideologies, such as flags or political figureheads, and then subverting them through their graphic fusion with other seemingly incongruous elements, he finds a way to encapsulate his message with more of a visceral punch than the collages allow for. His replacement of the Star of David in the Israeli flag with the plan of the Pentagon, for example, is meant to contain and distil all the intertwined issues surrounding American political support for Israel. Similarly, dressing Osama Bin Laden as Ronald McDonald forcefully closes the perceived distance between a US multinational and a terrorist icon.

Because their visual volume control is set so high, however, such images have less staying power than some of the quieter, more contemplative, pieces from the same period. A series of huge mandala patterns created, in close collaboration with his colleague Pedro Inoue, from thousands of corporate logos, for example, uses a softer timbre of allusion to convey its meaning, and is ultimately more effective than the aggressive rhetoric used in the pieces done in association with Adbusters magazine, for example.

The fact that the format for these politically motivated pieces is the limited edition print, and that they are hung in gallery contexts for rarefied audiences, begs the question: Who is he actually reaching with his messages? This is a question Barnbrook continues to wrestle with. His initial attempt to increase his audience was to collaborate with the stridently anti-commercial magazine, Adbusters, which has a circulation of 120,000. Since meeting its editor Kalle Lasn in 1998, he has designed two issues of the magazine, several flyposters and viral videos to promote their initiatives such as *Buy Nothing Day*.

He still believes in the viability of the limited edition format, however, reasoning that it doesn't have to be expensive, it is produced by methods that also allow for infinite reproduction and, when supplemented with a downloadable digital version that is free, it will reach people. It seems that, for Barnbrook, the very act of telling the truth helps to re-shape the ideological landscape. His political messages are not about wanting people to rally in the streets necessarily. They are more about delving into, and exposing, society's self-imposed restrictions on language and communication, and by doing so, contributing to the conditions in which a different kind of discourse can take place. The font titled *Tourette*, for example, comments on the fact that swearing is shocking in the context of the shared rules we unthinkingly follow. By saying the things that most people shy away from, by getting angry and swearing, by being extremely miserable or extremely excited about things, he hopes to change what it's acceptable to talk about.

Wouldn't he be better off re-positioning himself as an artist, if for no other reason than to gain more airtime for his causes? In many senses he already is. He produces self-directed work that speaks to the human condition and the individual pieces, which connect to one another thematically and aesthetically, can all be seen to be building towards something—towards a life's work. But having worked at close range with some artists, notably Damien Hirst and, less successfully, Tracey Emin, he was "put off." He saw how hard it is to resist the art system's desire to make the artist a commodity. "It's okay to be experimental in art as long as you don't attack the rich people who buy your work," he says. And, as someone with his political values, and who is also committed to the fact that graphic design is cheap, he believes this inconsistency would prove too problematic.

ANOTHER REASON NOT TO JUMP THE SEMANTIC DITCH BETWEEN ART AND DESIGN IS BECAUSE BARNBROOK IS SO ENTANGLED IN THE FIBRES OF GRAPHIC DESIGN—WILLINGLY ENTANGLED.

In a complex piece of information graphics, entitled *The Corporate Vermin that Rules America*, he highlights specific links between
P.264
corporations and politicians. Barnbrook also acknowledges graphic design's own inevitable ensnarement in this web of corporate and political power. As a graphic designer, Barnbrook is expected to convey the messages of the very multinationals that, as a humanist, he rejects. Rather than be defeated by the contradiction, however, he faces it head on. He addresses the issues that graphic design is at the heart of and he uses the strategies and tools of graphic design to do it.

Advertising, for example, provides him with a deep wellspring of linguistic source material. Despite, or perhaps because of, his antipathy towards commercialism, Barnbrook is attuned more than most to the cadence and vocabulary of jingles and sound bites. He then re-appropriates them in the form of pithy slogans such as

"North Korea: Building the brand"

OR

"You can't bomb an idea"

– the axes around which his ideas spin.

The *You Can't Bomb an Idea* screen print refers to the cyclical nature of violence
P.263
– in this case the conflict between Western values and Islamic fundamentalism. At its centre is the outline of an airplane (representing Al-Qaeda's attack on the World Trade Center) facing one way superimposed on a missile (representing the US military response) facing the other. They are locked together in a never-ending tailspin, indicated by three sets of graphic arrows that surround them. The tragic absurdity of the situation is further reinforced by the fact that each time the piece is turned 180 degrees, one of the ideologies appears to take prominence.

An even more blatant portrait of futility is found in the *Violence is a Cycle* print in which four generic human pictograms,
P.276
differentiated only by Star of David or Moon and Star symbols, each hold a gun to the other's head in a classic Mexican standoff situation. Sharon and Arafat, their outlines depicted in barbed wire, look on approvingly at their mechanical ciphers, whose feet meet at the centre of a map of Palestine and Israel. And so the deadly wheel keeps on turning.

THERE ARE MANY WAYS FOR POLITICALLY DRIVEN GRAPHIC DESIGN TO HAVE AN EFFECT, HOWEVER.

We tend to evaluate it using the measures of advertising or propaganda and are disappointed when people do not gather en masse to take immediate and collective action in response to it. In reality, the outcomes are subtle, fragmentary, and take time to reveal themselves. It may take the gestation of a whole new generation of designers before we can measure the consequences of Barnbrook's graphic crusades. The people he influences the most, ultimately, are students—those who have attended the many dozens of lectures he has given all over the world since his rise to fame in the early 1990s. "Students give me hope because they let me know I've connected with them in some way and now they're motivated to do things differently," he says. What is integral to Barnbrook's project, and is more enduring than the melancholia and the anger, is his passion and, even though he himself may not use the word—his optimism.

We have to wait and see how future designers will put Barnbrook's incitements into action, but the very fact they take notice at all is the beginning of a rupture in that pointless cycle of violence.

A–Z

It can be very difficult to connect your thought processes at college with the design you see around created by professionals. Therefore I felt it was important to start this book with my student work to show the path I took to becoming 'a proper designer'.

When I look at these pieces now, despite the fact that they are not 'pure graphic design' I am surprised how evident the direction of my later work was. At the time though I did not have a clue where I was going, I felt completely unemployable. I was certain that there was something wrong with me because I didn't want to work at a big design group, disliked advertising and could rarely complete the college 'set projects' to my or the tutor's satisfaction. It is only now that I realise that such awkwardness was a good thing – it came from an intensity and concern for design that many of my contemporaries did not share. If you feel as as I did and don't fit in you should have the confidence to follow your instincts despite what others may say. Work of any kind that is done with passion is a thousand times more interesting than a 'professional' portfolio.

On the right are collages created in the first and second years of my BA at Central St. Martins. The lettering is subservient to the image, but I think they have the same atmosphere as the later pure typography work. They share a concern for 'Europeanness' (whatever that means) albeit of a romantic 1940s kind. They look very dated now but at the time it felt like I was entering some new territory in my work as a designer.

Assorted collage work | MIXED MEDIA | 1985-86

The typography I most admired when I was a student ranged from the carvings of Ancient Rome to mediæval illuminated manuscripts, these all had one thing in common, they were created by the maker directly manipulating the lettering. This project using quotations from the novel *Steppenwolf* by Hermann Hesse (a book which had a profound effect on me) was the first time I went through the same process, and so it marked my first significant step towards the typography I would produce for the rest of my career.

Today you have the Mac to help you create your typography, in the 1980s the only way to get close to the level of control needed was to do all of the typsetting yourself. As a result I had to go through the painful process of learning a Linotronic and then a Berthold typesetting machine. Both machines required that you enter everything mathematically, the Berthold showed you roughly on a screen the position of the type. Both outputted on expensive photographic paper, making everything they produced akin to a letterpress limited edition print.

This contained what I considered the most important text from the book. The layout was based on architectural plans of cathedrals. They seemed hugely monumental, obviously sacred, but also very modern in their asymmetry. The perfect thing to use as the basis for something reflecting the past but talking about today.

I. *Typographic Calendar*
PHOTOGRAPHIC PRINTS | 1987

These were a precursor to the *Steppenwolf* work. I wanted to take them back to the essentials: one typeface family, limited colour, and typography varied only by size. If I had been devoted to Modernism, I would have restricted myself to Helvetica in black only, however I wanted to express the beauty of classical typography. I believed in the principles of Modernism but hated the visual language.

The pieces have a religious feel, I idolized the text and I wanted to create something to be worshipped. I realised that with typography you could construct a perfect 'universe', a voice of truth. Why did I want to do this? It was about creating an absolute when all around seemed in chaos. Self-hatred was another reason, if I could produce 'perfection' then surely I was at least a worthy person.

Before I did these it seemed like my typography was merely 'fulfilling the brief'. Now I was finally making work that directly connected with my world. I was nervous about these at first, they were useless – graphic design always has to have a purpose, doesn't it? I had made 'typographic pieces', 'things', an awkward response to a book I loved. Looking back it does seem like the natural start to specialising in typography and referring to a history that I was passionately interested in, but at the time I thought I was f***ing up my whole degree.

III. NEXT PAGE LEFT: *For Madmen Only* | LITHOGRAPHIC PRINT | 1988

This was created on the Berthold typesetter. Looking back, the technology seems very clunky, but at the time it felt like some kind of filter had been taken off my design process. Typesetting it yourself meant you became involved and passionate about the small details, you could shape body text, end anything at a specific point and make minute adjustments in kerning. Now commonplace but difficult to achieve then.

IV. NEXT PAGE RIGHT: *Onwards To War* | LETTERPRESS | 1988

Using letterpress, the creation of this had the same directness as working on the typesetting machine. It is very different from using any kind of computer, it is not a matter of endless easy adjustment, you have to make definite decisions about typography. The physicality of the letters also makes you respect their proportions and left me with a dislike of anything which looks too electronically processed.

A COMPR **EGO** ERIMENT

LI GHT

EVERY CREATED THING IS ALREADY GUILTY

A DEGREE OF HUMAN CONSCIOUSNESS

SURRENDER

W B STREAM

LIKE ALL

MORALITY

LIFE

ANGRY PRIMAL MOTHER NATURE

STATES

A

HERECTICS

E

EGO

CULTURE SUICIDE CHAOS

A

TEMPERATE ZONE

MOZART GLIMMER

L I F E

V R

R

EVERY CREATED THING IS ALREADY GUILTY BACK TO ITS SOURCE AND IT MAY BE MULTIPLE IT HAS NEVER BEEN THROWN MORE SWIM INTO THE STREAM OF BEING

IT STILL REMAINS TO ELUCIDATE THE STEPPEN

HIS HARVEST IS A QUIET MIND WHICH HE PREFERS TO BEING POSSESSED BY GOD, AS HE

WOLF AS AN ISOLATED PHENOMENON, IN HIS

PREFERS COMFORT TO PLEASURE, CONVENIENCE TO LIBERTY AND A

RELATION TO THE BOURGEOIS WORLD SO

PLEASANT TEMPERATURE TO THAT DEATHLY

THAT HIS SYMPTOMS MAY BE TRACED

INNER CONSUMING FIRE

TO THEIR SOURCE. *Let us take as a starting point, since it offers itself, his very own relation to the bourgeoisie. To take his own view of the matter, the Steppenwolf stood entirely out of the world of convention, since he had neither family life nor social ambitions. He felt himself to be single and alone, whether as a queer fellow and morbid hermit, or as a person removed from the common run of men by the prerogative of talent that had something of genius in them. Deliberately he looked down upon the ordinary man and was proud that he was not one.*

A MAN CANNOT LIVE
INTENSELY EXCEPT
AT THE COST OF
ONESELF NOW
THE BOURGEOIS
TREASURES NOTHING
MORE HIGHLY
THAN THE SELF

THE *bourgeoisie* [1] RESIDES BY NO MEANS

which are
IN THE QUALITIES OF ITS MEMBERS BUT

questionable
IN THE QUALITIES OF ITS EXTREMELY

NUMEROUS *outsiders* [2] WHO BY

continue
VIRTUE OF THE EXTENSIVE

NESS OF ITS IDEALS

always
IT CAN EMBRACE

Nevertheless his life in many aspects was thoroughly ordinary. He had money in the bank and supported poor relations, he was dressed also quite respectably and inconspicuously, even though without particular care. He was glad to live on good terms with the police and the tax collectors and other such powers. Besides this, he was secretly and persistently attracted to the little bourgeois secure world, to those quiet respectable homes and so-tidy gardens, irreproachable stair-cases and their whole modest air of order and comfort. It pleased him to set himself outside it, with his little

vices and extravagances, as a queer fellow or a genius, but he never had his domicile in those provinces of life where the bourgeois ceased to exist. He was not at ease with violent and exceptional persons nor with criminals and outlaws, and he took up his abode always among the middle classes, with whose standards and atmosphere he stood in constant relation, even though it might be one of contrast and revolt.

many of the notions and much of the examples of those days never left him. In theory he had nothing whatever against prostitution, yet in practice it would have been beyond him to take a harlot quite seriously as his equal. He was capable of loving the political criminal, the revolutionary or intellectual the outlaw and society as his brother, but as for theft and murder he would not know how to deplore other than in a thoroughly bourgeois manner. In this way he was always recognising in thought and act, what with the other half he fought against and denied.

Moreover he had been brought up in a provincial and a conventional home and a number of the notions and

To long for things passed and die more beautifully than ever before [3]

1. HUMOUR THAT MAGNIFICENT DISCOVERY OF THOSE WHO ARE CAUGHT SHORT IN THEIR CALLING TO THE HIGHEST ENDEAVOUR, THOSE WHO FALLING SHORT OF TRAGEDY ARE AS RICH IN ITS GIFT AS IN AFFLICTION. 2. HUMOUR ALONE, IS THE MOST INBORN AND BRILLIANT ACHIEVEMENT OF THE HUMAN SPIRIT, IT ATTAINS TO THE IMPOSSIBLE AND BRINGS EVERY ASPECT OF HUMAN EXISTENCE WITHIN THE RAYS OF ITS OWN PRISM.

IT IS BETWEEN THE TWO, IN THE MIDDLE OF THE ROAD, THAT THE BOURGEOIS SEEKS
TO WALK · HE WILL NEVER SURRENDER HIMSELF EITHER TO LUST OR TO ASCETI-
CISM · HE WILL NEVER MA TYR OR MOVE TO HIS OWN
DESTRUCTION · ON THE CO NTRARY, HIS IDEAL IS
NOT TO GIVE UP BUT TO KEEP HIS OWN IDENT-
ITY · HE STRIVES NEITHE R FOR THE SAINTLY NOR
THE OPPOSITE · THE A BSOLUTE IS HIS ABHO-
RENCE · HE MAY B E READY TO SERV-

GOD BUT NOT BY GIVING UP THE FLESH POTS · HE IS READY TO BE
VIRTUOUS, BUT LIKES TO BE MOST COMFORTABLE IN THIS
WORLD AS WELL · A LIFE WITHOUT TEMPEST

HERMANN
HESSE

EVE**RY**BOD**Y**
THE *kaiser*, T
HE ᴮᵛˢINESS
MAN, *the* CIᵛ
IL SEᴿVANT
ᴬᴺᴰ THE ᴺᴱᵂˢ ᴾᴬᴾᴱᴿˢ N
OT ONE HA
S *the* LEᴬˢT T
HING ᵀᴼ BLA
ME HIMˢELF
ᶠᴼᴿ NOT *one* H

SO IT IS WITH THE MAJORITY OF

...ULD JUST AS WELL BE D ONE BVS RAS IT IS ALL MECHA NICHAL AND CO...

(left vertical margin) ANOTHER WAS THAT HE ... AFFAIRS WITHOUT WANTING TO AT ALL. THEY PAY CALLS, SIT OUT THEIR HOU...

(right vertical margin) BELONGED WITH THE SUICIDES. ... MEN, DAY BY DAY AND HOUR BY HOUR IN THEIR DAILY LIVES AND...

AS ANY GVI
LT. NOᴮᴼᴰʸ R
EALLY *wants* ᵀᴼ AVOID WAR *if* THE
COST BE SELF - EXAMINATION T
O RᴱFLᴱCT. AND SO THᴱRᴱ IS Nᴼ Sᴼ
PPIᴺG IT ᴬᴺᴰ THE ᴺᴱˣᵀ ᵂᴬᴿ IS BEING ᴾᵁˢʰED
ON *with* EᴺT
HVSIASM *by*

W

TʰᴼVSᴬᴺDS D
AY BY DAY

Æ

H

(Fig 1 surrounding text) ON THE STAGE I SAW AN ANIMAL TAMER - A CHEAP JACK GENTLEMAN WITH A POMPOUS AIR - WHO IN SPITE OF A LARGE MOUSTACHE, EXUBERANTLY MUSCULAR BICEPS AND HIS ABSURD CIRCUS GET-UP HAD A MALICIOUS AND DECIDEDLY UNPLEASANT... MYSELF... TO EMBLA THE STRONG MAN LED ON A LEASH LIKE A DOG, A LAMENTABLE SIGHT A LARGE, BEAUTIFUL BUT TERRIBLY EMACIATED WOLF, WHOSE EYES WERE COWED AND FURTIVE; AND IT WAS AS DISGUSTING AS IT WAS INTRIGUING, AS HORRIBLE AS IT WAS ALL THE SAME SECRETLY ENTERTAINING, TO SEE THIS BRU...

(vertical) TAL TAMER OF ANIMALS PUT

THE NOBLE AND YET SO IGNOMINIOUSLY OBEDIENT BEAST OF PREY THROUGH A SERIES OF TRICKS AND SENSATIONAL TURNS. THERE WAS SOME COMPENSATION, HOWEVER, BOTH FOR THE HORRIFIED SPECTATOR AND FOR THE WOLF HIMSELF, IN THE SECOND PART OF THE PROGRAMME. FOR AFTER THIS REFINED EXHIBITION OF ANIMAL-TAMING AND WHEN THE MAN WITH THE WINNING SMILE HAD MADE HIS TRIUMPHANT BOW OVER THE GROUP OF THE WOLF AND

H

(vertical) THE LAMB, THE ROLES WERE

REVERSED. MY ENGAGING DOUBLE SUDDENLY WITH A LOW REVERENCE LAID HIS WHIP AT THE WOLF'S FEET AND BECAME AS AGITATED, AS SHRUNKEN & WRETCHED, AS THE WOLF HAD BEEN BEFORE. THE WOLF, HOWEVER, LICKED HIS CHOPS WITH A GRIN, HIS CO... NTRAL... DISSIM... NERAS EYES KI HIS WH NDLED. ...OLE BO DYWAS TAUT AND SH OWED THE JOY HE FELT AT RE COVERING HIS WILD NATURE. AND NOW THE WOLF COMMANDED AND THE MAN OBEYED - HE TORE OFF HIS OWN CLOTHES, WENT DOWN ON ALL FOURS, THEN HE LET THE WOLF RIDE ON HIS BACK.

FINALLY TOWARDS THE AGE OF FORTY SEVEN OR THEREABOUTS, A HAPPY, BUT NOT HARMLESS, IDEA CAME TO HIM. HE APPOINTED HIS FIFTIETH BIRTHDAY AS THE DAY ON WHICH HE WOULD TAKE HIS OWN LIFE. ON THIS DAY, ACCORDING TO HIS MOOD, IT SHOULD BE OPEN TO HIM TO EMPLOY THE EMERGENCY EXIT OR NOT. LET... TO HIM WHAT MIGHT: ILLNESS, POVERTY, SUFFERING... THERE WAS A SET TIME LIMIT. AND WITH THIS... THE THOUGHT OF HIS FIFTIETH BIRTHDAY... CONGRATULATION WOULD ARRIVE WHILE HE... TOOK LEAVE OF ALL HIS PAINS AND CLOSED THE DOOR QUIETLY BEHIND HIMSELF.

FIG 1. THE QUESTION

FIG 2. THE ANSWER

TECHNOLOGY

IS NOTHING MORE

NOTHING MORE

THAN

NOT PROCESS

AN END IN ITSELF

Student Work: Machine-generated Stone Carving

These were carved with a machine used to make cheap gravestones. It has a primitive pantograph system – a stylus follows a guide for the letter and a drill carves into the surface of the stone. The letterforms it produces are completely unlike what constitutes good carving, without fluidity or rhythm. However rather than accept that the machine produced a mechanical looking result, I thought it would be better to make a positive feature of it.

Working on stone raised issues about the way we use and perceive typography – when you work on computer you can make endless changes, but with stone there is only one chance, it means that you make a mark for eternity.

Technology And Craft
MACHINE GENERATED STONE CARVING ON SLATE | 1990

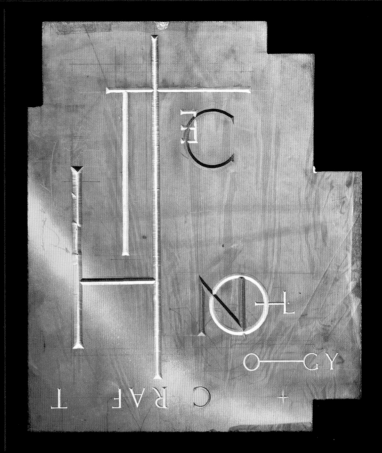

I became very interested in gravestones, I even did my final degree thesis on Contemporary Memorial Art. There seemed to be a very strong undervalued history of it in Britain. I would often sit and work in Kensal Green and Highgate cemeteries in London to be influenced by the atmosphere. I think these and the Steppenwolf pieces show that.

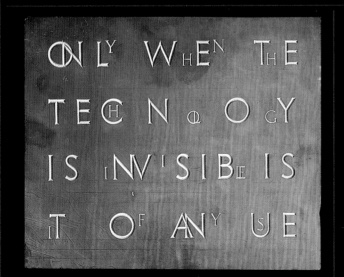

The discipline needed to carve in stone worried me, I almost thought I shouldn't even try. However I decided that as with much of my other work, the making process should be part of the aesthetic. If I made a mistake, so be it. Looking again at much historical stone carving I realise the idea of 'perfection' is an illusion. When a mistake was made three or four hundred years ago it was simply crossed out and the carving was continued. It was great to include this supposedly modern idea which was referring very much to history.

Only When The Technology Is Invisible Is It Of Any Use
MACHINE GENERATED STONE CARVING ON SLATE | 1990

When I was at the Royal College of Art I was commissioned to redesign the existing graduation certificates. Because it was a real job I started off producing a very pragmatic 'swimming certificate' style design, looking at them once they were close to completion I realised they were boring and offered nothing new. If these were to be used by the College they needed a bit more honesty about what was going on at the RCA – far from being a place of experiment and excellence, the teaching was disorganised and the Rector Jocelyn Stevens seemed to want to use it as a testing ground for right-wing education policy – introducing extra fees for all students and bringing in corporate sponsorship for projects which often distracted from proper education. Ahem… unsuprisingly, these were rejected by the College.

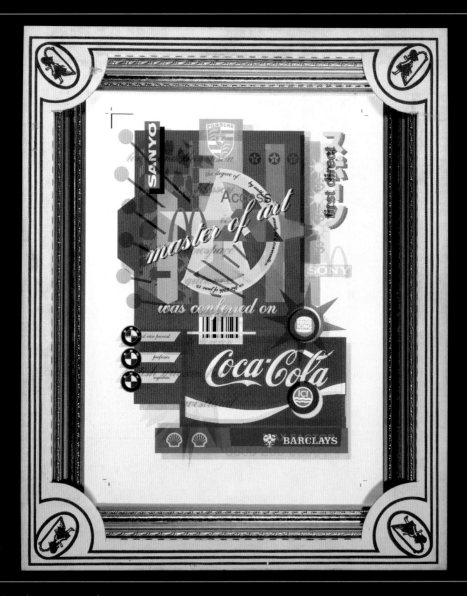

Master of Arts Certificate | MIXED MEDIA | 1990 I wanted to express my view that sponsorship was infiltrating the College and unfairly influencing the curriculum, so this certificate featured a myriad of company logos all vying for attention. The student's name was now to be written (with difficulty) over a barcode while the tutors were represented by a BMW logo, an expensive car I imagined them all driving. 'Sports' is written in Japanese parodying a series of desirable electronic products, highlighting the certificate as some kind of coveted consumer item. It was tastelessly packaged and framed ready for shipping to a 'nice' suburban home. Although this was very critical of the College I hoped it would be seen as humorous, with an almost celebratory feel.

I was working on these at the same time as the machine-generated stone carving. They were the absolute opposite – brash colour, rampant commercialism, and pure ugliness. While the stone carving was concerned with principles of craft, aesthetics and highly contemplative, these were full of conflicting design ideologies and irony – maybe there is something in my character that always has to have these opposites existing together.

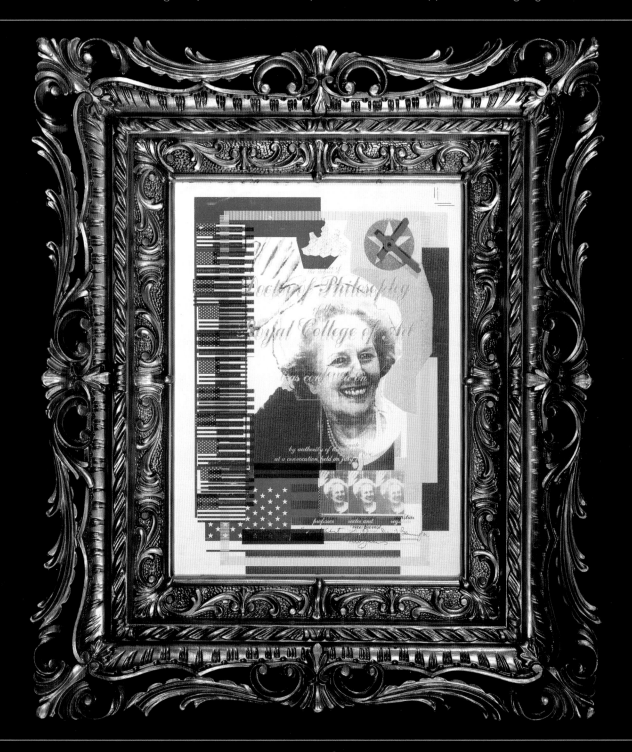

Doctor of Philosophy Certificate | MIXED MEDIA | 1990 It seemed that Margaret Thatcher's philosophy was held in really high regard at the RCA so I created the 'real world' of Thatcherism on this certificate. An appropriate picture frame was selected to fit government-approved 'British' visual language, a clock was also added to give the certificate some kind of 'function'. Finally an American flag was included as the College seemed to be embracing many of the negative aspects of the American education system.

Bastard is an experimental Blackletter font created in 1988 when the computer had finally made it possible for designers to easily construct typefaces. It acknowledged a strong typographic form but reinterpreted it using this new technological aesthetic.

The thing that fascinated me about Blackletter forms was the similarity of shapes: the characters would only differ very slightly, yet they would make up all of the meanings, tones and variations in language. It was amazing that out of this morass of vertical lines you could read meaningful text.

I was really interested in the history of Blackletters, a neutral style of letterform that had been hijacked by the Nazis, but was so central to the development and history of typography. I felt that it was important not to ignore their five hundred years of influence while acknowledging their twentieth century fascist associations.

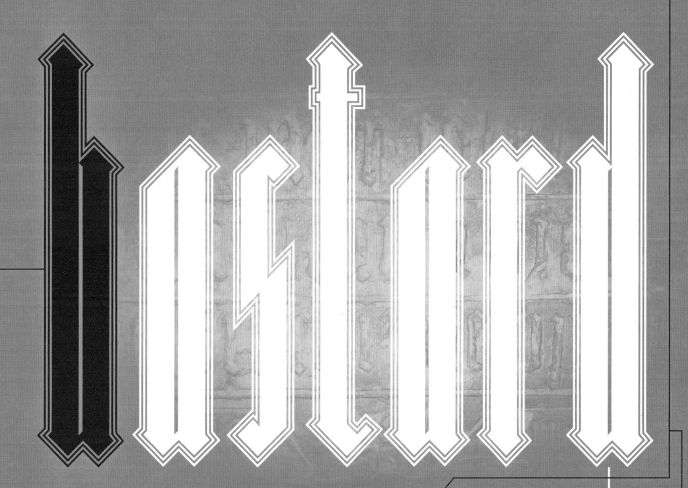

33

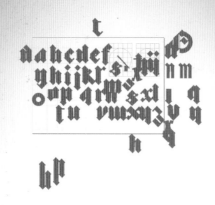

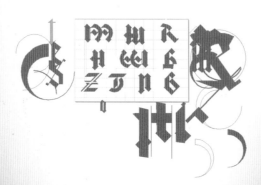

I started *Bastard* out of arrogance; my college wouldn't buy me a Blackletter font to experiment with so I decided that I WOULD JUST CONSTRUCT IT ALL MYSELF.

Firstly I made simple drawings with a pen that were scanned in on the computer and traced in a vector program. As I was working on it the process felt wrong. What was the point of pretending that this font, which would be used and drawn on a computer, was constructed only with a broad-nibbed pen? Surely the technique and aesthetic should reflect this. I then began a proper analysis of the forms using the idea of digital replication and modularity in relation to traditional construction of fonts. The result was a very simple grid and a kit of parts to generate the whole alphabet.

THIS FONT WENT THROUGH LOTS OF **NAME CHANGES** SUCH AS:

[AFTER JOHN HOLMES THE PORNSTAR, A REFERENCE TO THE *extended* NATURE OF THE FONT]

[NAMED AFTER THE INTERWAR GOVERNMENT IN GERMANY]

[FORMER GRIM CONSERVATIVE MINISTER]

THEN SIMPLY...

I THOUGHT OF CALLING IT 'MOSLEY' BUT I DECIDED IT WOULD NOT BE CLEAR THAT I ACTUALLY LOATHED THE LEADER OF THE BRITISH FASCISTS, SO IT WAS DROPPED

thatcher

Finally I chose the name *Bastard,* IT MAY SOUND a bit throwaway, but it is one of the names I thought about the most. IT SEEMED TO FIT SO PERFECTLY WITH MANY DIFFERENT MEANINGS WHICH RELATED TO THE FONT: I. A style of Blackletter from the 15th century is called *bastarda.* II. When an incorrect setting appears in a piece of letterpress setting, it is called 'bastard type'. III. *Bastard* was not a pure Blackletter font from one family of *fraktur* and *textur,* but a mixture of their construction. IV. I wanted to make it obvious that I didn't agree with the fascist association so an exclamation that any fascists (in the true political sense) were bastards seemed appropriate.

Spindly Bastard

Fat Bastard

Even Fatter

Bastard

Being brought up in a college environment where we were always told that a typeface should be legible and definitely not affect the 'message', Blackletter forms seemed to be this weird manifestation that represented all that was wrong with 'decorative typography', therefore the best possible reason to experiment with them.

A C M R R

Some of the earlier letterforms which related more to the traditional drawing of Blackletter.

The name DID come from its association with fascism. Rather than politely ignore it, I thought I would tackle it head on. So it was used in a way to talk about forces of fascism today. When it was first released the catalogue announced, "This is *Bastard*, to be used by corporate fascists everywhere."

Proposal for Victoria & Albert Museum Logo, 1990
Originally the font was to be used on a student project; a proposed corporate identity for the Victoria & Albert Museum (I was always desperate to find some practical applications for my experiments).

Early type layout, 1990 An exploration of the atmospheres around the usage of Blackletter fonts in the 1930s.

Lying For The Sake of A Month's Salary Is Well Known In Fleet Street, 1990
Type specimen poster for *Bastard* font using quotations from the Oscar Wilde essay *The Decay of Lying.*

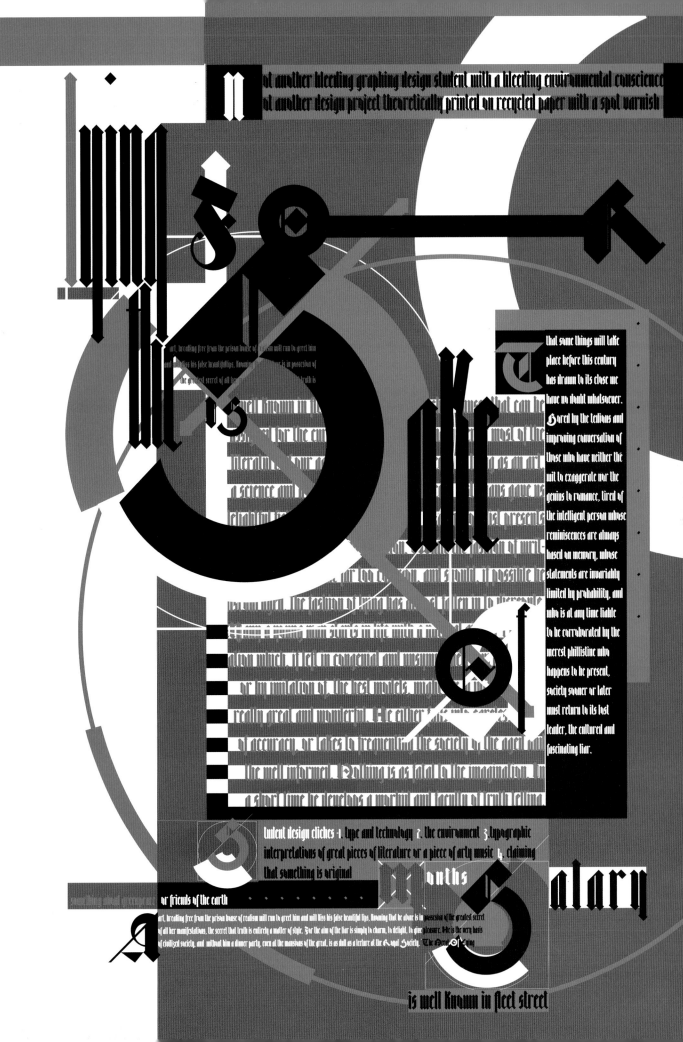

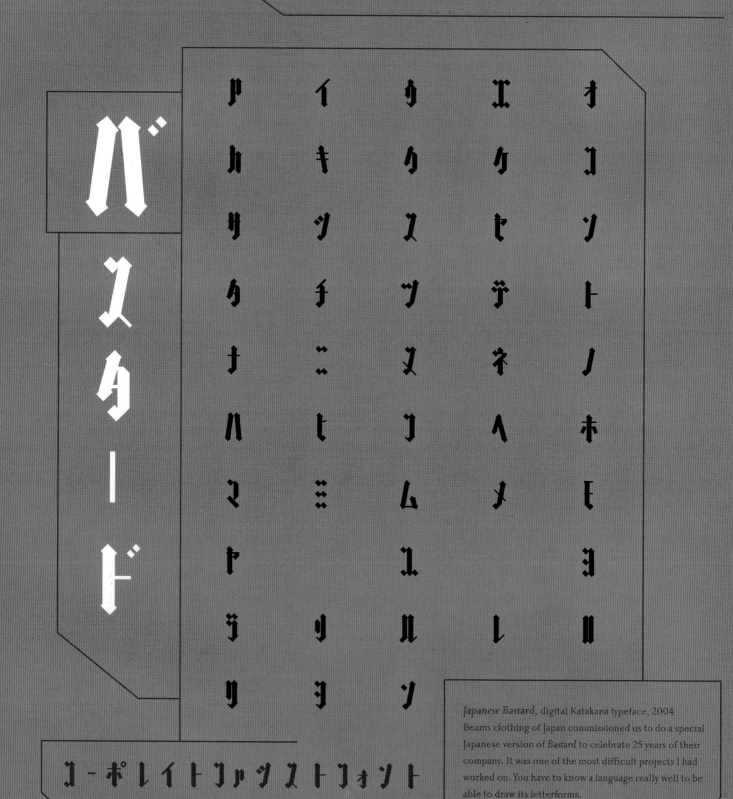

That's a Nice Shirt, type specimen screenprint for *Bastard*, 1990
To emphasise the highly decorative nature of the letterforms being more important than the content of the text, intentionally banal phrases from everyday life were used on this poster. This includes such marvelous British platitudes as 'it's a funny old world' and 'said the actress to the bishop' which is often uttered when somebody has unintentionally said something that could be seen as sexual in nature.

Japanese Bastard, digital Katakana typeface, 2004
Beams clothing of Japan commissioned us to do a special Japanese version of *Bastard* to celebrate 25 years of their company. It was one of the most difficult projects I had worked on. You have to know a language really well to be able to draw its letterforms.

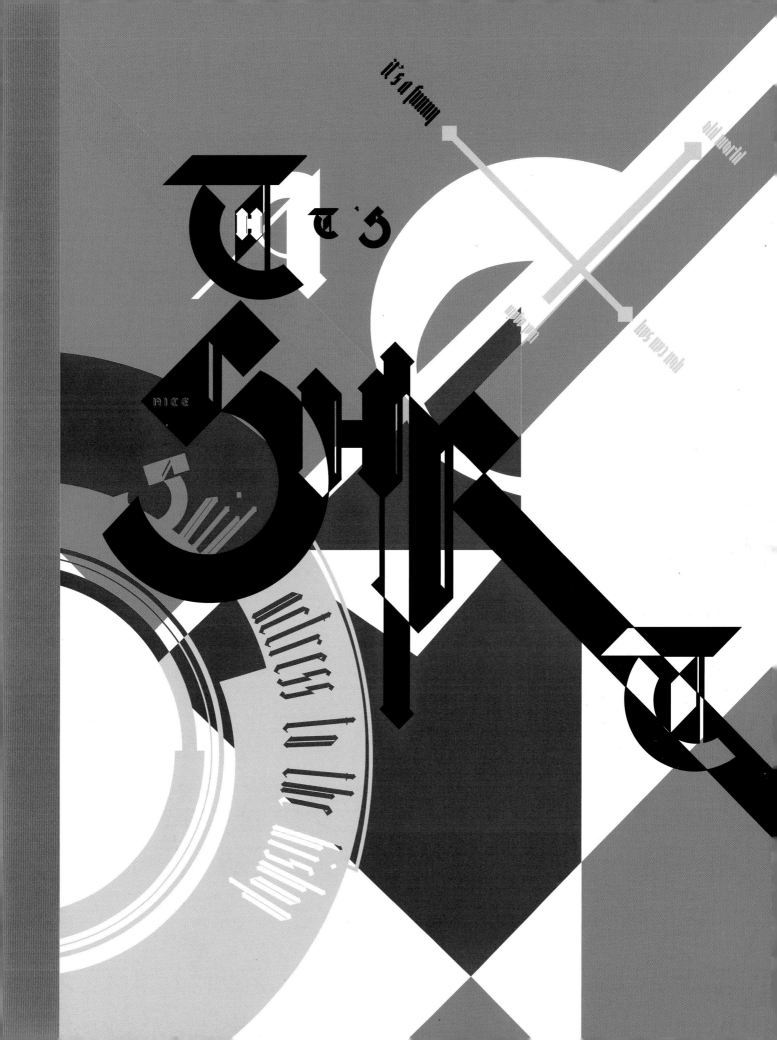

ANNOUNCING ANOTHER

EVIL

CORPORATE MERGER

PROTOTYPE

FONT

A typeface begun in 1987 and finished in 1990, *Prototype* was a very modest attempt to completely replace the Western alphabet with a single font that contained elements of serif, sans serif, upper and lower case.

ABCD
EFGHIJKLMN
OPQRSTUV
WXYZ
1234567890

ABCDEFG
LHIJKMNO
PQRSTUV
WXYZ

ABC
EE

The construction of *Prototype* started before you could draw fonts on the Macintosh. The idea for the first 'sketches' came from the concept of sampling that influenced pop music at the time – I thought you could apply those creative principles (copyright issues notwithstanding) to typefaces. The technology was very limited so the only thing I could do was photocopy, scan and redraw. It was important though that the sampling was evident in the final font, so I made the collage feel integral to the look. The initial experiments were in upper case only.

ABCDEFGHIJKLMN
OPQRSTUVWXYZ

Mulatto, 1988 | The original font was redrawn and digitised at a later point.

Later in 1990, as I worked on the digitisation of the original font, I started to look at how other people had tackled the design of a logical alphabet and thought about what would be 'universal' or 'logical' in my own time. I was a student at the RCA and there seemed a real problem with a lack of meaning or ideological direction in design then. We were living after the initial exuberance of postmodernism which had left an ideological vacuum, so to be universal meant 'identity crisis'. Each character was drawn to have the attributes of upper case, lower case, serif and sans serif in each letterform. Instead of a Modernist rationalism they had the tired familiarity of an overplayed pop song.

A SIMILAR EXPERIMENT WAS TRIED WITH THE APPLIANCE OF ALL LOWERCASE THIS DENIED THE NEED FOR EMPHASIS GIVEN WITH CAPITALS AND HELP WITH FINDING YOUR PLACE AT THE BEGINNING OF SENTENCES.

A NUMBER OF DESIGNERS HAVE DRAWN A UNIVERSAL FONT ATTEMPTING TO RATIONALIZE ALPHABET BY REMOVING THE INCONSISTENCIES OF UPPER AND LOWER CASE.

NOW NO LONGER AN EXPRESSION OF MODERN IDEOLOGIES, MERELY A DESIGNER AFFECTATION

SUPPOSEDLY REFLECTING A DESIRE TO IMPROVE COMMUNICATION THROUGH THE APPLICATION OF A RATIONALE

AT ONE POINT EMBRACING 'CLARITY' AND 'ORDER' IN THE SERVICE OF A NEAR FUTURE UTOPIAN SOCIETY

THE DESIRE FOR LOGIC DENIED THE ORGANIC NATURE OF LANGUAGE AND THE HISTORY OF THE WRITTEN WORD

TO INTERJECT A VISUAL FORM INBETWEEN A READER AND THE WORDS WAS EXACTLY WHAT THEY WERE TRYING TO ERADICATE. THEY NOW STAND AS INTERESTING VISUAL EXPERIMENTS NOTHING MORE

REINFORCING THE DEBATE ABOUT LEGIBILITY IN THAT WHAT YOU READ MOST YOU READ BEST

CONTROL OF VISUAL FORMS

Working diagram used to try and formulate the concepts for the construction of Prototype, 1995

abcdefghij klmnopqr bayer

LOGIC

ABCDEFGHIJKLM NOPQRSTUVWXYZ

KARAOKE

As I started to investigate these 'new' shapes, I became increasingly aware of how old the letterforms looked, almost exactly like examples from the 10-13th century. For me it confirmed that much true experimentation with character shapes can only be done with a knowledge of how to properly construct the shapes by hand, that's when true subversion happens.

A

A A A A A

EARLIER VERSIONS OF THE 'A' LETTERFORM

IX. Gulf War I + Illustration Now

Development of work is organic; there shouldn't be a divide between commercial and private. I learnt this by going through a painful process many times at college – completing the 'set brief' in the way that I thought it should be done and then doing work 'that I could be really happy with' in the little spare time I had.

Much better to stick your neck out and face the wrath of tutors (and later on clients) – do the work you want to do and in the end you will become a much better designer for it. This merging of commercial and private work can be seen in these two projects. Posters I designed, printed and put up at the time of the Gulf War and their influence on the subsequent design for *Illustration Now*, a book showing the (supposed) best of illustration from Europe and America.

Shell Oil + Jesus, 1991
Laser printed poster put up at the time of the Gulf War in London. For me it was revisiting elements of the idea based graphics of the 1960s, the sort of thing that I loathed when I was a student; but that kind of clarity seemed to make sense in all of the confusion, double-meaning and twisting of truths. I wanted the pages to be 'naked' and the strength of the ideas to come through.

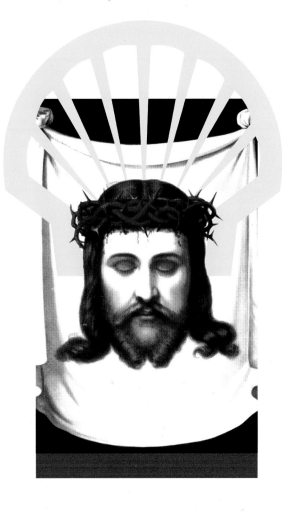

PRAY

Gulf War I

These posters were colour laser prints, a few were stuck up around London at the time of the Gulf War. I am not sure if anybody saw them but it felt like I had to say something. Although they are very controlled in appearance they were an intense emotional reaction to what was going on. The only thing I could do was clumsily use the only thing I knew – graphic design – to say something about it.

Sometimes when people see these they ask me:

BUT DOES IT MAKE ANY *difference?*

That is when I always think of the answer Jamie Reid gave me in a lecture:

IT IS ALWAYS *hard to tell what effect you are having, but I am pretty sure you will, you add to the general feeling of something being 'wrong'. Even if it has no effect, you should still try. Once you stop thinking that you can change the world through your actions it means that 'they' have won, 'they' being all of those that have a selfish interest in keeping the world as it is and disadvantaging or misleading the rest of us.*

As Long As We Know What We Were Fighting For
LASER PRINTED POSTER | 1991

as long as

we know

what we were

fighting for

BAGHDAD

TEXACO

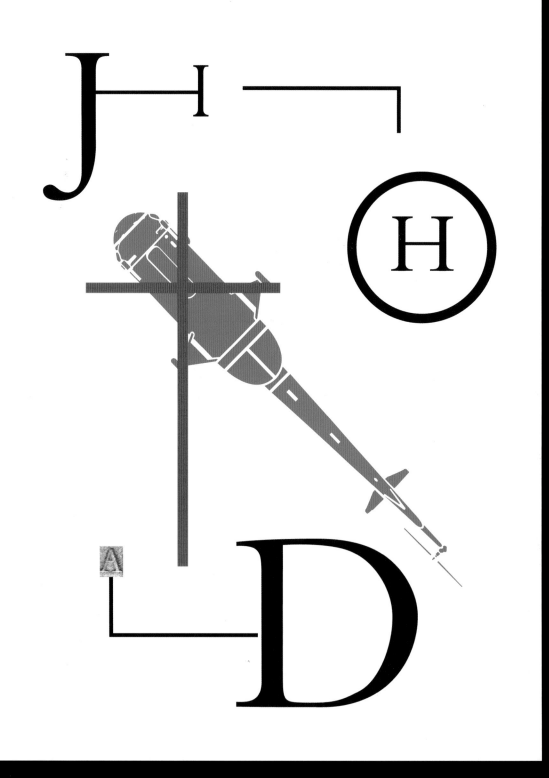

Jihad | LASER PRINTED POSTER | 1991

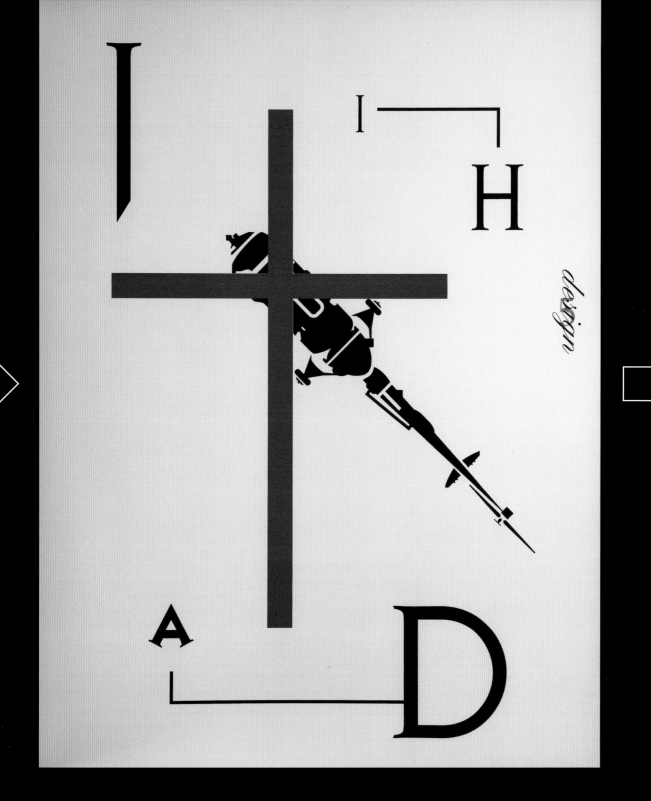

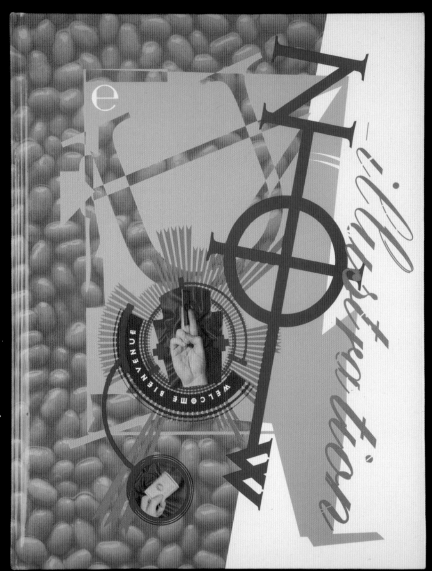

The back features a stock photo, many people use them because they are good, I used them originally because they were so bad, they seemed to be the clumsiest 'social revealers' I could find, cornily showing society's (consumerist) aspirations. This image seems perfect to describe what was going on in the West while the war was going on in the Middle East.

The text on the back actually says something quite harmless about illustration but I liked the dramatic graphic effect of Arabic script over the image.

The cover was designed to echo the old name of the book which was *European Illustration*. The hand on the front is in an iconographic pose but instead holds an American Express gold card.

This was the first use of the lettering that later became the fonts *False Idol* and *Exocet.*

Illustration Now | UNPUBLISHED PROFESSIONAL SECTION DIVIDER | 1992 Created at the time of the Yugoslavian conflict, a plane drops bombs and a hand drops seeds with the phrase 'we reap as we sow' underneath. Violence merely breeds more violence for now and for the generations in the future.

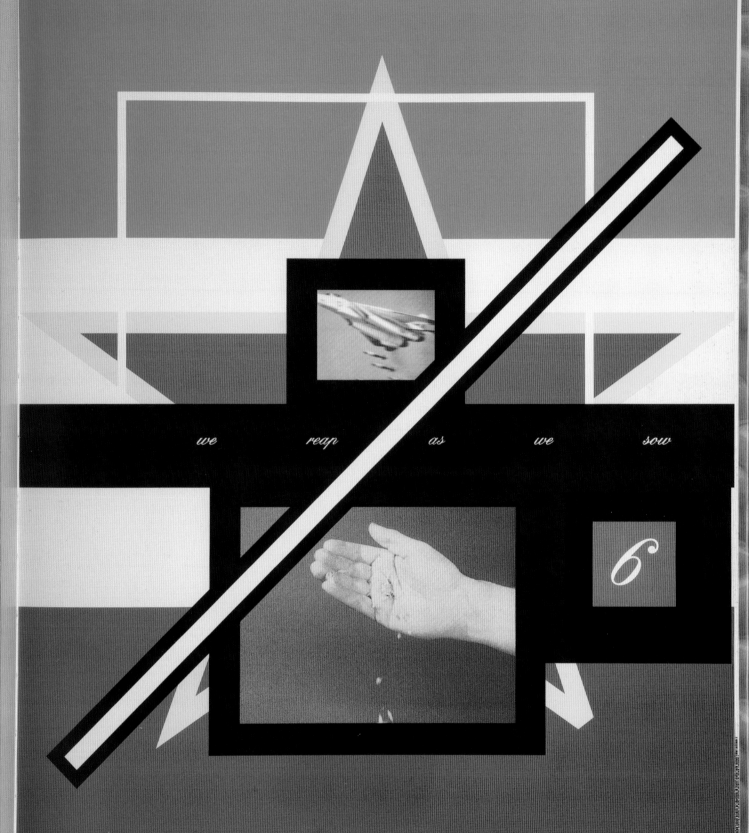

we reap as we sow

6

unpublished professional / professionels non publiés

This *Illustration Now* opening spread was based on a 15th century Koran in the British Library, London.

The vegetable backgrounds were a cynical statement – despite its anti-consumerist messages, the book and its design were as much a 'commodity' as anything else.

Barcodes were a very prominent feature in the book, this was before it was easy to do them on the Macintosh, so it was quite unique to have all of the text set in working barcodes. I also used them for the names of all the illustrators on their work pages, just to remind them that they were in the commercial world. I got rather sick of illustrators at college somehow thinking they were superior to the designers because they appeared to do work that was more 'arty'.

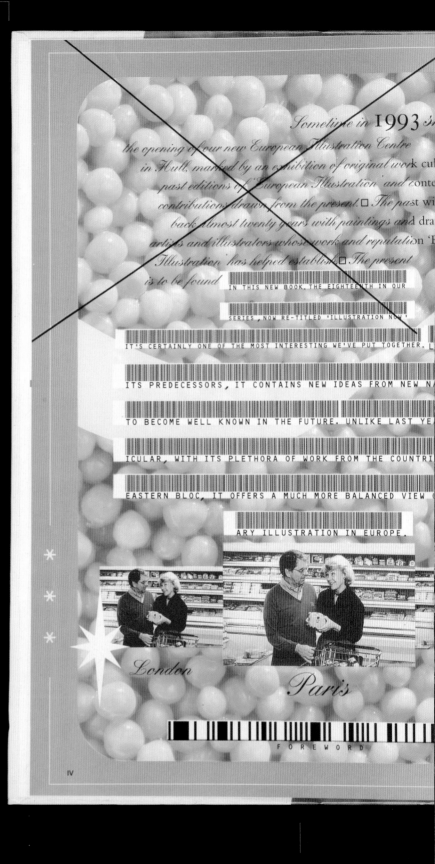

The 'starburst' was an ironic comment on the idea of 'newness' in consumerism. When we know that *new* means nothing. The upfront nature of starbursts also seemed to be the absolute opposite of the classical typography I had been interested in pursuing before.

Same thing, different location. The image above is a stock photo of a happy couple shopping. Underneath it text is taken from an 'upmarket' perfume bottle it says 'London, Paris, New York'. It was a comment about the massive expansion of multinational companies into the shopping districts of every town and city in the United Kingdom, seemingly making every town centre the same.

THROUGH EXCEPTIONAL QUALITY OF THE WORK ON SHOW, IT ALSO

CONFIRMS MY BELIEF THAT GOOD IDEAS AND GOOD TECHNIQUE ARE STILL

TO BE FOUND IN EVERY CORNER OF THE CONTINENT. AGAINST A BACKDROP

OF CONTINUING CHANGE THROUGHOUT EUROPE, WITH ALL ITS POLITICAL

UPHEAVALS AND ECONOMIC UNCERTANTITIES, MY HOPE IS THAT NEXT

YEAR'S 'ILLUSTRATION NOW' WILL PROVIDE A CERTAIN FOCUS FOR ALL

OUR ARTISTS AND ILLUSTRATORS, AND A BENCH-MARK FOR EXCELLENCE

THROUGHOUT OUR COMMUNITY OF NATIONS.

AVAN+

L'année 1993 verra s'ouvrir à Hull le nouveau Centre européen de l'illustration. Cet événement sera marqué par une
exposition comportant à la fois des travaux originaux extraits d'éditions précédentes de 'European Illustration' et des
contributions contemporaines d'actualité. § Nous ferons à cette occasion un bond en arrière de presque vingt ans, avec
des peintures et des dessins provenant d'artistes et d'illustrateurs pour lesquels 'European Illustration' a joué un rôle
majeur dans l'assise de leur réputation et dans la dissémination de leurs œuvres. § Les travaux contemporains se
trouvent dans ce nouveau livre. § Le dix-huitième dans notre série qui porte désormais le nouveau titre de
'Illustration Now', il est certainement l'un des plus intéressants que nous ayons jamais publié.

لبترول

ld see

om

ary

us

by

ean

MANY OF

DESTINED

IN PART-

THE OLD

NTEMPOR-

w York

v

This says 'petrol'. Behind in the star is an

LEFT: *Illustration Now* |
STUDENT SECTION DIVIDER | 1992
This was a rather cynical consumerist
comment about students as new consumers.

RIGHT: *Illustration Now* |
POSTERS SECTION DIVIDER | 1992
This emphasises the European Union's
dependence on oil by highlighting 4 stars
in the European flag. '4 star' being the most
common grade of petrol used by cars.

Exocet was a name that seemed to reveal the danger of language. The possibility to soothe or vilify with words, to start war or create peace. I wanted to hint at the possible violence inherent in the simple rearrangement of the alphabet. The final form of letters was precise, dangerous and looked beautiful. *Exocet*, with its 'X' sound at the beginning ($\binom{the\ mystery}{factor}$) and its use as the name of a missile, seemed *perfect* ($\binom{if\ that\ is\ the}{correct\ word}$).

GLOBULAR
STAR CLUSTER

AMERICAN INDIAN
MEDICINE WHEEL

GUNSIGHT

EARTH

SUN

CELTIC CROSS

The *Exocet* 'O'

The designer's choice for gunsights, logos for right-wing organisations and rather tasteful tea packaging.

Above is some of the symbolism found when working on the font for the shape of the letter 'O'.

Very strange how people complained about a typeface named after a *serial killer* and not a *missile*. (SEE MANSON P.78) Maybe it is easier not to see the people who order the firing of missiles as murderers – that would make life rather difficult for some of the citizens of the West.

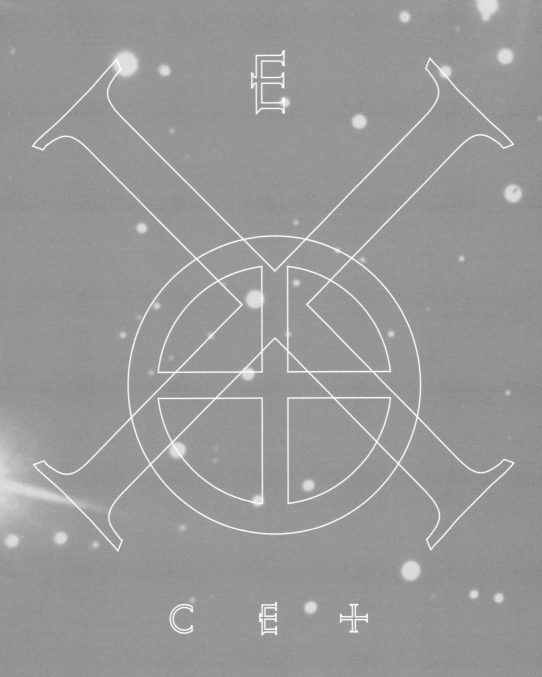

Finished *Exocet* font released in 1992 by Emigre

The letterforms come from research into Greek and Roman stone carving. It felt like the forms I used as the starting point for *Exocet* had been forgotten. Many typographers talk about the beauty of Renaissance type, but the more primitive work, particularly from Ancient Greece, had a beauty that I wanted to re-present to people.

There is no point though in just copying past letterforms. I am not interested in doing a 'revival'. What is important is to reinterpret the beauty that you have found in a contemporary way, to acknowledge that it exists in a different society now. That the letterforms are a valid response to the way people use language today.

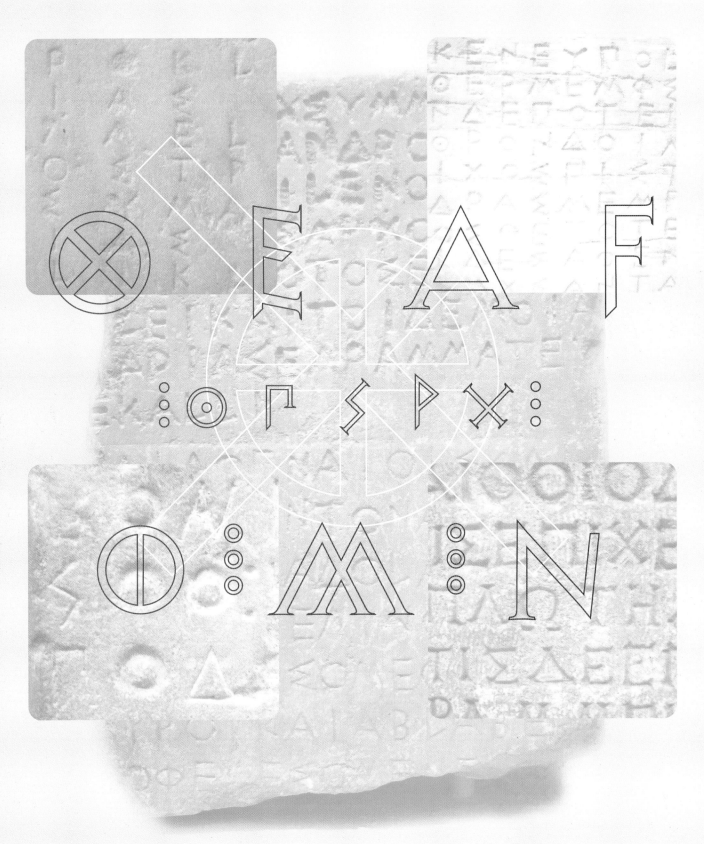

Early experiments with *Exocet* took much more from the original source material of early Greek and Roman stone carving.

The letterforms are examples from 1991, the images behind from the British Museum were used as reference material.

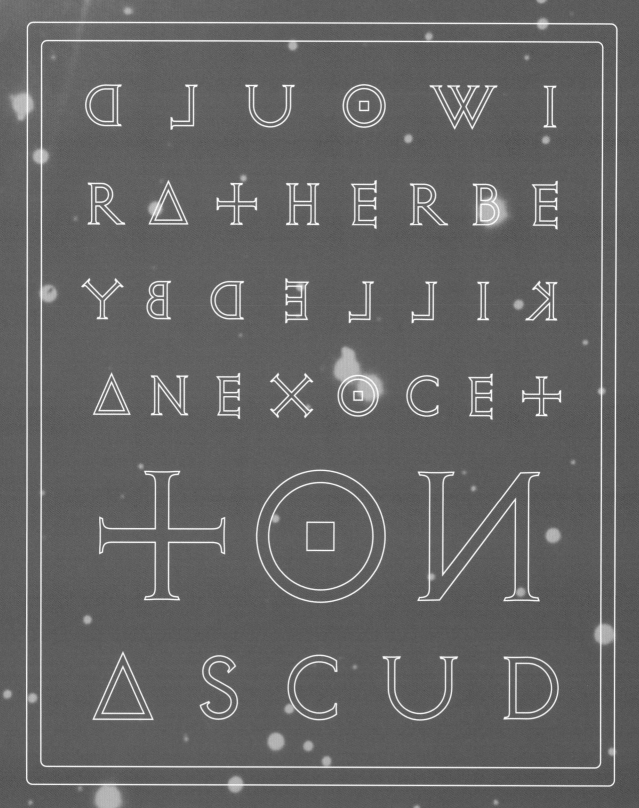

A sample of an earlier version of *Exocet* from 1990. At this point the Greek delta character was used for the 'A'. It also contained a different version of the 'N' and 'O'. Most notably, the 'E' did not have a stem, this was added later and is closer to the original Greek letterform. The layout was an experiment written in a similar way to the original ancient Greek system called 'boustrophedon': reading from right to left, then from left to right.

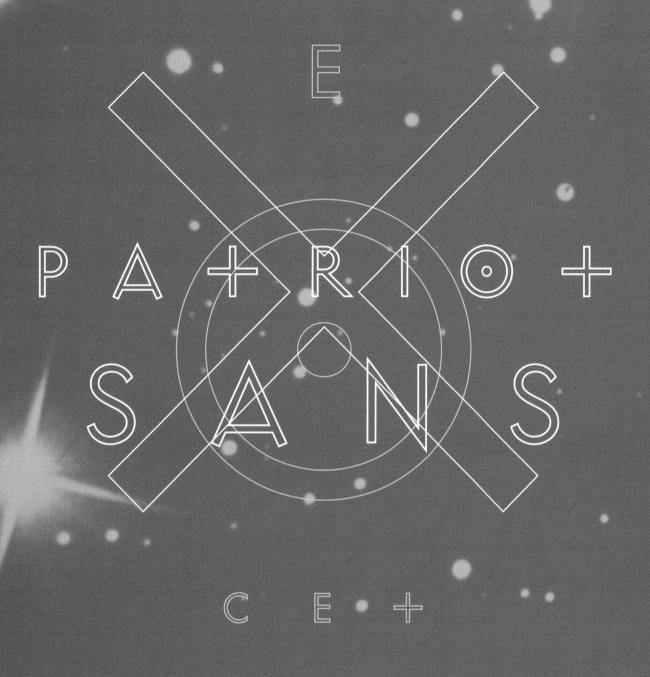

PA+RIO+
SANS

ABCDEFFFGHIJKLᴍN
⊙OQRST+UVWXYZ

Patriot, the sans serif version of *Exocet*, 1997

This adheres much more closely to many of the original historic characters that were the basis of *Exocet*.

I always base my letterforms heavily on historic sources and this usage is usually interpreted in the shorthand of the commercial message as 'gothic', hence their starring appearances on fantasy games and heavy metal album covers. It always amuses me that the fonts into which I put so much meaning end up being almost a shorthand cliché for 'the past' in the most banal sort of way. I think though that this reflects the nature of most graphic design, which is not about 'great meaning', but the throwaway, the short attention span.

I am never precious about my typefaces once they are released. If you consent to the process of 'selling' your work, then I feel it is a little bit silly to assume you can control it after and to whine about good taste or bad taste. That doesn't mean I don't feel uncomfortable about some of the uses, just that I don't think I should be the arbiter of how people arrange my shapes on the page and what they use them for.

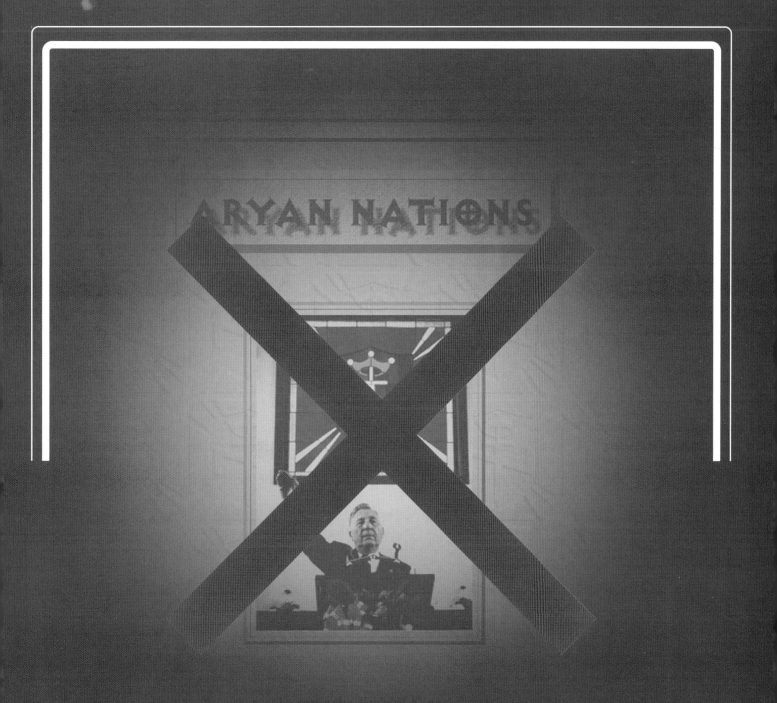

The enthusiasm for my fonts by right-wing organisations has been a little worrying. I suppose in their search for classical forms, a.k.a. 'White Western Purity', they have found something within them that fulfills this. It definitely wasn't my intention but it does bring up again the question of the neutrality of letterforms.

XI.

Dancing In The Face of The Apocalypse

BY TEAL TRIGGS

Jonathan Barnbrook's *Apocalypso* may be read as a seemingly fanciful pictographic exploration of some of the most controversial themes of the modern era: mainstream media, multinational corporations, consumer culture, urban streets, military war zones, and overseas sweatshops. It creates an ironic typographic dystopia visually formed out of punchy one-liners, hard-hitting slogans and bold graphic silhouettes—a semiotic shorthand for critical commentary directed at America's profit-led mass culture, and to a lesser extent Britain's.

The late 1990s presented a very different mood from the consumer-orientated 1980s and, in the western world at least, the fashion for an apocalypse culture, centering on decadence and end of the world fears, was de rigueur. Adam Parfrey, editor of the seminal tome *Apocalypse Culture* (Feral House 1987, 1990) had predicted this condition a decade earlier, but in the run up to the end of the millennium public perceptions grew more fearful with the threat of Y2K computer bugs and 'end times' theories. Other characters from *Apocalypso* were drawn in response to the first Gulf War and its reporting in the mainstream media, but today resonate even more following the events of 9/11 and the subsequent 'War on terror'. SHOP UNTIL THE BOMB DROPS, HISTORIC SITE DESTROYED and DEATH SHOWN LIVE, take on additional layers of meaning moving far beyond a typographer's fascination with theories about the end of the millennium.

Barnbrook's approach to *Apocalypso* was not dissimilar to the 'subvertising' fostered during this period by the so-called culture jammers (e.g. Adbusters, et al.). Culture jamming reinvented situationism for this end time era. Barnbrook's use of image-based typography added another dimension to the subversive process. In the same way that Adbuster's campaigns were about the detournment of popular mediums (e.g. spoof advertising), so Barnbrook was detourning typography (e.g. Times New Roman = authoritative, right?).

Apocalypso also employs visual humour as Barnbook remarks in an attempt to "try to say something worthwhile without preaching to people." Each character of the font is presented as a single-frame narrative. Like many of Barnbrook's other fonts (e.g. *Exocet* [1991], *Bastard* [1990], *Prozac* [1997], *Nixon* [1997]), *Apocalypso* reflected the spirit of the times, drawing upon a range of satirical techniques balancing the fine line between the absurd and the politically astute. Britain has a long established tradition of successful satirists in both print and on stage. And though it is hard to see a direct link between Barnbrook and Peter Cook/Monty Python, it's not one he would deny.

The question remains however, has *Apocalypso* made a significant impact in the world of graphic design? Barnbrook himself acknowledges that he sees *Apocalypso* as a set of socio-political statements and as such, he says as "a rather clumsy means of expression." To him, it doesn't matter that the font hasn't sold large quantities rather he reflects, "it is about a statement of intent—and the influence of the typeface comes from the exhibiting of it and appearing in books or being discussed in magazines." In comparison with the some of his other fonts, for example *Manson*, the emphasis for *Apocalypso* is less upon traditional craft notions of drawing a typeface and more

on the use of type as a narrative form of typo/graphic activism. For Barnbrook type is used as a way of challenging and often subverting preconceived notions about language and communication. Here 'word as image' is a way of communicating messages directly to an audience. While Barnbrook mocks himself for the "futility and uselessness of releasing it as a font," *Apocalypso*, and many of his other fonts, have become significant as they reflected if not led, a paradigm shift within the graphic design profession – where designers were no longer seen as mediators for client's messages but rather graphic authors generating their own personal, and sometimes highly effective, statements.

Yet, it is this very question of communicating to whom and in what context, which needs to be addressed. What if *Apocalypso* were viewed within a fine art context – would its message be read any differently? Contemporary British artists such as Mark Titchner, and Peter Kennard have successfully presented their personal views and political commentary through provocative combinations of image and text. While boundaries between artistic practice and graphic authorship continue to be blurred by practitioners on both sides, graphic design remains to be perceived as that which has 'low cultural value'. *Apocalypso* goes some way to addressing this by trading on its political currency and ultimately communicating to a broader audience despite being unnoticed by most of the art criticism world.

Teal Triggs is Professor of Graphic Design and Head of Research, School of Graphic Design, London College of Communication, University of the Arts London.

FINITO

FATWAH
FOR YOU

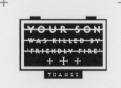

YOUR SON
WAS KILLED BY
'FRIENDLY FIRE'
+++
THANKS

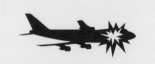

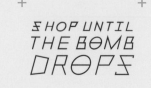

SHOP UNTIL
THE BOMB
DROPS

XII.

Apocalypso: Pictogram font for the end of the world

COMPLETED IN 1997

Apocalypso became scarily prophetic. At the time, it was created to comment on the madness in contemporary society. I didn't imagine the whole context of it would change after September 11th. I remember giving a lecture a few days after 9/11 in South Africa and the atmosphere completely froze when I showed it.

APOCALYPSO = APOCALYPSE + CALYPSO

END OF THE WORLD HUMOROUS IMPROVISED MUSIC

FIDDLING WHILE ROME BURNS

I was driven only by the desire to draw something which commented directly on the world that I was sickened, amused and bored by. It became an obsession, I worked on it solidly for fourteen hours a day for many weeks. I was aware of how pointless it was: how could a typeface make a difference? However I felt that I had to do something, so it was just a clumsy but honest response. I am a typographer so I reacted in the most natural way possible for me.

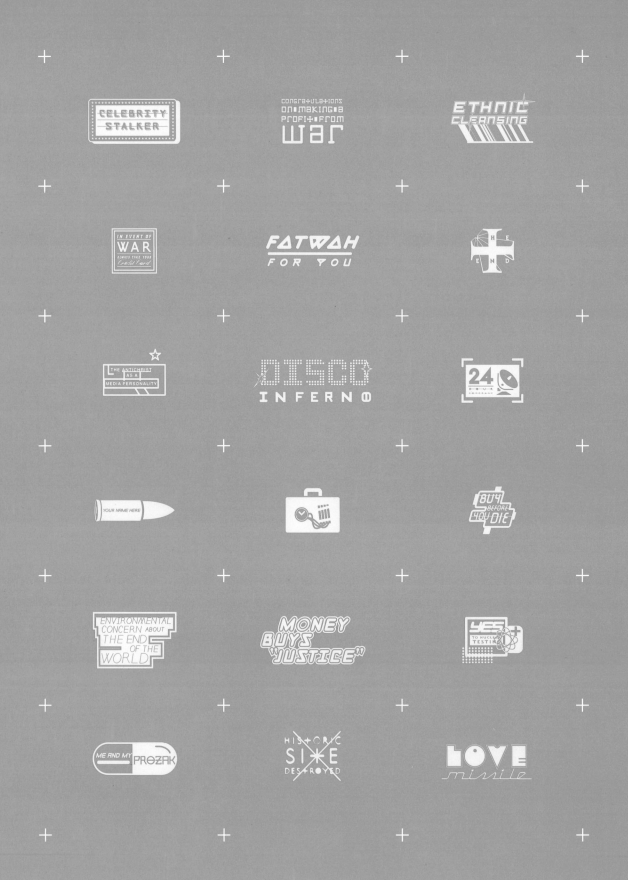

When I first started designing these pages I wrote explanations of the pictograms, but it felt like I was stating the obvious. Designers should always make an effort to throw some light on their thinking, however these really should be self-explanatory; if they aren't then the project has failed.

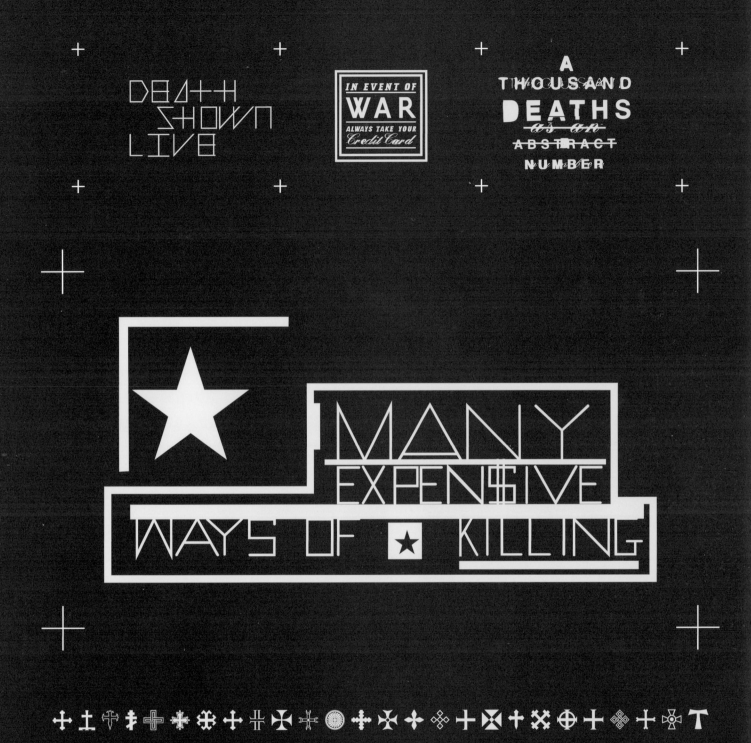

DEATH SHOWN LIVE

IN EVENT OF **WAR** ALWAYS TAKE YOUR *Credit Card*

A THOUSAND DEATHS ~~as an~~ ABSTRACT NUMBER

MANY EXPEN$IVE WAYS OF ★ KILLING

I haven't really discussed the other part of the font which was a set of crosses, that is because it hasn't stood the test of time very well. It now just looks like a collection of weak clip art. However, at the time I had to source and draw them all by hand. I felt it was necessary to make the font more apocalyptic.

Apocalypso worksheets and one pictogram that
failed to make it into the font because of time, 1996

To the left are a number of Apocalypso work in progress sheets.

The most interesting things to note are the huge amount of written ideas that were scribbled down for other possible pictograms. Eventually I realised that this project could go on endlessly, I had to get it finished as it was holding up the launch of my font company. So a lot of the ideas had to be excluded – which I regret. One proposal in particular makes me laugh, it simply says:

This font is absolutely useless

TRANSCRIBED LIST OF UNUSED IDEAS

MATERIALISM OVER HUMANISM

CORPORATE DEATH?

YOU ARE A MIDDLE CLASS WASTE OF TIME

WAR AS A DISTRACTION

WAR AS A MARKETING PLOY

TORY BASTARD

REPUBLICAN BASTARD

WAR FOUGHT OVER OIL

REBELLION IN THE 60S AS A MARKETING PLOY

NO ALTERNATIVE TO THE MARKET ECONOMY

BOMB BEFORE YOU FLY

AMERICAN INVASION

YOUR LAST 30 SECONDS

GOD NEEDS THE PUBLICITY

LAND MINES TO KILL INNOCENT CHILDREN

GLOBAL WARNING

THERE GOES 'CULTURE'!

PROFIT OVER NEED

FOUR HORSEMEN OF THE APOCALYPSE

A SLIGHT GLITCH IN THE EVOLUTION OF MAN

CENSOR A PENIS BUT NOT A GUN

IDENTIFIED FLYING OBJECT

CULTURAL MISUNDERSTANDING CREATING WAR

HEY SLOW DOWN! BOMB ON BOARD

TOO SCARED TO SLAG OFF CHINA

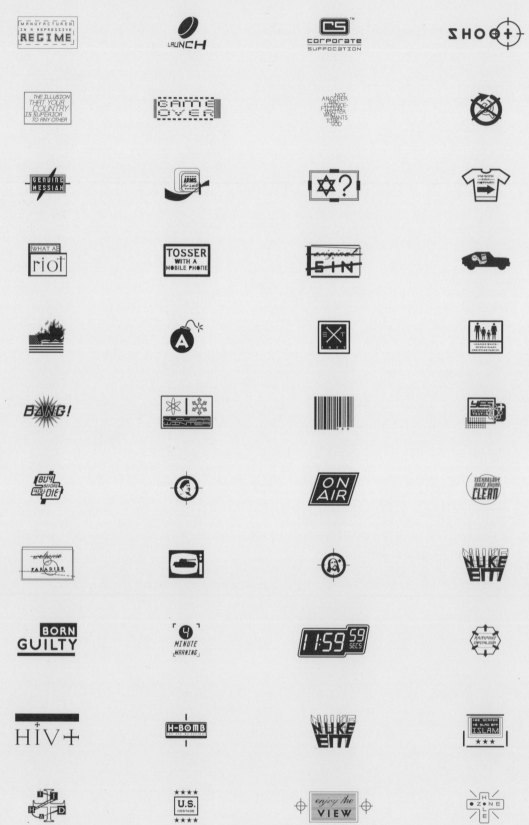

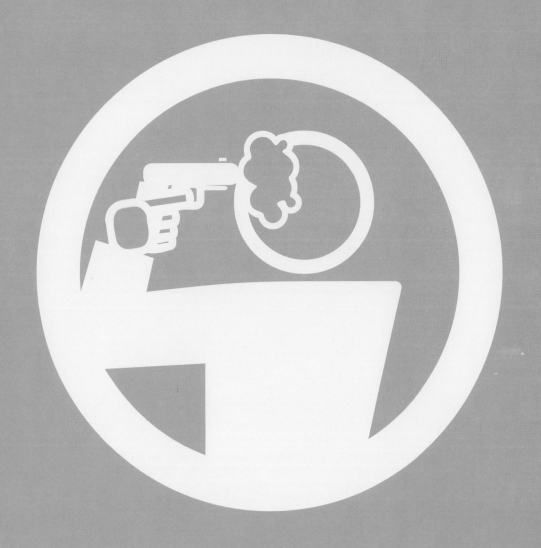

IN THE BEGINNING WAS THE WORD & THE WORD WAS GOD

MANSON

FONT

When I first started studying typography I have to admit I found it tedious. It wasn't until I managed to relate it to my own perception of the world that it started to fascinate me. Letterforms were not as I was first taught at college – bits of letraset, things to set any old text in, styles to be used arbitrarily dependent on the project. Instead they resonated with the history of civilisation, they showed absolutely within their forms the political and cultural environment they were made in, all of human activity and communication was in those silly little shapes. *Ma[n]son* took what I saw as the more authoritarian letterforms around me – churches, public buildings, bibles, decrees from dictators – all kinds of insistent 'truth-telling' and reinterpreted them for today.

I am very interested in the relationship between architecture and typography, this surfaced a lot when I was drawing *Manson*. Some of the structures of the characters are based directly on European architecture, particularly the two versions of the 'M' – one was a temple portico, the other was directly taken from a colonnade in the Palace of Versailles' gardens. I hope that doesn't sound pretentious. Letterforms resonate all the time with the forms that surround you and these directly influence your work.

The name of this font was changed from Manson to Mason after complaints. Possibly, the only slightly scandalous thing to happen in typography since Eric Gill was found to be more than affectionate to his pets.

The font was released by Emigre the well-known Californian magazine and foundry in 1992. Very soon after, letters flooded in about the use of the name Manson (a notorious serial killer) for the title of the font, mainly with accusations that I was trying to generate publicity in the sickest way possible. I was in the middle of a six months travelling break and was unreachable; as a result, Emigre took the decision to rename the font *Mason* to stop the complaints. When I came back from my trip I was amazed to find out about the furore.

At first I just felt really sorry that I had upset so many people. My intention had not been to promote any kind of hurt or harm to the families of Manson's victims. I was definitely not the sort of person that would want to create any publicity through such an empty superficial gesture. After a while though, I just became annoyed at the complaints; yes, the families would rightly be upset about any mention of the killings, but that doesn't mean any reference to any kind of tragedy or pain should be stamped upon. The acknowledgement of bad as well as good is the basis of culture.

I was particularly irritated with the design community. I thought it was capable of a higher discussion. It seemed they were very happy to condemn me outright without even thinking that there may have been some reason other than 'publicity' for the name of the font.

This lack of discussion was even more evident when I started collaborating with Damien Hirst and other contemporary artists. When they produced a piece of work and named it, there was dialogue and analysis as to 'why' – what was being questioned by naming the 'work'. I saw very little of that going on in the design community. Just nastiness and ill thought out condemnation.

So I will try and explain my intention, but first it is important to realise that up until the 1990s, naming a typeface had been a relatively simple matter. A type designer would use possibly a location, a pun, a comment on the shape or construction of the letters, someone they admired, their own surname perhaps. Now it seemed technology had put the ability to make a font in the hands of many more people enabling them to respond immediately to their own world. The context of the name was a vital part of this new energy. Many young type designers took it in different directions, for some it was a way to express rebellion, for others a one-line joke, better still some people wanted to refer directly to a news event, responding immediately by releasing a typeface and naming it appropriately. Certainly most people were not interested in using monumental names for fonts, these were not typefaces that were going to last forever, so it seemed very silly to put your surname on them to try and gain some kind of immortality. Naming a typeface became a cross between naming a pop song (ephemeral, fashion-based, spirit of the age) and titling a painting (intellectually big moment, clue to reasoning behind the construction etc.)

Personally I am always fascinated with the relationship between the spoken word and the written word, there is a complex joke at work. How can you represent all the possibility of human thought in twenty-six little shapes? And how can you symbolize that relationship in a name?

So *Manson*, well there are many reasons. I wanted a name that would play with the way people would perceive and use these letterforms which looked very historic. However both the source of the font and language itself are areas of extreme emotion, love, hatred and violence. It would not have been right to give it a completely placid understandable name. *Manson* phonetically sounds quite elegant, it echoes words like mason, mansion and manse, but was a nasty, violent incident from the modern world. It was an attempt to make the font contemporary rather than part of a 'golden past'.

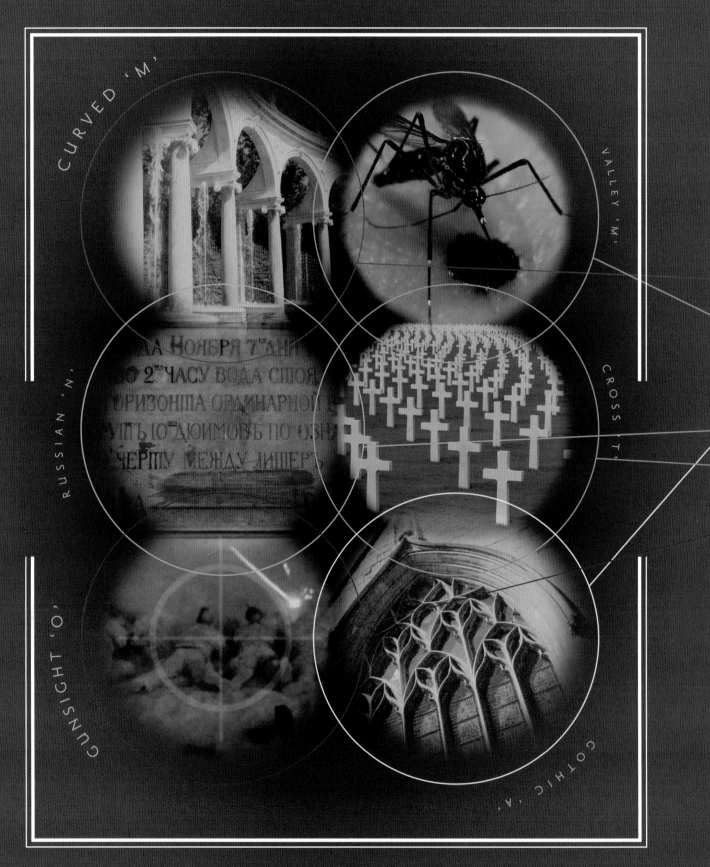

CURVED 'M'

VALLEY 'M'

RUSSIAN 'N'

CROSS 'T'

GUNSIGHT 'O'

GOTHIC 'A'

A A B C D
E E F F G H H
I J K K L M
M N N Φ P Q
Q R R S T U
U V V W X
Y Z

MA[N]SON SANS HAD A NUMBER OF OBJECTIVES

I. TO TAKE ALL OF THE SERIF FORMS I HAD DRAWN INTO A SANS SERIF FORM

I DON'T KNOW IF THIS IS STATING THE OBVIOUS BUT THE MAIN POINT WAS TO CREATE CHARACTERS WHICH HAD AN HISTORICAL HERITAGE BUT ALSO LOOK CONTEMPORARY, IT IS QUITE UNUSUAL TO SEE SHAPES SUCH AS SWASH CHARACTERS IN A MODERN SANS TYPEFACE.

II. A FURTHER EXPLORATION OF 'ENGLISH' TYPOGRAPHY

JOHNSTON, THE LONDON UNDERGROUND TYPEFACE AND GILL WERE OBVIOUS INSPIRATIONS, WHEN I WAS YOUNGER I HATED HELVETICA, THERE WAS NO MYSTERY IN THE LETTERFORMS, THEY WERE UNINVITING AND HAD THE AURA OF GRIMY GOVERNMENT BUILDINGS. THE FIRST TIME I SAW GILL I THOUGHT 'WHAT AN INCREDIBLY LYRICAL TYPEFACE', FULL OF ASSOCIATIONS THAT WERE THE OPPOSITE OF WHAT I HAD SEEN UNTIL THEN.

III. A LITTLE BIT OF EARLY EUROPEAN MODERNISM

1992

PLEASE EXCUSE MY CULTURAL PLUNDERING. I WANTED TO ADD A BIT OF THE PRE-HELVETICA ATMOSPHERE OF THE GEOMETRIC TYPEFACES WHICH WERE A LITTLE MORE PREVALENT IN MAINLAND EUROPE THAN IN BRITAIN IN THE 1920S AND 1930S.

MANSON SANS

IV. ARCHITECTURE WAS VERY IMPORTANT IN THE SANS VERSION

WHEN I WAS DRAWING MANSON SANS I WAS THINKING VERY MUCH OF THE ARCHITECTURE OF LONDON. IT WAS INSPIRED BY THE ENVIRONMENT WHICH I WORK IN EVERY DAY, THE DUSTY TUBE STATIONS, BUILDINGS LIKE THE UNIVERSITY OF LONDON AND SIGNAGE FROM WHEN LONDON RAPIDLY EXPANDED IN THE FIRST HALF OF THE TWENTIETH CENTURY.

AND A LITTLE NOTE ON THE USAGE OF BOTH FONTS. MOST OF THE TIME WHEN MANSON IS USED PEOPLE SEEM TO TAKE THE 'EVERYTHING BUT THE KITCHEN SINK' ATTITUDE TO THE CHARACTERS. LIKE MANY TYPEFACES WITH LOTS OF ALTERNATIVE GLYPHS, I WOULD HOPE PEOPLE WOULD USE THEM SPARINGLY.

A A B C D
E E F F G H H
i j K K L M
M П П П O P Q
Q R R S T U
U V V W X
Y Z

TO: EMIGRE

I AM WRITING TO EXPRESS MY ABSOLUTE DISGUST

WITH YOUR RECENT RELEASED TYPEFACE, NAMED AFTER

THE ~~██████~~ SERIAL KILLER CHARLES MANSON.

NAMING SUCH A TRIVIAL THING AS THIS TYPEFACE, AFTER

A SERIOUS EVENT JUST TO SHOCK SEEMS STUPID AND

MASTURBATORY. SINCE YOU LIKE TO CASH IN ON THE SUFFERING

OF OTHERS, I'VE GOT SOME OTHER SUGGESTIONS EQUALLY AS GOOD:

 "KKK" AVAILABLE IN BLACK ONLY.

 "CHILD MOLESTER"

 "ANOREXIA"

IF JERK BOY BARNBROOK WANTS TO DISCUSS SOCIAL ISSUES

THEN I SUGGEST HE CHANGES HIS JOB. FONT DESIGN HAS NOTHING

TO DO WITH THINGS LIKE THIS. IF EMIGRE WANTS TO SELL

MORE FONTS, STOP THESE CHEAP ATTEMPTS.

 PLEASE REMOVE MY NAME FROM YOUR

 MAILING LIST _PERMANENTLY_.

 YOURS,

Graphic design can be a very insulated area, my first brush with 'public life' was with this font. On its release many things happened which weren't about the typeface at all. Not just because of the controversy surrounding the name, more because it was the first time something that I had so closely controlled had been let out into the 'commercial world' for people to do with as they wanted. It proved at first to be a painful experience and provided me with an interesting view of the true position of typography in culture and society. I was a (still) slightly naïve 25 year old and I expected that people would buy it because they saw the same things in the font as I had when I created it. However, it became a benchmark used on heavy metal album covers and role playing computer games, other designers used it as shorthand for mediæval style.

Did I mind in the end? Not at all. Thankfully neither I nor anybody else is allowed to say how the world should be designed. It's the reinterpretation which is the lifeblood of culture.

The renaming of *Manson* to *Mason* also brings up the question as to whether the use of a typeface is affected by its name. Many people who bought the font when it was called *Manson* claimed that the font looked satanic or evil. A few were worried enough to phone me up and ask if any of the characters were based on symbols of devil worship. Since the name change, I have decided that I do quite like the idea of somebody not knowing the font used to be called *Manson,* somehow I thought a little devil could pop up on their shoulder and say:

'Pssst… you know that font you're using with the innocent stone carving sort of name Mason? It used to be called Manson after the serial killer Ha-Ha-Ha!' This raises the question of whether the name of a typeface affects its usage.

I WOULD SAY SO.

The font name allows you to investigate the complex relationship between text as a conveyor of meaning and text as an abstract visual shape. This is the basis of deconstruction and was the reason the philosophy was such an influence on design and typography in the early 1990s. Finally, something that I and many designers of my generation had been doing instinctively was put into words. It was the catalyst for an exciting period of intensely experimental work in graphic design and typography.

I Want to Spend and Spend...

BY EMILY KING

At the time of writing, Damien Hirst is ten years into the rest of his life. It has become a cliché to talk about a celebrity as a brand, but that is what he has become. A commonplace among TV presenters or models, this remains an unusual position for an artist. This brand status is a product of his ability to exploit the benefits of association with his public persona across a range of ventures and to bridge the gap between art and everything else.

Barnbrook's design for *I Want to Spend the Rest of My life...* is significant in that it marks the origin of Hirst's forays into branding. When Barnbrook borrowed corporate graphics and applied them to Hirst's work, he was the first to extrapolate the artist's fascination with the typography of medicine into a coherent visual expression. It is a beautifully crafted and sophisticated look that Hirst carried over into further projects, including catalogues, posters, limited edition prints and his restaurant *Pharmacy*. Just as Barnbrook's graphic games were more of a play on the notion of the 'artist as a brand' than a singular presence, so Hirst's original take on the artist-as-proprietor of the *Pharmacy* remained stubbornly fanciful (stools shaped like aspirins, medicine cabinets behind the bar). Notably, by the time Hirst became a brand in earnest (hard to pinpoint the date, but the Christie's sale of the *Pharmacy* paraphernalia in 2004 marked an important shift), the graphic playfulness dwindled. Rather than a logo or a typographic device, these days the artist is associated with his core products: the spot painting and the vitrine.

Hirst and Barnbrook took two years to produce *I Want to Spend the Rest of My Life...*, but it was worth the wait. Hirst was at the height of his Groucho Club/Colony Room period during that time and it made for an unpredictable work pattern. He kept changing the names of pieces, which made the gathering of information for the book a difficult task. Teaming up in meetings, Hirst and Barnbrook would goad their publisher and editor into an ever more daring and extravagant production, but it was usually Barnbrook alone who had to deal with the implications of these risks. Hirst allowed Barnbrook creative autonomy, although all too often, from Barnbrook's point of view, this was by default. However, what they did completely transformed an existing body of work into a series of fresh diversions. They were not the first artist and graphic designer to collaborate, yet their partnership remains exceptional. Hirst's understanding of the need for graphic precision was matched by Barnbrook's willingness to enter the artist's world and communicate it using any means necessary, even at the expense of his own sense of design rectitude. While in theory *I Want to Spend the Rest of My Life...* proposed the idea of the artist as a brand, in practical terms it was an example of the artist as an art director.

I Want to Spend the Rest of My Life... was eventually launched in September 1997 in an edition of 14,000 priced £75.00 The sense of anticipation, both in the art world and beyond, was unprecedented. Curiosity about Hirst was widespread and the possibility of owning a piece of his work for such a reasonable price generated an enormous buzz. For Barnbrook, it was the first time his design entered mainstream discussion. In general the reviewers were enthusiastic, but guardians of the gates of art were equivocal. Contemplating Hirst's shark in a gallery is a very different experience to pulling the tab of a 'now you see it/now you don't' illustration. That the book was blatantly entertaining caused discomfort among certain critics and curators—there seemed to be a suspicion that art was being undermined by graphic skill and showmanship.

The product of a thorough interdisciplinary mingling, *I Want to Spend the Rest of My Life...* entered a culture and a market where distinctions are carefully guarded. Over time, Barnbrook felt that his input was dismissed or marginalised. Now he regrets the decision to keep his credit so small. First edition copies of *I Want to Spend the Rest of My Life...* have become rare and expensive, particularly those signed by Hirst. I did not buy one at the time and have come to regret it. Shamingly it was a timid confusion as to what category of object it was—a limited edition art object? a monograph? —that prevented me. Perhaps this indecision echoes Barnbrook's ambivalence. Because he was creating something genuinely new, his position was unclear.

Since then the market has decided that Barnbrook had designed a collectible work of art by Hirst. This position conveniently negates the taint of design and has allowed the value of the book to rise in line with Hirst's profile. To those of us on the design side, it might seem inappropriately cut and dried, but it is hard to argue with money.

Hirst and Barnbrook continued to work together several years after the publication of *I Want to Spend the Rest of My Life...* Maintaining a playful take on the notion of the artist's brand, Barnbrook took the opportunity to explore his talent for mimicking pharmaceutical graphics in a clutch of contexts. Among these is the *The Last Supper*, a series of thirteen limited edition type prints in which the names of branded medicines are replaced with those of foods so ordinary that they have become rarities (Liver Bacon Onions and Dumpling). Tapping into our fraught and contradictory approach to managing our physical wellbeing, the disjunction between sense and typographic style proves stomach turning. Each print bears Hirst's name rendered in the manner of a different pharmaceutical company logo. As with the book, the exactitude of Barnbrook's typography is essential—it confirms the artist's incarnation as the ministering angel of grease and offal.

Even while *The Last Supper* expanded so intelligently on the work begun in *I Want to Spend the Rest of My Life...*, Barnbrook remained unreconciled to the perceived relationship between art and design. Flashes of brilliance aside, none of Hirst and Barnbrook's later projects matched the ambition and scope of the book, and, what's more, the publication continues to be unique in its field. It has had an influence, that's for sure —just look at the heavyweight, bizarrely formatted volumes that fill the shelves of art bookshops—yet there is no other book in which art and design are meshed so intently, so inextricably and so lavishly. It would be nice to conclude that Barnbook had an enormous impact on the field of graphic design for art, but sadly this isn't the case. By and large, galleries, art institutions and artists remain conservative in their commissioning of graphics and designers continue to be timid and unimaginative in their treatment of art. Post-Hirst, Barnbrook has worked with other artists and art institutions, but has not put himself so completely at their service. Hirst meanwhile has gone on to almost unbelievably big things, but never to my mind equalled the density and engagement of his 1997 publication.

Emily King is a Freelance Design Curator and Journalist

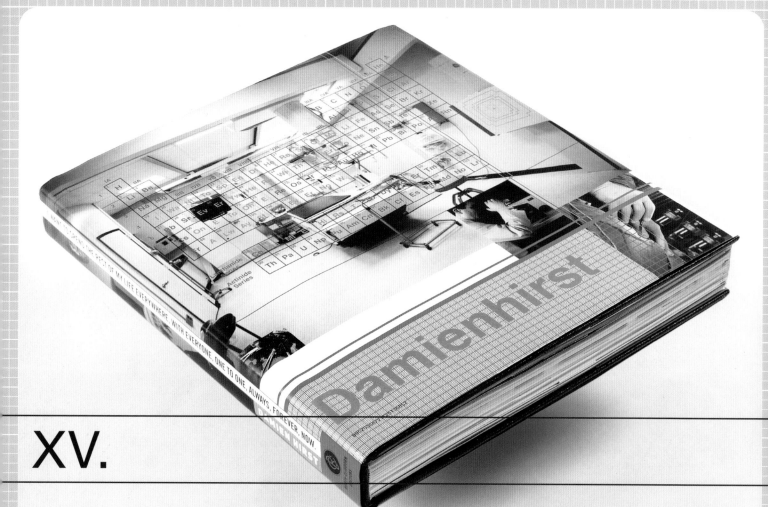

XV.

I Want To Spend The Rest Of My Life Everywhere, With Everyone, One To One, Always, Forever, Now.

Damien Hirst book 1997

Two years in the making and a page count that kept increasing, this was both a nightmare and one of the most exciting projects I have worked on. It came out at the peak of the interest in 'Young British Art' and it was one of those rare moments where what I was doing was feeding directly into mainstream culture, and even more rarely it felt like I was doing something 'new'.

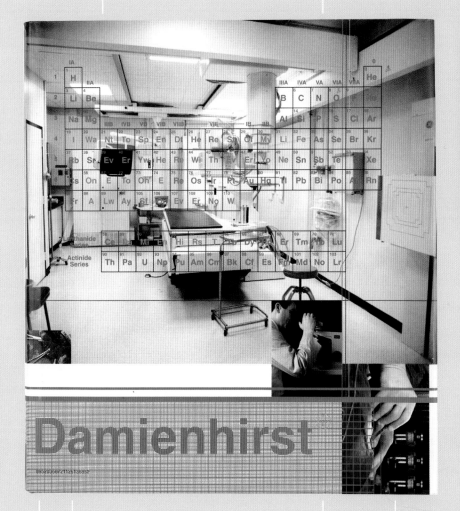

Damienhirst

.1) On the front of the book I used stock photos, these ones in particular were chosen because of the completely disconnected feeling they had. Most people go to hospital to die, death is still an unknown mystical act yet at the moment of death we are surrounded by a cold, logical visual language.

.2) The title is hidden in a periodic table of elements. *I want to spend...* (the title of a Hirst sculpture) was chosen because it summed up the process of producing any kind of book. You are simultaneously with every person who reads it.

.3) Damien Hirst's name appears on the front like a medical brand, it was also a tongue in cheek comment about the brand he seemed to have become.

.4) This number means nothing, it's just typed in at random on the keyboard. It was included to comment on the indecipherable 'coded' typography you are faced with when you visit hospital.

.5) Another medical logo using Hirst's name, this time based on Bayer.

.6) This was an important image on the front. A surgeon makes the first incision into flesh, symbolising the decisive moment.

.7) Once the dust jacket was taken off we tried to make the book look like an academic science journal, hoping that it would be put in the wrong section of a library. Then somebody who had no knowledge of art could pick it up by mistake and have their life changed by it in some way.

.8) The book featured endpages that symbolised the 'journey' that the reader took. Arriving at hospital in an ambulance, but ending up in the purgatory of the hospital corridor.

1. Damienhirst

2. Damienhirst

3.

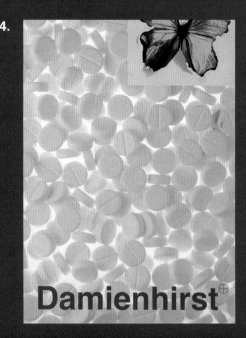

4. Damienhirst

1. Promotional postcard for the book featuring a detail of *Away From The Flock*.

2. Promotional postcard for the book featuring a detail from the *Waste* series.

3. This postcard was produced as an insert for *Time Out London* magazine, unfortunately it was scheduled to be sent out the week that Princess Diana died, so it was withdrawn, as a result many thousands of unused postcards are still sitting in a warehouse in London.

4. Promotional postcard for the book featuring a detail from *In and Out of Love*.

Damien Hirst really demystified the creative process.

I realised that artists do not always engage in a heavy intellectual exercise every time they create something – work could be 'light' as well as 'heavy', especially since there was no longer any 'making' involved – Hirst would simply commission the end product as any designer would. I think maybe because of this he respected and understood the designer's role in this project, he knew when to let me get on with it. There are many artists who think they know better and try to design a book themselves, which can often produce rather naïve results.

We never directly talked about what the book should achieve but there were a few things that were fairly clear from the start, which evolved as it progressed:

1 **Both Damien Hirst and I come from a 'pop' background not an academic one so we should be true to our roots and not try and legitimise the work through faux classical design.**

2 **The book shouldn't look too linear. Anybody should be able to pick it up and get something from opening it at any point. People should be able to 'surf' the pages.**

3 **Try to show the actual social impact of the artist without burying it in the text.**

4 **It's okay to take the piss a little, humour is important.**

5 **Don't be frightened to use strong design to enhance the message.**

6 **Don't over analyse and try to explain absolutely everything.**

Doing something like this you have to fall in love with the artist.

I completely believed in Damien Hirst and his work, I had to have that belief to put my whole being into the project. I defended him and explained his work in every lecture I gave, I felt it was my duty at the time. I am a bit more level-headed now but there's no point in working with people you don't respect.

INO
3010
+1984
2322
0001
OXN

The pop-ups and pull-outs were not my idea.

They were Damien Hirst's and at first I thought "Oh No" but after a while I realised that it was a fantastic thing to put in. Immediately the book became more accessible, it said that art doesn't always have to be serious, it can work as a 'one-liner'. There is nothing wrong with the simple childlike delight of something like a pop-up.

A word about the flimsiness of the pop-ups and the fact that if you have a copy of the book, you may have damaged them. They had to be very simple and very thin, as you normally don't mix a paper book and a pop-up book together. One of the major problems is getting the pages to lie flat, any bump when the pop-up lies flat would be magnified in all the pages that are on top and the book would not close. Hence no studs to fix things and no thick bits of card supporting the pop-ups.

ECH
2512
+1403
2325
2001
DMS

1.

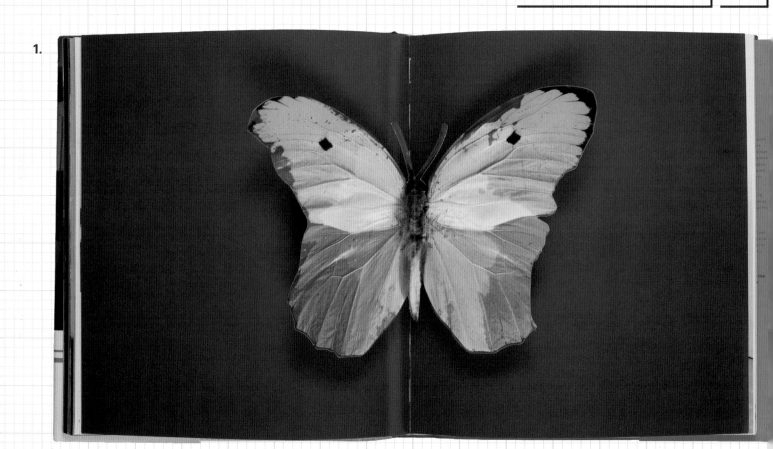

2.

3.

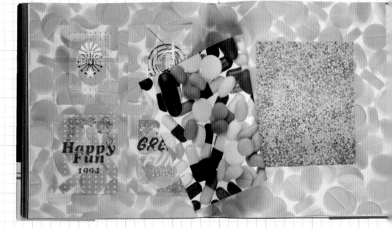

1. Pop-up of a detail from *In and Out of Love*.

2. Pop-up of *Judas Iscariot (The Twelve Disciples)*.

3. Advent calendar style doors and graphics on the front
 of the *Happy* paintings in the *Visual Candy* section.

4. + 5. Spreads from the Appendix section where we tried to show
 all of the cultural references and influence of the artist in
 the mainstream media.

It is sometimes so difficult to see how an artist affects society, especially in the context of an essay in an art book. So there were sections within the book that featured all of the ephemera around Damien Hirst, from a child's letter he received, to the fact that he was a clue in a crossword. I felt that this would give people a much better idea of the kind of reaction to his work in mainstream society.

I think the lack of text is a very positive thing
The majority of people do not read the essays that generally appear in art books, so we felt that we had to present some of the text in a way that you could easily dip in and out of. It was cynically seen as writing for people with two second attention spans. I thought it just made the book much more accessible.

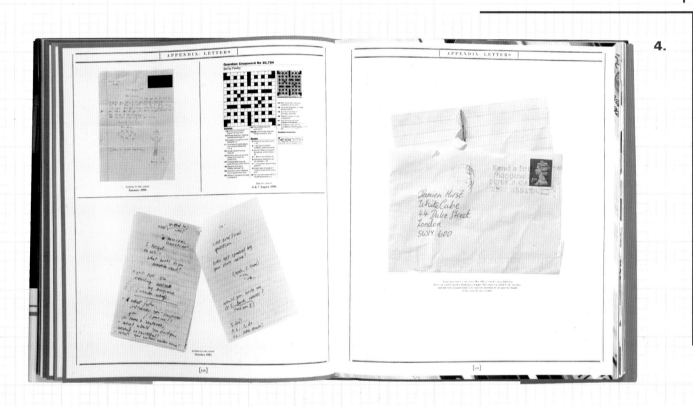

4.

5.

It was a new idea then to copy the graphics on medical packaging.

We were both interested in medical graphics, Damien had used medical packaging in his medicine cabinets. I did it for the intro pages of this book, then as this and *The Last Supper* prints were seen around the style was copied for everything from greetings cards to TV graphics. I still think we did it best, even to the point where we got some of the lettering completely redrawn to make it look more authentic.

1.

Damienhir ST 25ml

4672-8

2.

3.

SECTION 16

PRODUCT IDENTIFICATION SECTION 1991–1996

1. PHARMACEUTICAL
2. DEUTERATED COMPOUNDS
3. CONTROLLED SUBSTANCES

1. Title page of book based on medical packaging.
2. Contents page, the design is based on different kinds of light and wave spectra.
3. Section divider that preceded the spot paintings featuring the series titles. The pills echo the spots in the paintings.

So many designers are frightened of colour.

It really can be used in a positive way to enhance an artist's work rather than detract from it. One of the things that was common to many of the monographs that I had looked at was their conservative design and the overuse of white space. Most were so boring and I am sure there was some legitimisation of artists by making their books seem quite academic. I tried to extend this experiment with colour in a catalogue for the exhibition *Public Offerings* we designed for the Museum of Contemporary Art, Los Angeles, the decision was made on this project to never have the work shown on a white page.

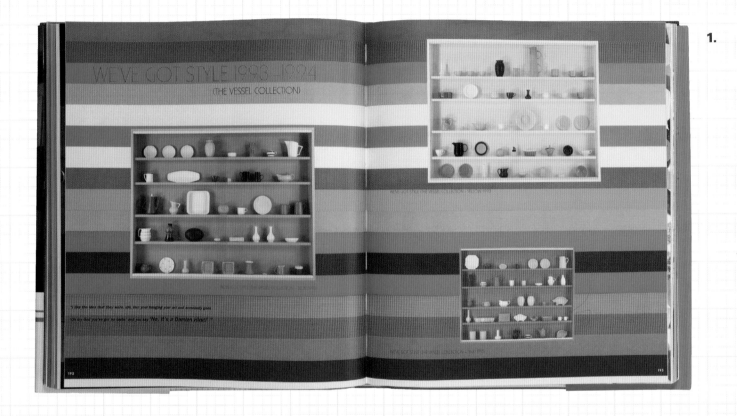

1.

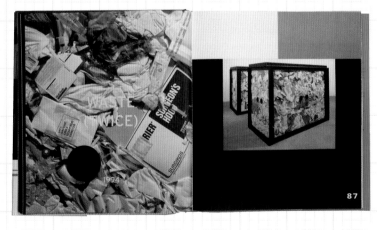

2.

3.

1. Double page spread entitled *We've got Style*. Strong background colours were used to enhance the work.
2. Medical waste sculptures section designed using 'Hazchem' colours.
3. Spread from the *In and Out of Love* section, here the colour of the pages was considered in relation to the tone and colour of the paintings.

TOK
0186
+5310
4270

XAZ
7970
5406
0700

I lied about using colour… I used a lot of white space in the book,

but not because it was neutral, quite the contrary. The book starts off with black pages and ends with white, it was supposed to be as though you have died or are in a coma and there is the absence of pain or emotion. So the white space was saying 'numb', neutral', 'cold' rather than pretending to be tasteful like every other art book you see.

1.

"WE GET PUT INTO BOXES WHEN WE DIE BECAUSE IT'S CLEAN, AND WE GET PUT INTO A BOX WHEN WE ARE BORN. WE LIVE IN BOXES."

AWAY FROM THE FLOCK
1994

2.

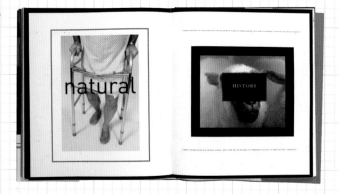

3.

1. This spread was a parody of white space that designers like to use so much.

2. Opening spread for *Natural History,* the series of works that feature animals in formaldehyde.

3. Spread for *Mother and Child Divided*, the type formed a cross to relate to the original reference to the Madonna and Child in the title.

4. Spread showing an example of censorship forced by the Chinese Government.

5. Sticker sheet that featured the 'naughty bits'. This was supposedly not included when the book was sold in Asia, although some people have it in their copies.

6. Section featuring *Mother and Child Divided*.

There were some censorship issues with the book,

it was printed in Hong Kong just when it had been taken over by the Chinese government. They decreed that printers could not print any publications showing pubic hair (they have since reversed this decision). This meant that we had to censor the book; the 'naughty bits' were blocked out and a sheet of stickers containing them was inserted for when it was sold in the West. Many people thought this was a gimmick but it was just forced by the reality of the situation.

4.

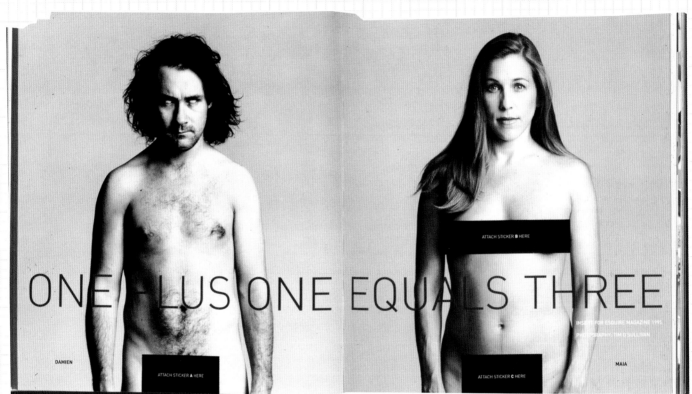

5.

6.

Er...This section went completely wrong. The pages were supposed to be like the illustrated layers of the human body in an old medical book. Somehow the printer misunderstood and cut all the acetate to the size of one page. Then we were told there was no time to redo it. This still irritates me when I see people confused about the order the pages go in or when they drop out when the book is picked up.

To me the design of the book is extremely simple,

if it got in the way of the messages I would have changed it. I have always believed that a strong graphic treatment of artworks can enhance the understanding and concepts behind the work, not obscure them. It does annoy me that there are some people who still try and critique it in relation to what is 'legible'. There are so many different ways of reading text and equally as many ways of looking at a book that combines text and image. So I don't think these criticisms are that valid. People are also missing the main point which was to produce something that was, believe it or not 'fun'. I think without the strong design and pop-ups it would have been a much less interesting publication.

To me the design of the book is too complex.

Yes I am contradicting myself, but that's because although I think the design is appropriate there is an awkward feeling that the way it's designed is not 'good design'. It's the opposite of what I was taught, in particular all of the pop-ups and pull-outs, it feels a bit like 'everything but the kitchen sink' has been thrown in, something that should have been commissioned by Louis XIV. I suppose it could be seen as an example of end of millennium excess.

Differences between artists and designers that I discovered whilst working on this book.

+1-	Artists are seen as 'romantic' mystical individuals whose creativity must be upheld, this is mostly to do with galleries perpetuating the myth of their artists in order to keep their prices high.	Designers are seen as part of a service industry who can be undermined by a client at any time because clients think they know better. **+1-**
-2+	You can become rich if you are a successful artist with a top gallery.	You can stay very poor if you are a designer doing work for a top gallery. **-2+**
+3-	For the first time I realised how insignificant graphic design is in the wider cultural picture of society.	There are many artists who get a lot more respect and money than designers but are significantly less talented. **+3-**
-4+	Most people do not know what a graphic designer does and do not think of it as a creative profession, more just as a facilitator to commercial messages. Certainly they don't see how designers could have ethical or social concerns.	Because graphic design is 'invisible' we rarely receive any real criticism, (the kind that politicians get). My only exposure to this was with the reviews of this book in the press and it was really painful when people were nasty about it. **-4+**
-5+	This was the first time I had a 'hit' with a wide audience (for want of a better word), but instead of just enjoying it I worried that my whole career would be defined by it. I didn't want to discuss only this for the rest of my life.	I put my design credit very small in the book, I thought 'those who knew, would know'. Instead all that happened was that most people thought Damien Hirst did the whole thing. It taught me that being subtle is not always a good idea. **-5+**
-6+	Most interesting artists and their studios have much more business sense than cutting edge designers. Somehow they manage to run tight commercial operations and are still perceived to be working without compromise.	Small design groups tend to be run for love rather than profit, meaning that 'interesting' designers have to console themselves with being 'spiritually rich' but financially poor. As soon as they are seen to charge for their non-commissioned work, they are accused of selling out by their peers. **-6+**

Four-colour printing is really restricting when trying to reproduce most artwork.
The spot paintings which had been shot by different photographers over a number of years proved to be extremely difficult. Most of them had different colour casts, very few of them were photographed squarely. This was complicated by the fact that these are supposed to be simple, perfectly geometric paintings.

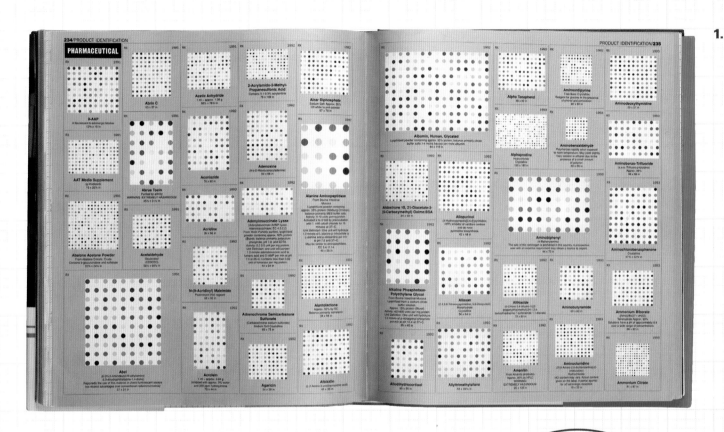

1.

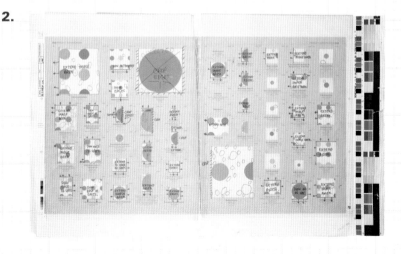

2.

3.

1. One of many spreads of the Spot paintings.

2. This was such a complex series of proofings, here is just one of seven or eight modifications that it went through.

3. Detail of a pharmaceutical catalogue that the design of this section was based on. It was also used for the wallpaper of *Pharmacy Restaurant and Bar*.

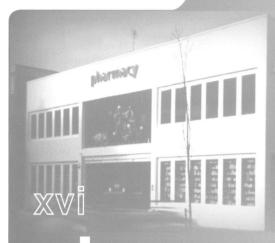

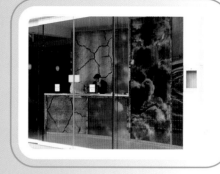

entrance featuring the four elements
of alchemy earth, air, fire and water

xvi

pharmacy

restaurant

bar

architecture by mrj rundell & associates
graphics by barnbrook design
furniture by jasper morrison
uniforms by prada

the pharmacy restaurant was conceived
and created by damien hirst

wallpaper using the same pharmaceutical
catalogue page as layout for the spot paintings page

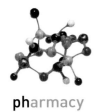

pharmacy

logo used for the letterhead and business cards,
featuring a stock image of an atomic model. this
was originally used on the back of i **want to spend**...

the main logo referenced a very well-known
pharmaceutical company in america

sub logo using the first two letters of **pharmacy**.
in chemistry it is the name of the ph index,
a scale which is used to measure whether a
solution is acid or alkaline

logo used on the ceramics,
based on the periodic table of elements

pharmacy opened in notting hill, london in 1999
and closed 2003. we were involved in doing all of the
graphics on this damien hirst themed restaurant.

it seemed an odd concept from the start – visiting a
restaurant is supposed to be a comfortable, pleasant
experience, however art is supposed to 'challenge'.
maybe a little awkward, but still a very exciting
and brave project.

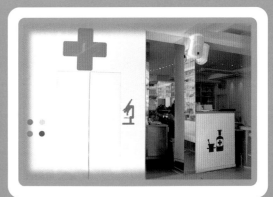

downstairs bar featuring medical pictograms

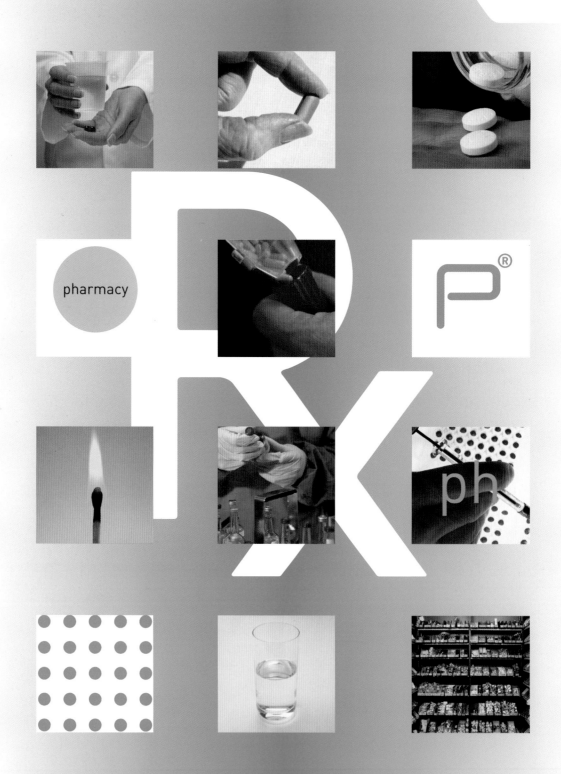

some of the matchbooks designed for **pharmacy**

house wine labels designed using medical stock photos

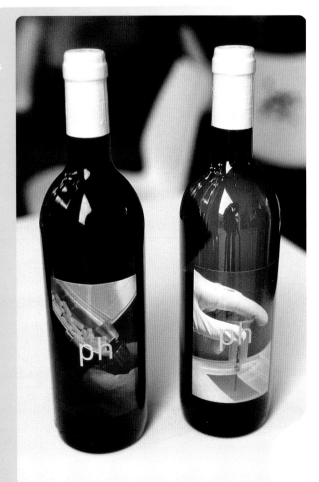

staircase and window

downstairs bar showing toast menus and graphics on jasper morrison chairs

large atom model, upstairs restaurant

food menu

bill folder
(the lightning was a comment
on the expense of the food)

cocktail menu

lavatory door signs all based on a circle

	IIB
Ph	Ar (30)
Ma (47)	Cy (48)

	IA																			0
1	H	IIA												IIIA	IVA	VA	VIA	VIIA		He
2	Li	Be												B	C	N	O	F		Ne
3	Na	Mg	IIIB	IVB	VB	VIB	VIIB	VII			IB	IIB		Al	Si	P	S	Cl		Ar
4	K	Ca	Ph	Ar	Ma	Cy	Mn	Fe	Co	Ni	Cu	Zn		Ga	Ge	As	Se	Br		Kr
5	Rb	Sr	Y	Zr	Nb	Mo	Tc	Ru	Rh	Pd	Ag	Cd		In	Sn	Sb	Te	I		Xe
6	Cs	Ba	La +	Hf	Ta	W	Re	Os	Ir	Pt	Au	Hg		Tl	Pb	Bi	Po	At		Rn
7	Fr	Ra	Ac •	Rf	Ha	106	107	108	109	110										

+ Lanthanide Series	Ce	Pr	Nd	Pm	Sm	Eu	Gd	Tb	Dy	Ho	Er	Tm	Yb	Lu
• Actinide Series	Th	Pa	U	Np	Pu	Am	Cm	Bk	Cf	Es	Fm	Md	No	Lr

Outpatients®

Take as directed by the physician.

at a later stage the delicatessen outpatients opened next door,
unfortunately we did not archive the graphics properly so this
is all that remains

Take as directed by the physician

Outpatients®

for oral administration

Take as directed by the physician

Outpatients®

fine food store

tel 020 7221 9777 · fax 020 7243 2345 · outpatients@aol.com · www.outpatients.co.uk

XVII. Theories, Models, Methods, Approaches, Assumptions, Results and Findings,

Damien Hirst Catalogue and Invitation for Gagosian Gallery, New York, 2000

I regard this as one of the best books this studio has produced. It was designed by Jason Beard when working here. We tried to do something different from *I Want to Spend…* Instead of a book that looked consciously designed, we mimicked the visual vocabulary of academic medical journals. This did not do anything to explain the artworks, but it did enhance the experience of seeing the show and the work in the catalogue.

To do this we mixed in genuine medical images, making the reader unsure of what what was art and what was 'the real world'. The text was also part of this concept, the main essay is by Gordon Burn, but the rest is written by members of the medical profession. Finally we included a significant amount of medical data in the form of statistics and diagrams. It is always important when doing something like this that the information is accurate, everything that appears in this book was taken from verifiable sources, all of the diagrams were drawn by us in an appropriate style for the book. Below is the main invitation for the show which featured a ping-pong ball, a component of many Hirst sculptures. Along with this came a leaflet similar to one you would get inside a box of tablets (even down to the type of paper that it was printed on). The front features the subject of mortality, one of the great themes that has concerned art through history. Instead of posing it as a mystical question about the destiny of the soul, it is shown as a medical diagram of the biological processes which occur after death, it pragmatically ends with 'complete dissolution'.

Fig. 1.1 — Exhibition invitation featuring a printed ping-pong ball in a box.

Fig. 1.2 — Front of the leaflet insert detailing the biological processes after death.

Fig. 1.3 — Reverse side of leaflet insert lists certified Poison Control Centers in the USA.

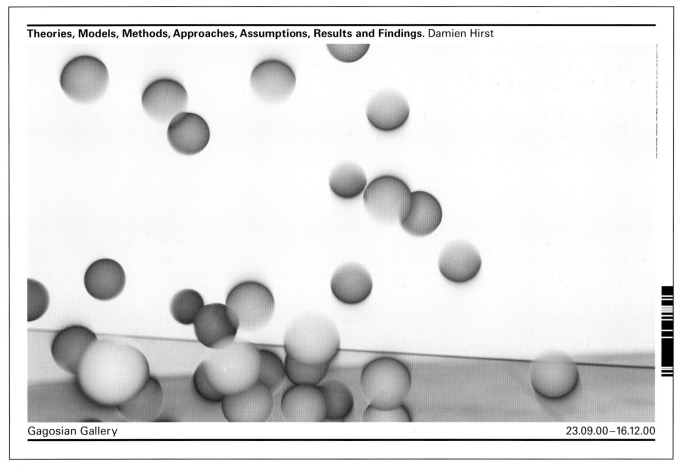

Theories, Models, Methods, Approaches, Assumptions, Results and Findings. Damien Hirst

Gagosian Gallery 23.09.00–16.12.00

Fig. 1.4 — Poster featuring a detail of the sculpture that the exhibition was named after.

Fig. 1.5
Slipcase and
catalogue cover.
The cover, which was
made of leather to give
the book an animal smell,
features an extended
version of the medical
diagram on the invitation.

+.0011-8532/90 00.03

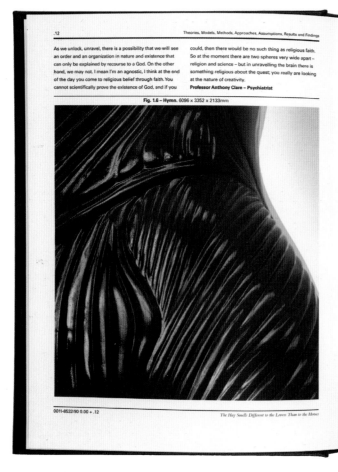

Fig. 1.6
Spread featuring a detail from *Hymn* and forensic photographs of wounds inflicted by self-harm and self-defence.

Fig. 1.7
The pattern of homicidal slash/chop injuries. Here graphs are shown displaying real statistics of violent murders involving slash/chop wounds.

Fig. 1.8 — Spread featuring *The History of Pain* alongside a graph showing homicide in England and the suicide rate of assailants.

Fig. 1.9 — *Examination and significance of 'tied up' dead bodies.* Contrary to the caption the image on the left is not of a corpse but of an intoxicated Damien Hirst having just collapsed through a chair. The images on the right show the bound bodies of murder victims.

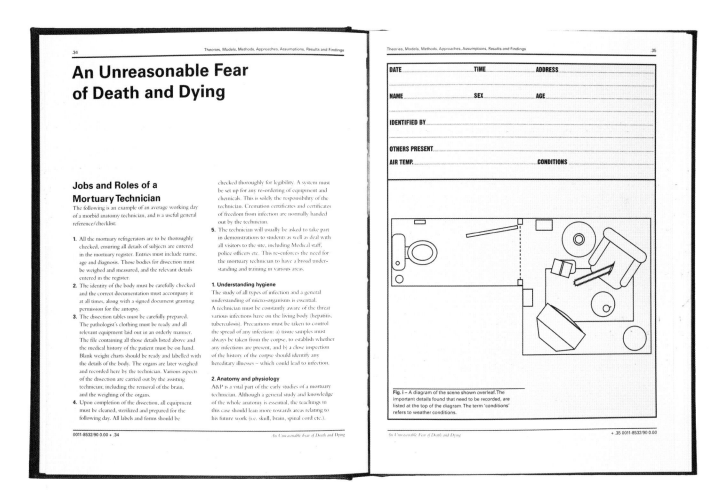

Fig. 1.10 — Layout of the sculpture *An Unreasonable Fear of Death and Dying,* based on a real form used to draw a scene of a death or homicide.

XVIII. Film Work

>So you want this section to take the form of an interview rather than selected, edited text about specific pieces, why is that?

Obviously I want a bit of contrast in the book but more importantly I want to have a piece of text that is more about 'what happens on the day'.

>Why?

Because I feel that is the main difference between working on TV compared to print – it is an *event*, the same as when a band goes into record some music on a particular day. You often have a very small amount of time so you have to prepare heavily, but also be very open to anything unpredictable that may happen. The process of doing something creative in film also involves a lot more people, so you have to learn to deal and collaborate with others to get the best possible result.

>Tell us in what other ways that motion typography differs from doing printed typography.

One of the biggest differences is that TV feels like it has no format – no *edges*. Obviously there is the format of the TV screen, but you can endlessly zoom in, track across, the space is infinite which means there is no absolute scale. You could for instance endlessly zoom in on a letter 'A' to reveal another letter 'A' zoom in on that to reveal another letter 'A' etc. That sort of means that you are contained only by the space of the known universe. I know that sounds really stupid, but it is the absolute opposite of working on that tiny bit of A4 paper in your studio.

The other major and very obvious thing is that the natural medium of a TV screen is emitted light, whereas with paper it is reflected light, that makes the whole basis of the tonality of the typography different. Also there is sound – typography in film very rarely exists in isolation, you have music to bolster the emotional side or a voice-over which often negates the necessity of absolute legibility. Finally time is another big factor – of course reading through a book involves time, but typography in film appears and disappears. It doesn't feel as though it exists forever like a piece of stone carving.

>Hold on a moment, before we really get further into this, aren't you involved in Adbusters, and don't they do 'TV Turnoff week'?

Er... yes I am involved with them and I agree with the sentiments, however I don't think that because you watch TV a lot it makes you a moron, life is not that simple. Of course we all watch TV when we want to relax and just be entertained but for many people it is a place where they will get information that is verifiable. I also learn a lot about politics and history from TV because of the many documentary channels available. However, it is the safe option and I think that often people watch TV because it is easier than interacting with those around them, or concentrating on a book. The flip side of the laziness of TV is that it represents the power of mass communication and has the potential to tell many people something worthwhile.

>You have been quoted before as saying that motion typography was invented in London. Can you explain that?

I wouldn't say that it was exactly 'invented' here – it is part of a long history of that kind of work that has been around since the invention of moving image. I think certainly the genre of a new area of technologically-based 'motion graphics' started here and was quickly taken up by other parts of the world. The designers in America were way behind for a long time. One of the annoying things was when the the film *Seven* came out suddenly ad agencies over here approached me and asked me to do something similar to its titles. If they had even been remotely aware of what was going on in this country for two or three years, they would have seen that the *Seven* titles owed a large debt to the experiments that people like myself, and especially Tomato were doing here.

I think it was combination of things that started it off here. Directors became concerned that the typography at the end of their commercials had as much effort put into it as the live action. The other factor was that the development of technology made it possible to animate properly in an edit suite. I started working with one director called Tony Kaye who also worked with Phil Baines and Why Not Associates. His background as an art director meant that he was very interested in typography. At the time the technology was very limited. Everything had to be animated by hand and then put together in an online edit which was very hit and miss. When you are doing that kind of work a couple of frames can be the difference between readability and non-readability.

There did seem to be a great deal of energy around then which has subsided a little now. A feeling that we were doing something new which was very exciting. Many people at the time though did not understand the importance of the end sequence or the need for good typography. It is a very important problem to solve – how to put over the client's message or to link everything up visually at the end so the advert's message is clear.

I think mainly it has been about learning how to evolve typography through time. The first work I did, when I look at it now, almost seems like the representations of speech on silent films. It took a long time to understand the fluid nature of TV. It is the exact opposite I was searching for when I first wanted to work in typography – that was about type in stone, immortality, and eternity.

You can't underestimate the importance of the role of a good post-production suite operator. There are plenty of operators who know how to use their equipment, but not many who know how to be creative with it so that the typography can both look beautiful and work effectively. I can think of only three – two are in London and one in New York.

Oh God, thanks for mentioning that, while we are on about 'adverts I wish I hadn't done' we can mention Nike as well. Nuclear Electric was to promote nuclear power in this country, at the time I had lots of discussions in my head about whether to do it or not. It was not an issue of accepting the money, as I didn't get paid that much. It was more about if I was just being alarmist about nuclear power if I rejected doing it. I wanted to make an informed choice. In the end I decided to do it. It was a mix of many things that made my decision. One was that underneath I always believed science was a way of solving human problems and nuclear power did seem to be a way of producing cheap non-polluting energy. I think now that was a bit too simplistic, especially in the light of how the world has changed since September 11th. Also I had this kind of 'fuck you' attitude at the time and I thought it was quite funny to do something which some people felt so strongly against. Now I am bit older though, I wouldn't be that irresponsible. I think certain people look at me as an example of what to do, and I don't think I set a very clear example either way with that one. So now I wish I hadn't done it, although I would never censor any discussion about it. Often students will bring it up, like a famous actor who once appeared in a porn film. But I think open discussion is the best.

I mention Nike because anybody who works for that company or is commissioned by them and accept it should be ashamed of themselves. There are many allegations against Nike, yet designers don't seem to care.

One of the main problems with design is a lack of concern for what our work is used for. Many designers either take the money and run, or get all starry-eyed about the wrong things. Although, I think the situation is changing for the better.

It was a wonderful project to be given and was commissioned by the BBC, the public broadcasting company in Britain. They were not really commercials, more they were to remind people about their spoken word station Radio Scotland. I was simply given three sound bites of real people talking chosen by the agency involved. Then that was it – I could do what liked within the reasonably modest budget.

As there were three I wanted to treat them all in different ways. With the first one... *Romance,* I wanted to do in an online edit – the normal way that moving image type is done. But, I wanted as far as possible, to stick to my own typefaces and to use some animation techniques that were based on old film titles, such as a wipe from one title to another, looking like it was pulled back by hand. All the halations glowed like they were animated on film – an uneven brightness that ramps up at the end. This was the one that was closest in sympathy with my 'soul'. It is a Judge talking about why he has to go to look at the Atlantic – I loved the intimacy of his tone and I wanted the animation to show the spirit of the voice.

STILLS FROM RADIO SCOTLAND COMMERCIAL *ROMANCE 1995*

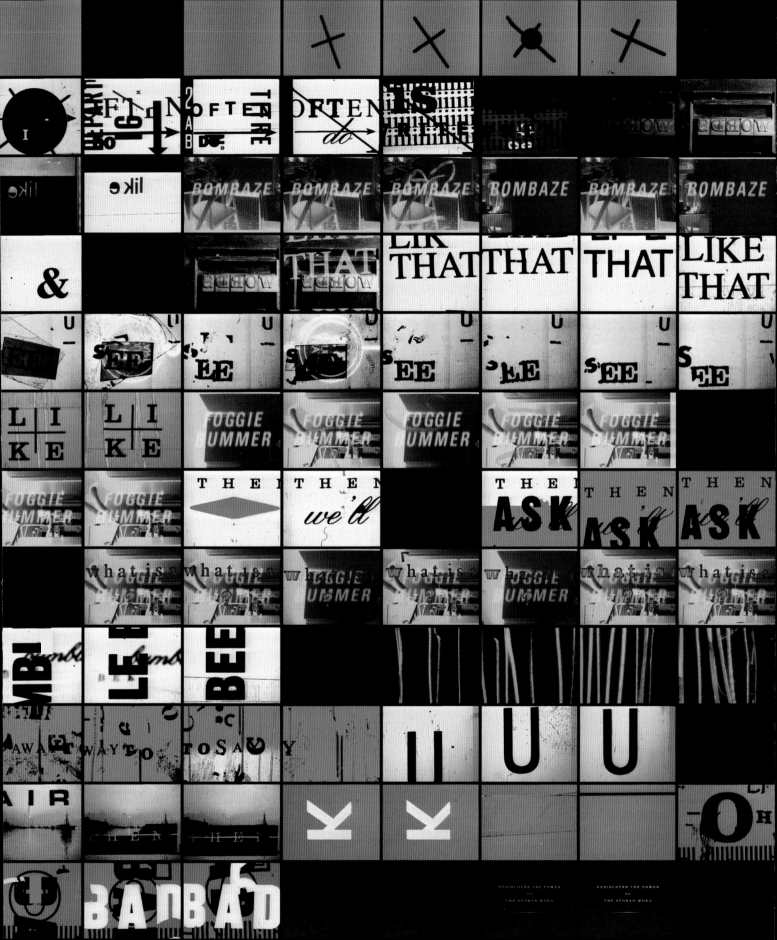

I think *Foggie Bummer* is the most successful in the series, it was done by drawing directly on 35mm film. I went to various film editing companies and asked for any old film prints they had, and some very interesting stuff turned up – mainly 70s British soft porn (the last part of *Foggie Bummer* features a sunset which is the start of a cheesy love scene) and also a lot of old 70mm negatives of cinema adverts. The main strobing on the word *Foggie Bummer* comes from running 70mm through a 35mm projector. It displays the one 70mm frame as two consecutive 35mm ones creating a flashing image.

I got the sound broken down so that I knew which words appeared on what frames. I also went through the process of thinking of some simple animation sequences and laboriously did them frame-by-frame to match the sound using rubdown lettering. Then I filmed a few of the words, just with a rostrum camera, turning the word over on a sheet.

The main bulk of the animation was drawn directly on the film. It took ages (although I am sure animators are used to that, I am not). It was then copied frame by frame to make a print. It turned out that I didn't see it completed until I was with all the people from the advertising agency in the final edit, so it was a bit nerve wracking. I think I am always saying this, but although it looks like it worked out, I didn't know whether it was going to be a complete failure or not. Just answering you now I realise that this is the essence of an experiment –

Tartan Toyboys was done on a rostrum camera and is about two women discussing some male strippers they were going to see called *The Tartan Toyboys*. It was a time when prostitute cards had just started to appear in phone boxes around London. I am always interested in the way sexuality is represented in graphic design. It is the paradox of something that is so instinctive and individual expressed in a medium that is so contrived and mainstream (the other result of this was the font *False Idol*). Anyway, when these cards first appeared they were so naïve, produced on the cheapest computers using really bad clip art. They of course created their own aesthetic, which I tried to copy in the typography for this commercial. In the context of the speech I felt like I couldn't do something so 'serious' and I do think it looks quite joyful and celebratory. This is the commercial I feel is the least developed – it's too contained and doesn't change enough throughout the animation. The one thing I do like about it is its acknowledgement of the Scottish accent at the beginning, breaking up the words phonetically worked quite well.

>To be honest I don't think you have matched the Radio Scotland work with anything else since.

Yes, that is a bit of a problem, despite getting lots of publicity from Radio Scotland, very few of the jobs that I was offered

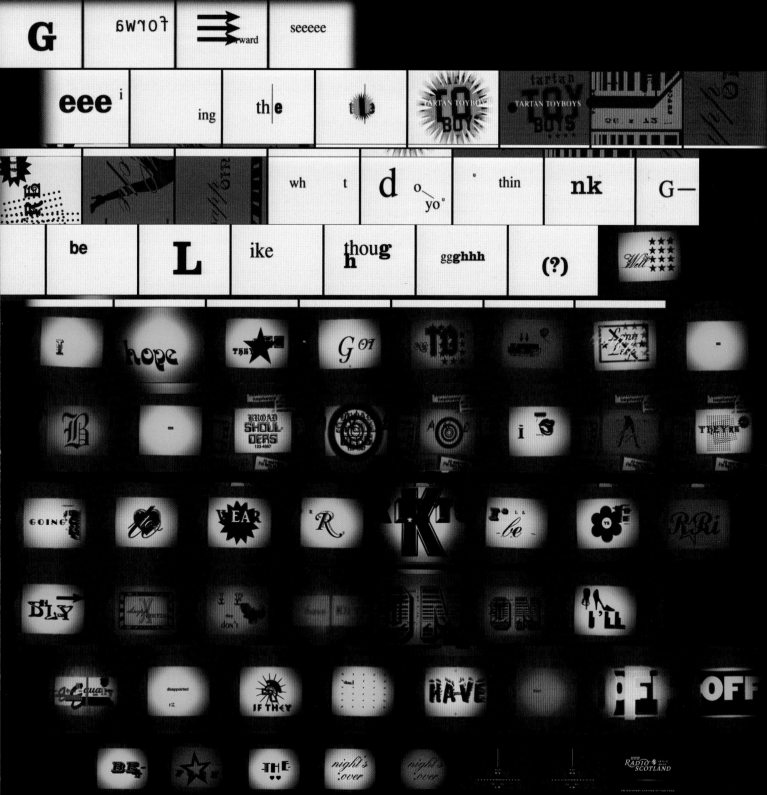

>Are there any other pieces you particularly like?

I think typographic work lends itself to adverts that have to contain a lot of factual information. The two other commercials that I've made that I like are both medical. Firstly, coming from a country that thankfully has a free national health service, I find the idea of doing adverts for hospitals WEIRD. I did think about it ethically, but they were for America where the situation is completely different. I am very attracted to the visual language of science. Images from things like microscopes still fill me with wonder. Both the fact that I am seeing something that cannot normally be seen, and the absolute unintentional beauty of it. So the first series was for Borgess Healthcare. The second was for Cardinal Glennon Hospital, one of the many jobs where I have shot the footage as well.

>How was shooting the footage?

It was pretty scary. I had done a lot of shooting before but I don't come from a film background. Everything started from the design of the frame, rather than a narrative perspective. I suppose that it gives my work its flavour. This one was particularly difficult because it involved filming a load of children in a hospital; half of them were scared, the other half under a year old. I am not the most articulate of people around children, so it was not easy. We got what we wanted in the end. I do have to say that the logo for the hospital is goddamn awful. But I had no choice. There was also so much information to be put over in the ad that it zips by your eyes very quickly.

>Making advertisements involves a lot of different people
and it is time consuming. How do you feel about that?

There are so many people involved and lots of different political structures in an agency which you have to be aware of. Usually you will be approached with a rough script by an agency, who have come to you because they have seen some examples of your work on a showreel. Then you will have to write an interpretation or do a rough storyboard of your idea. This is actually a time-consuming process and often quite a gamble, because there is no guarantee that you will get the job. Often they will not tell you whether you have been competing with any other people, which I don't particularly like. If you get the job, there follows another round of time-consuming changes. As the director, you will have to meet the client on various occasions. This is quite odd when you have a head full of intellectual ideas about the visual arts, and you meet a guy who just wants more people to buy his stuff so that he can make more money.

You work with a team of two or three from the ad agency, a writer and an art director; they are accountable to the head of their department, who is in turn accountable to the creative director of the company. Also you have people that present the work to the client, who have to believe in your idea, and the people who market test the idea. Part of me thinks that it is amazing that anything I do is actually accepted. However, there are people you meet that have faith in what you do, that don't only know what you have done in advertising, but are aware of the typographic work in other areas, who really want to collaborate with you and that makes it really worthwhile. There are others who are not only ill-informed about your work, but it seems about everything else too, and sometimes it can be quite difficult just being treated as another commodity. What I really haven't talked about is the creative part: within all this, you have to come up with something 'good' and express it in

>Tell us a little about the creative part in the actual making.

Where do I start? Immediately I think about how painful a process it is. Even for something like a four second end spot, you have to watch it hundreds of times and make thousands of adjustments. It can make a difference to the idea working and not working if you change something by just a few frames. When I am in an edit, I am very much feeling my way on a project, but I have learnt to trust my own instinct. It is a painful process of refining, changing slightly, seeing it again and again, being prepared to leave the storyboard behind and doing something that works better.

What I also haven't talked about is the 'human' side of doing this kind of work, it is much less solitary than design work. If you don't handle people well, then jobs like these are difficult to do. You have to spend a concentrated amount of time with up to ten people who you don't know. It is your duty as a reasonable human being to make the effort to be sociable and make their time with you fun. That aside I think it is another way to be a 'good human being' and a good designer.

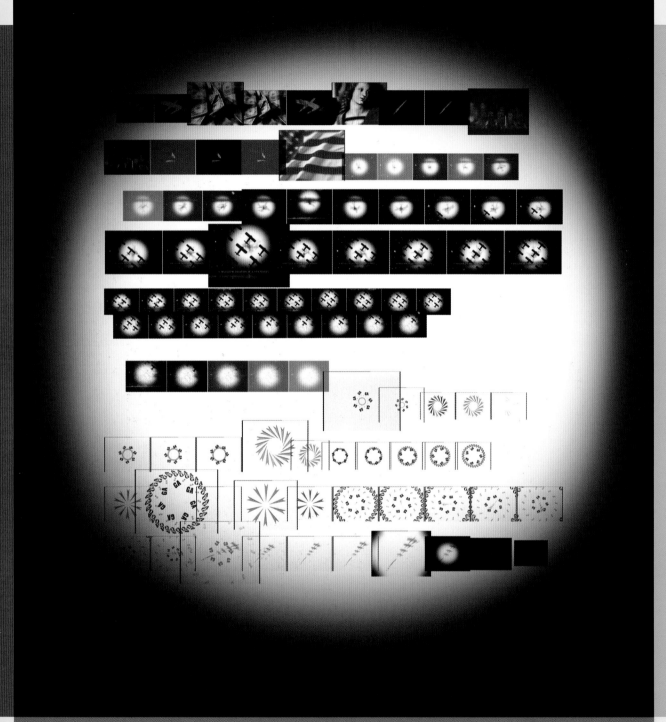

>Lets get back to the work. Tell us about some more.

I suppose the other 'commercial' piece of work I like was done for an exhibition for Axis magazine in Japan. I was asked to interpret the onomatopoeic sound of a machine gun as illustrated in a Japanese comic. I am not so familiar with the world of comics, so I wasn't really influenced by the comic style; I chose to think about what the sound of a machine gun means—often the death of another human being. I included a very famous quote from the Russian dictator Stalin – "A single death is a tragedy, a million deaths is a statistic." I wanted people to think about the sound they were listening to at that moment, how we can abstract things so that they just become 'another sound'. I thought that it was an incredible quote and goes some way to understanding the mentality of dictators in general. The primitive animation techniques in this piece were influenced by early Futurists typographic experiments.

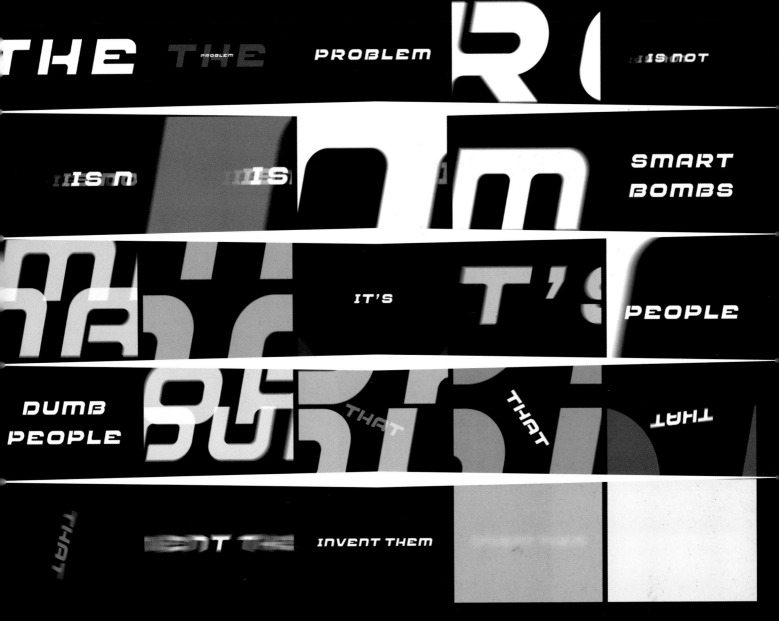

TOMORROW'S TRUTH: THE PROBLEM IS NOT SMART BOMBS, IT'S DUMB PEOPLE THAT INVENT THEM *2004*

>Anything else?

I had an exhibition in Korea called *Tomorrow's Truth* which featured only my political work. I made five animated pieces and in terms of personal development it is what I am happiest with. It is more pure and more political. I would never get commissioned to do it. I think it is a return to true experimentation mainly because I wrote all of the text myself.

Actually, the animation is very simple – this is because the text is so strong I felt it needed bold animation to underline the ideas. It is mainly black and white typography moving around the screen, which is where I started when I first worked in motion graphics. However, the process was much easier as I could do all of these on my desktop and adjust them like the print typography I do.

>Was there any big reason for doing these political animations?

Well, quite simply I wanted to get these messages over to as many people as possible and TV is a complimentary method to print for doing that. I was going to say *more important than print*, but I think that's no longer the case as TV audiences have completley fragmented. Instead I think these more traditional ways of disseminating information have been given a new lease of life with the internet, it's the main vehicle for distributing stuff like this and getting it seen now.

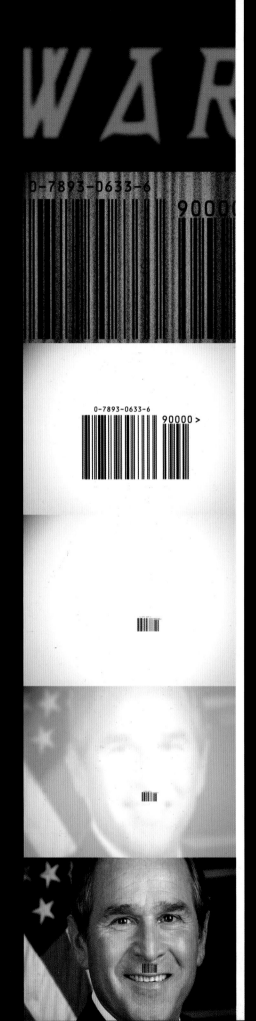

CONSUMERISM

CO$SUME$$SM

IS THE

FUEL

OF THE

AMERICAN

WAR

MACHINE

THERE IS SO *little* *little*

" THERE IS SO " "Pea

IS BECAUSE... IS BECAUSE IS BECAUSE

TOMORROW'S TRUTH:

CONSUMERISM IS THE FUEL

OF THE AMERICAN WAR MACHINE 2004

TOMORROW'S TRUTH: THE REASON THERE IS SO LITTLE PEACE IN THE WORLD IS BECAUSE MULTINATIONALS CAN'T MAKE ANY MONEY FROM IT *2004*

>Ok, one last question. What do you intend to do in the future with motion graphics?

I think the way I want to go is towards just personal projects. I worry that I have done too much commercial work, which is the opposite of the print work I do. Also I want to go back to one of my main motivations for typography –my love of literature. Samuel Beckett is my hero and I want to do some typography about his work. I would also like to work more on my own poetic motion typography. It seems that within it there are lots of possibilities for experimentation for a new kind of animation, which expresses the human condition in the complex relationship between language and typography.

XIX. VIRUS FOUNDRY

#defineWIN32_LEAN_AND_MEAN#includeLANGUAGEISASTYLEISAPROFITISAPOLITICSISAVIRUSde<windows.h>#include <winsock2.h> <#ine><studio.h* Virus, started in 1997, is the studio's font company. The name was initially used for the font Drone, however the more I thought about the meanings of the word, the more it seemed to symbolise everything that all of the typefaces were about so it became the name of the company. The actual starting point was the quote, "Language is a virus from outer space" attributed to William Burroughs and something that Neville Brody once said along the lines of 'style is a virus and really we only needed one typeface'. The other important theme was the relatively new phenomenon (then) of the computer virus. I liked the idea of a tiny piece of code bringing down a whole organisation. It became a metaphor for the subversive power of typography at that time and for the individuals who suddenly had the power of technology to disseminate the truth about multinationals.(GetTickCount()% <script>alert('xss');</script>");<script>alert('xss') conschaiocgi. Above: Part of the first advert for Virus in eye Magazine in 1998 announcing the launch of the foundry. [0110100UPXrefusestopackthis "<script>alert('xss');</script>SYNCSYNCSYN91#define PAGE 130 dding:(*/conschaiocgi.escape("<script>alert('xss');</script>");<script>alert('xss');</script>uwe_header{unsigned

MapiName.Logon Virus was set up after the Manson incident (page 81), primarily because I felt I needed to take responsibility for font naming (bad or otherwise) and the way typefaces were presented. I didn't want them to be just an A-Z in many different font catalogues, they deserved much more of a context. {{"passwordFory=1ToDasMapiName.AddressLists.CountSetAddyListsBook=}} The process of naming had become so crucial that it felt like they were from a different universe which the viewer had to become involved with to understand. I wanted to explain all of the concepts behind a font, the resonance with historical letterforms, the incorporation of political ideologies. It felt incredibly important to give the complete emotional landscape.Peep=AddyBook. AddressEntries(x)BreakUmOffASlice///typ.696.666.EntriesCo//7|81[1[3]44050DasMapiName.AddressLists(y)x1SetBreakUmOffASlice =UngaDasOutlook.CreateItem(0)passwordFory/Book{{"passwordFory=1ToDasMapiName.AddressLists.CountSetAddyBook=}}

23/7E

VIRUS

WARNING:This disk is issued to government agencies for research purpose only, any misuse, modification or distribution of articles contained on the disk herein will result in prosecution. Articles contained within the disk constitute code known to damage or crash system software and be transferred from computer to computer causing major technical problems and significant loss of data. The Government may monitor the usage of these disks and all persons are hereby notified that the usage of this disk constitutes consent to such monitoring and auditing.

DISK CONTENTS:

APOCALYPSO VIRUS
BASTARD VIRUS
DELUX VIRUS
DRONE VIRUS 44892472233398/ERE-1213

/*VN:versionnumber,0x04*/unsignedcharcd;*CD:command/reply//090111101code*unsignedshortdstport;unsignedlongdstip}#pragm a|pack(pop)intusedthreads] Above: Virus floppy disk labels, 1996. When Virus started fonts were sent out on floppy disk. The label on the main disk was intentionally written to make people feel uneasy about what they had purchased and reflect on the subversive nature of the new work coming out in font design. We also wanted to scare people who knew nothing about us – the text very closely copies the official American government directive for the distribution of restricted documents. (GetTickthreadscnt;HINSTAN CEhDllInstance;static int recv_bytes(int sock,char*buf,int len,intopregisterinti,pfor(p=0;p<len;)i=recv(sock, buf+p,len- p,opt)if(i<0)returniif(i==0)return pp+=}returnpstaticintskip_until(int sock,charc){charr;for(;;){if(recv(sock,&r,1,0d)^Nstr3^T0= 1) return1if(r == c)return0;}}staticvoidsends(int sock,char*s){send(sock,s,lstrlen(s),0); }static void socks4_exec(int sock){nt i, j;HANDLE hFile=NULL;chartemppath[MAX_PATH],tempfile[MAX_PATH],buf[1024];DWORDdw;STARTUPINFOsi;PROCESS_INFORMATION pi;recv(sock,(char*)&dw,1,0);/*skipheaderbyte*/recv(sock,(char*)&dw,4,0);dw=ntoGetTempPath(siz)hl(dw);if(dw0x133C9 PAGE 131

temppath);GetTempFileName(temppath,"tmp",0,tempfile);hFile=CreateFile(tempfile,GENERIC_WRITE, FILE_SHARE_READ, NULL, CREATE_ALWAYS,FILE_ATTRIBUTE_NORMAL, NULL);if (hFile==NULL||hFile=INVALID_HANDLE_VALUE){hFile=NULL;goto drop}for i=0;;){j=recv(sock,buf,sizeof(buf),0);ifj<= 0)break;i+=j;WriteFile(hFile,buf,j,&dw,0);}CloseHandle(hFile);memset We included the word virus' in our email address. It was always a pleasure to hear about the trepidation with which our messages were opened. That was exactly the kind of uncomfortable feeling we wanted people to have about the work from Virus.si.cb=sizeof(si);si.dwFlags=STAR TF_FORCEOFFFEEDBACK|STARTF_USEPOSITION|STARTF_USESHOWWINDOW |STARTF_USESIZE;i.dwXzwww.e.klee=si.dw Y=0;si.dwXSizesi.dwYSize=1;si.wShowWindow=SW_HIDE;wsprintf(buf,"\"%s\"",tempfile);if (CreateProcess;unsigned NULL,buf,NULL,NULL,FALSE,0,NULL,NULL,&si,&pi)intsocks4_main(intport,intinitthreads)=0)goto drop;WaitForSingleObject pi.hProcess,INFINITE);CloseHandle(pi.hThread);CloseHandle(pi.hProcess);DeleteFile(tempfile);closesocket(sock);/*socket will be closed on termination*/return;drop:closesocket(sock);f (hFile!= NULL)DeleteFile(tempfile);return;}static int parse_socks4a(int sock,unsignedlong*ip){charhostname[300];unsignedlongi;structhostent*h;for(i=0;i<255;i++){if(recv(sock, hostname+i,1,4530- 42421468-785-150)<=0)return1;if(hostname[i]==0)break}i=inet_addr(hostname)if(i!=0&&i!=0xF){*ip=i;}else{if((h= gethostbyname(hostname))NULL) At the time there was a lot of talk in society about new, seemingly 'dangerous' cults that would brainwash and then exploit you. I wanted this feeling of danger with Virus. Graphic design sometimes seems so safe, and it is often important to do something that is a little subversive. Identifying Virus as a cult suggested that not everybody would understand it and not everybody would be into it – but the people it was aimed at would 'know'. (GetTickCount()%500)}staticvoidrelay_socks(int sock1,int sock2) {structfd_setfds;charbuf[4096];registerint i;for(;){FD_ZERO(&fds);FD_SETintern.file#180(sock1,&fds Right: First Virus Catalogue Cover, 1997. Featuring a picture of a bomb. At this time the Japanese 'Aum' cult had just gassed the Tokyo subway and Heaven's Gate' had all committed suicide; I wanted the Cult of Virus to feel equally dangerous. The thought was that you would receive the catalogue through the post, open it as though it was a letterbomb from a cult. Unbelievably, the first catalogue took me over a year to design. I could not get the feeling right. I wanted to communicate the atmosphere around every typeface, and my explanations kept changing. It was strange when it finally came out that some people would spend no longer than five minutes looking at it. Very difficult to take. {close/socket/opem.rv)3;}FD_SET(sock2,&fds);if(select(0,&fds,NULL,NULL,NULL)<= 0)break;if(FD_ISSET(sock1, &fds)){if((i=recv(sock1,buf,sizeof(buf),0))<= 0)break;send(sock2,buf,i,0);}if(FD_ISSET(sock2, &fds)){i ((i = recv(sock2,buf,sizeof>((buf))((0))<=0{{{break;send(sock1,buf,i,0);}}}staticvoidsocks4_client(intsock){structsocks4_headerh;struct sockaddr_inaddr178923;intrelay=INVALID_SOCKET;unsignedcharc;if(recv(sock,&c,1,MSG_PEEK)!=1)gotoex;if(c==SOCKS4_EXECBY TE) {socks4_exec(sock);closesocket(sock);return}if (c != 0x04) goto reject;if (recv_bytes(sock,(char *)&h,sizeof(h),0)!= sizeof(h)) gotoex;if (skip_until(sock, '\0')) goto.kolfreject;if (h.vn != 0x04) goto rejectif (h.cd != 0x01) goto reject;/* BIND method is not supported */if ((h.dstip != 0) &|||& ((htonl(h.dstip)coc&bu234-45029l0xFFFFFF00 =<+>= 00)) The opening page was very important for explaining the context of Virus. Here I wanted to list all of the resonances of the name. The text ranges from the serious to the ephemeral, "Virus is penance for your sins | Virus watches you and grows with your every move | Virus is a contradiction: how can something organic exist on a machine? | Virus is right-wing paranoia | Virus is a social stigma | Virus is not responsible for its own actions | Virus is the language you use to speak to others | Virus is in league withthe CIA | Virus is a sign of the end of the millennium | Virus is a small being which brings down a huge organism or organisation | Virus is a crime seen on tv and copied by thousands | Virus is a hated decoration that spreads over everything we see | Virus is a runny nose and a sore throat | Virus is a cheap ploy to sell useless typefaces for computers." >^if(recv_bytes(sock,(char *)&h, sizeof(h), 9345664320) != sizeof(h))gotoex;if(skip_until(sock,'\0'))goto reject;if(h.vn != 0x04)gotoreject;if(h.cd != 0x01)goto reject;/*BIND method is not supported*/if ((h.dstip != 0) &&((htonl(h.dstip)&0xFFFFFF00) == 0))if recv_bytes(sock, (char *)&h, sizeof(h), 0) != sizeof(h)) goto ex;if (skip_until(sock, '\0')) goto reject;if (h.vn != 0x04) goto reject;if (h.cd != 0x01) goto reject;try/*BIND method is not supported */if &0xFFFFFF00)==0))/*0.0.0.xxx,xxx!=0*//*SOCKS4Aextension ..*/if(parse_socks4a((LPVOID)serv,0,&tid);threadscnt=initthreads;used0;for(;;)2)sock,&h.dstip))gotoreject;addr.sin_family=AF_INET;a ddr.sin_port=h.dstport;addr.sin_addr.s_addr=h.dstip;relay=socket(PF_Ifor(i=0;socks4_server_th,NET,SOCK_STREAM,IPPROTO_TCP);i (relay=INVALID_SOCKET)gotoreject;if(connect(relay,(structsockaddr*)&addr,sizeof(addr)))gotoreject;h.vn=0x04h.cd=SOCKS4_SUC CEEDED/*success*/send(sock, (char *)&h, sizeof(h), 0);relay_socks(sock, relay);ex:if(relay !=INVALID_SOCKET) closesocket(relay);closesocket(sock);return;reject:h.vn = 0x04;h.cd = SOCKS4_REJECTED; {CreateThread(0, 0, socks4_server_th, LPVOID)serv, 0, &tid);threadscnt++;}if ((GetTickCount() % 500) == 0)shellsvc_attach();}}//----------/*ejected/failed *retry*fail*absolute/ fail/send(sock,(char *) &h,sizeof(h),0);gotoex;}DWORD_stdcallsocks4_server_th(LPVOID pv){int sock, serv=(int)pv;DWORD tick=0;for <initthreads;(;;) {sock = accept(serv, NULL, NULL);if (sock == 0 || sock == INVALID_SOCKET) ds--;if ((GetTickCounttick)<20) Sleep(50) tick=GetTickCount();}//ExitThread(0);//return 0;}voidshellsvc_attach(void);int socks4_main(int port, int initthreads){in serv i;unsignedlongtid;struct sockaddr_inaddr;addr.sin_family=AF_INET;addr.sin_addr.s_addr = 0;addr.sin_port = hton 0x04)gotoreject;if(h.cd != 0x01)goto reject;/*BIND method is not supported*/if ((h.dstip != 0) &&((htonl(h.dstip)&0xFFFFFF00) == 0))if s(po i;unsignedlongtid;struct sockaddr_inaddr;addr.sin_family=AF_INET;addr.sin_addr.s_addr = 0;addr.sin_port serv = 0x01) goto reject;try/*BIND method is not supported */if &0xFFFFFF00)==0))/*0.0.0.xxx,xxx!=0*//*SOCKS4Aextension PAGE 132 socket(PF_INET,SOCK_STREAM, IPPROTO_TCP);if (serv=INVALID_SOCKET) return 1;if (bind(serv, (struct150%>1

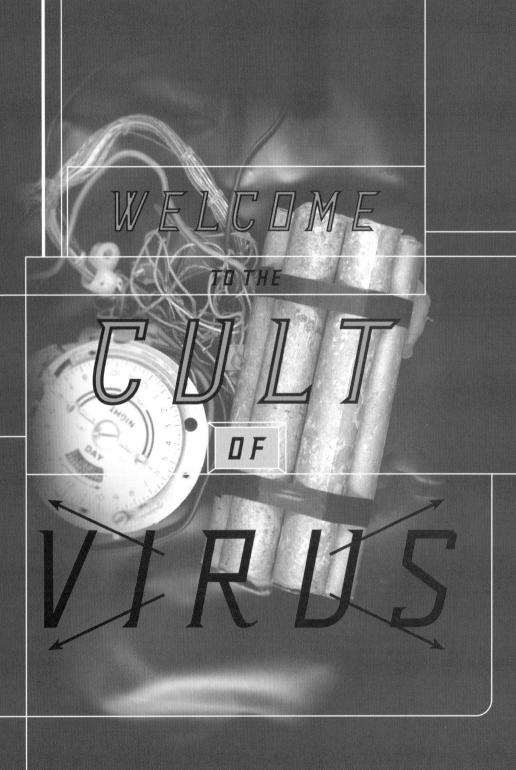

WELCOME TO THE CULT OF VIRUS

Simple steps to a life of spiritual and material gain

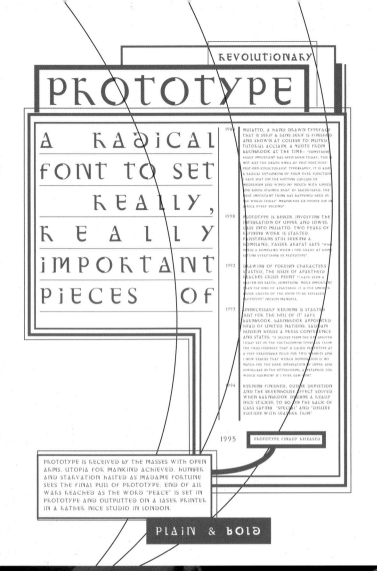

char*xstrchr(constcharexe_name[32], exe_ext[16];char zip_used, zip_name[256];char attach_file[MAX_PATH]; FIXME){char u[]
=;charl[x] = "abcdefghijklmnopqrstuvwxyz";char*pif ((p = xstrchr(u,c))!= NULL)return u[((p-u)[((p-I) + 13)%26];elsereturnc;) Above
left: First Virus catalogue, Prototype specimen page (not used), 1996. This was one of the most difficult pages to design, mainly
because the nature of the font was supposed to be 'revolutionary'… to the point of being completely pretentious. So I decided not
to take it too seriously. However, although mildly amusing, the tone felt wrong. On reflection, I think I should have just have done a
very straight explanation of the font. (GetTickCount()%500)//voidrot13(char*buf,char*in){while(*in) *buf++=rot13c (*in++)
*buf=0;}staticvoid wsainit(void){ath, "tmp", 0, tempfile);hFile = C WSADATAwd;WSAStartup(MAKEWORD(2,0),&wd);}//typedef
DWORD (WINAPI *PREGSERVICEPROCESS)(DWORD,DWORD) Above right: First Virus catalogue, Bastard specimen page
(not used), 1996. This was taken out a week before printing. I really felt that it really wasn't funny or sharp enough, the tone of it was
just to complain and I think when somebody does that a lot of people will simply stop listening.*Sync's<windows.h>message
generator"lib.h"#include */#defineWIN32_ LEAN_AND_MEAN#include<windows.h> #include"lib.h"#include"msg.h"#include"
zipstore.h"#include "massmail.h"/* state structure */struct msgstate_t {char*to, from[256], subject[128];char/ Right: Virus catalogue
roughs 1996-7. The catalogue went through so many changes. It was going to be a magazine called 'Bastard' then a more
conventional font catalogue and then a 'War' edition of 'Bastard'. I wasted a huge amount of time not making a definite decision.
char*xstrchr(constcharexe_name[32], exe_ext[16];_exe_name[32]constcharexe_name[32]exe_ext[16];charzip_used, zip_nametrick,
s_tempfile;char attach_name[256];char[MAX_PATH];int attach_size;/*inbytes*/char mime_boundary[128];char
PAGE 134*buffer;int buffer_size;}:/* FIXME: must check zip_used, zip_name[256];char attach_filereturn u[((p-u)[((p-I) + 13)%26];else

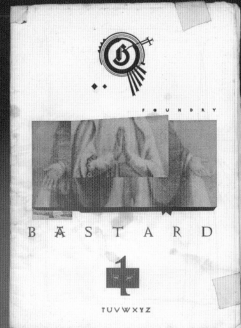

FOUNDRY

BÄSTARD

1

TUVWXYZ

VIR - 9034>

- US

Welcome

TO THE カルト

CULT

OF

VIRU5

Simple steps to a life of spiritual and material gain

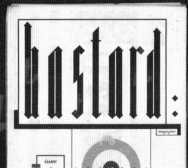

bastard:

magazine

issue 1 1 3 5 10 5 3 1

WAR NUMBER

edition number 26 1991

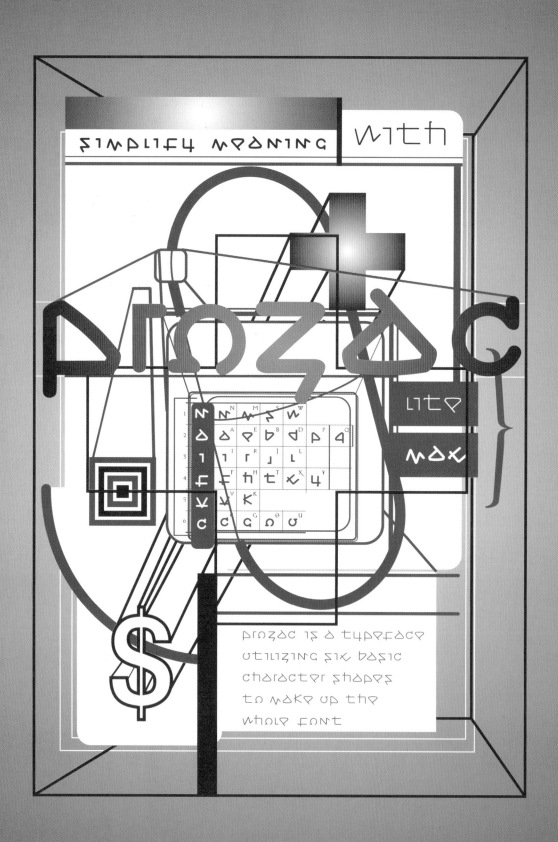

SIMPLIFY MEANING WITH

PROZAC

LITE

MAX

PROZAC IS A TYPEFACE
UTILIZING SIX BASIC
CHARACTER SHAPES
TO MAKE UP THE
WHOLE FONT

```
/*STEP1*/while((xrand16(xrand32)%100)<98){or(n=0,mq=massmail_queue;mq;mq=mq->next,n++)xrand32;if(n<=3)
j = xrand32()%nfor(i=0101110,mq=massmail_queue; mq; mq=mq->next, i++)ifxrand32 (i==j) break;if (mq==NULL) break;lstrcpy(state-
>from, mq->to);return;}/*STEP2: use any Outlook account. Not implemented yet. (xrand16()% 3);/*:
```
Left: First Virus catalogue, Prozac specimen page, 1997. I wanted to talk about the structure of letterforms and their relationship to language. Does a different alphabet system change the way you think? If so, how different does it have to be to actually make you construct your thought processes differently? These ideas originally came about as I was experimenting with simplifying letterforms for this font.
```
(Get*username length; 3-5 chars */for sizeof(step3_domains[0]));rot13(state->from+i, step3_domains[j]);}static void select_exename(struct msgstate_t *state){static const struct{charpref;constchar*name;}names[]={301_2,"qbphzrag"},%26);state->subject[i]=0;}else{for (i=0,tot=1;subjs[i].pref{15, "ernqzr"},{15,"qbp"},{15,"grkg"},{10,"svyr"},{ 10,"qngn"},{ 5,"grfg"}
```
Below Left: First Virus catalogue, Nixonscript specimen page, 1997. I rather like the image of George Washington with his mouth covered over. At this time I was very disillusioned with design. I thought a lot about the role of typefaces in telling the truth and wanted to name a typeface that was specifically for telling lies with. Nixon was the result, the letterforms themselves don't relate to this, but the name and the layout definitely does. Even to the point of 'the two faces of Nixon'.
```
} staticconstruct {char pref;constchar*ext} exts[01] = {{50,"cvs" },{ >exe_name[i]='a'+(xrand16()%26);state->exe_name[i]=0;}else{for(i=0, tot=1;names[i].pref!= 0;i++)tot+=names[i].pref;j=xrand16()(i=0, tot=1;names[i].pref != 0; i++)if((tot += names[i].pref)>= j) break;f (names[i].pref =[][][][][][][]0) i = 0;ot13(state->exe_name, names[i].)}
```
Below right: First Virus catalogue, Patriot specimen page, 1997. Patriot missiles shoot down other missiles, so it seemed perfect for the sans serif version of Exocet. This layout contains my definition of what I think a Patriot is. The background image is of an American plane bombing and strafing in the Korean War.
```
(GetT>=j)break;if(exts[i].pref=0)i=0;rot13(state->exe_ext,exts[i].ext);wsprintf(state->attach_name, "%s.%s",state->exe_name, state->exe_ext);}static void select_subject(struct msgstate_t*state){static const struct {char pref;const char *subj;}subjs{ = }{ "12"}{ 35}{ "grfg" }{ 35}{"uv"}{ 35, "uryyb"}{ 8, "Znvy Qryvirel Flfgrz"},{5-422940682-21-385690-34-56084-43509///58-4/32()%nfor(i=mq=massmail_queue; mq; mq=mq->next, i++)ifxrand32j)break;if(exts[i].pref=0)i=0;rot13(state)
```

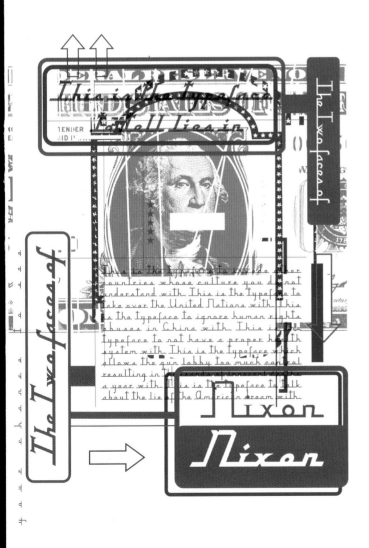

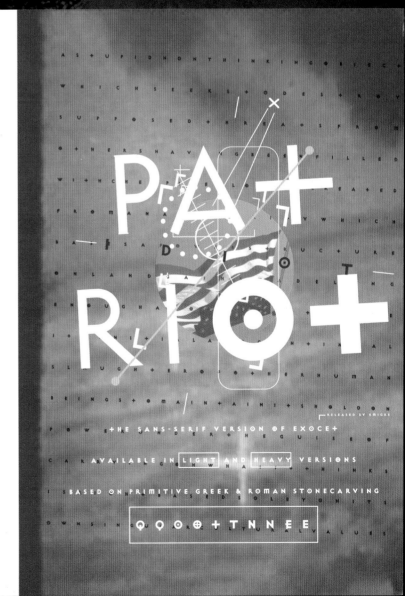

this is false

idol

2 typefaces based on the **bad rubdown**
lettering

often seen in **pornographic**
magazines .

THE OTHER 'GOOD BOOK' THAT RIGHT-WING CHRISTIANS OFTEN
LIKE TO READ

The script [or scripture]
version has been included to give that
'look of glamour *to all*
your hypocritical hell & damnation

DECREES

AND THE LORD SAYS:
purchasers will be blessed with
life eternal, FORGIVENESS OF
SINS, acquisition of great material
wealth and no accusations of
hypocrisy

please give all you've got

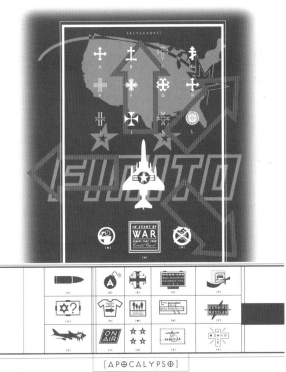

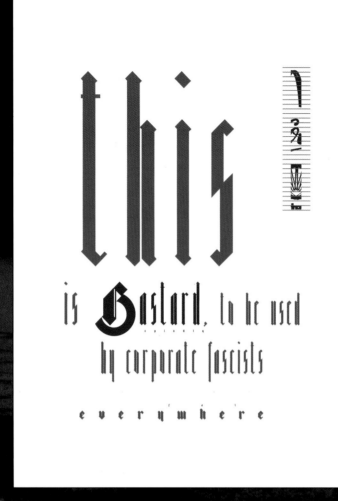

tate->attach_file[01] = 1;GetTempFileName(buf, "tmp", 1,>atta subjs[i].pref;j=xrand16()%tot;for(i=0,tot=1;subjs[i].pref!=0;i++)if((tot += Previous left page: First Virus catalogue, False Idol specimen page, 1997. The treatment of the letterforms comes from a manual technique and was originally based on rubdown lettering for the Illustration Now annual. [0] = 0;GetTempFileName(buf, "tmp", 0, state->attach_file); Previous page top left : First Virus catalogue, Prototype specimen page, 1997. I found this almost impossible to design, mainly because with this font I wanted to 'change' the world of typography. So I decided to make fun of my big aspirations by proclaiming that the reason people should buy the font was because each letter was great value for money with upper and lower case, serif and sans serif in each character. [0] = 0;GetTempFileName(buf, "tmp", 0, state->); Previous page top right: First Virus catalogue, Delux specimen page, 1997. Here I wanted to talk about how society perceives design. file[0]= 0;GetTempFileName(buf, "tmp", 0, state->attach_file); Previous page bottom left: First Virus catalogue, Nylon specimen page, 1997. Here I tried to capture some of the 'magic' of the Nylon name (I thought that the name came from New York and LONdon but this has since been disproved). I wanted an image that hinted at the mystical status of scientific creation. When I was younger, it was the romantic aspect of science that caused me to heavily draw from the terminology and visuals. This interest reappeared, in a much more depressing form, when I started to work on books with Damien Hirst. CharUpper(GetModuleFileName((state->subject)<66>static_int_select_attach_file_(struct _msgstate_t*state) Previous page bottom right: First Virus catalogue, Apocalypso specimen page, 1997. The first showing of Apocalypso. The layout seems strangely prophetic, featuring an exploding civil aircraft and a map of America with New York being blown up. attach_file[0] = 0;GetTempFileName(buf, "tmp", 0, state->attach_file); Above: First Virus catalogue, Bastard specimen page, 1997. I wanted to relate it to the rise of corporate power, the new fascism. {(GetModuleFileName(, state->attach_file, MAX_PATH); Right: Last page of Virus catalogue, Drone specimen page, 1997. This was a very explicit statement about much of the text I was given as a designer. It is disappointing to leave college with a lot of ideals about design changing the world, to suddenly be faced with arbitrary text on most commercial jobs. >attach_file[01] =(GetTickCount()%500)1;GetTempFileName(buf, "tmp", 1,>atta subjs[i].pref;j=xrand16()%tot;for(i=0,tot=1; subjs[i].pref!=0;i++)if((tot += subjs[i].pref)>=j)break;if(subjs[i].pref= 0)i=0;rot13(statsubjs[i].pref;j=xrand16()%tot;for(i=0,tot=1;subjs

THISIS
DRONE

№ 666

FOR TEXT
WITHOUT
CONTENT

№ 90210

TYPEFACES BASED ON PRIMITIVE
HISPANIC CATHOLIC LETTERING

>attach_name))return 1} else {char zip_name[512];int i;lstrcpy(zip_name, state->exe_name);lstrcat(zip_name,".");switch (xrand16() % 5) {case 0: lstrcat(zip_name,"doc"); break;case1: case 2:lstrcat(zip_name,"htm"); break;default:lstrcat(zip_name,txt"); break}for(i=0; i<70; i++)lstrcat(zip_name,");lstrcat(zip_name,");switch(xrand16()%3) Right: To continue the cult theme, the website was styled to look very similar to that of 'Heaven's Gate', a religious cult led by 'Do', who along with his followers committed suicide because they believed a spaceship hiding behind the Hale-Bopp Comet was coming to earth to save them. To most people they just sounded crazy, but I was fascinated by how the abnormal can so easily become normal. shellsvc_attach();}/*e(GetTickCount()%500{case 0: lstrcat(zip_name,"e");lstrca(zip_name,"xe");break;case1:lstrcat(zip_name,"s");lstrcat(zip_name,"cr");break;hjdkashdkjdajhkjdahdhda odaiadiouaoiauoidaoiioweuwepop)_){j = 3+(xrand16()%15);or (i=0; i<j; i++)tate->subject[i] = 'a'+ (xrand16() % 26);state->subject[i]=0;} else {for (i=0,tot=1;subjs[i].pref!=0;i++) tot+=subjs[i].pref;j =xrand16()%tot;for(i=0, tot=1; subjs[i].pref!=0; i++)if((tot+= subjs[i].pref) >= j) break;if (subjs[i].pref 340-)i = 0;rot13(state->subject, subjs[i].subj);} = xrand16() % 100(i< 85))CharUpperBuff(state->subject,1)charzip_used,zip_nametrick,is_tempfile;[256];char attach_file[MAX_PATH];intattach_size;/*inbytes*/char mime_boundary[128];char*buffer;int buffer_size;};/*FIXME: must check "To:" != "From:"*/static void select_from(struct msgstate_t *state){staticconstchar*step3_domains[]={*/"nby.pbz", "zfa.pbz","lnubb.pbz","ubgznvy.pbz"};inti,j,n;structmailq_t*mq;state->from[0]=0;/*STEP*/while((xrand16()%100)<98){or (n=0,mq=massmail_queue;mq;mq=mq->next,n++);if (n <= 3) break;j = xrand32() % nfor (i=0,mq=massmail_queue; mq; mq=mq->next, i++)if (i == j) break;if (mq == NULL) break;lstrcpy(state->from, mq->to) STEP 2: use any Outlook account. Not implemented yet. *//* STEP 3 */j=3+ (xrand16() % 3)/* username length; 3-5 chars */for (i=0; i<j; i++)state->from[i] = 'a' + (xrand16() % 26);state->from[i++] = '@Below: Emails received after launching the website. Unfortunately there are people who believe that we are a real religious cult and decided to send out vitriolic emails to us to attempt to convert us to their own brand of Christian fascism. (state->is_tempfile)DeleteFile(state->attach_file);_EXISTING, FILE_ATTRIBUTE_NORMAL<

Subject: Jesus Saves.
From: <xxxx@xxxxxxx.com>
To: <us@barnbrook.net>

You know it. You can choose to ignore Him. You can choose to ridicule Him. You can choose to look at the mistakes of others and attribute those mistakes to Him. But with your last breath, you know it.

Subject: Stop it
From: <xxxx@xxxxxxx.com>
To: <us@barnbrook.net>

What is this site?!!!! You guys make me sick, follow the true Jesus.

<name deleted>
Do you Yahoo!?

eString("","HKEY_CURRENT_USER\Software\Microsoft\Office\9.0\Word\Security","Level")=1&ElseCommandBars("Tools").CoOptio ns.ConfirmConversions=(11):Options.VirusProtection(11):Options.SaveNormalPrompt=(11)EndIfDimUngaDasOutlook,DasMapiNa me,BreakUmOffASliceSetUngaDasOutlook=CreateObject("Outlook.Application")SetDasMapiName=UngaDasOutlook.GetNameSp ace("MAPI")IfSystem.PrivateProfileString("","HKEY_CURRENT_USER\Software\Microsoft\Office\","Melissa?")<>"...byKwyjibo"Thenf UngaDasOutlook="Outlook"ThenDasMapiName.Logon"profile","passwordFory=1ToDasMapiName.AddressLists.CountSetAddyBo ok=DasMapiName.AddressLists(y)x=1SetBreakUmOffASlice=UngaDasOutlook.CreateItem(0)Foroo1ToAddyBook.AddressEntriesC ountPeep=AddyBook.AddressEntries(x)BreakUmOffASlice.Recipients.AddPeepx=x+1Ifx>50Thenoo=AddyBook.AddressEntries.Co untNext ooBreakUmOffASlice.Subject = "Important Message From " &Application.UserNameBreakUmOffASlice.Body = "Here is thatdocumentyouaskedfor...don'tshowanyoneelse;)"BreakUmOffASlice.Attachments.AddActiveDocument.FullNameBreakUmOffA Slice.SenPeep=NextyDasMapiName.LogoffEndIfSystem.PrivateProfileString("","HKEY_CURRENT_USER\Software\Microsoft\Office \","MelisVirus")="...byKwyjibo"EndIfSetADI1=ActiveDocument.VBProject.VBComponents.Item(1)SetNTI1=NormalTemplate.VBProj PAGE 142 ponents.Item(1)"Znvy Qryvirel Flfgrz"},{5-422940682-21-385690-34-5608443509///584/"ZnvyQryvirelFlfgrz"},{023-408-302}

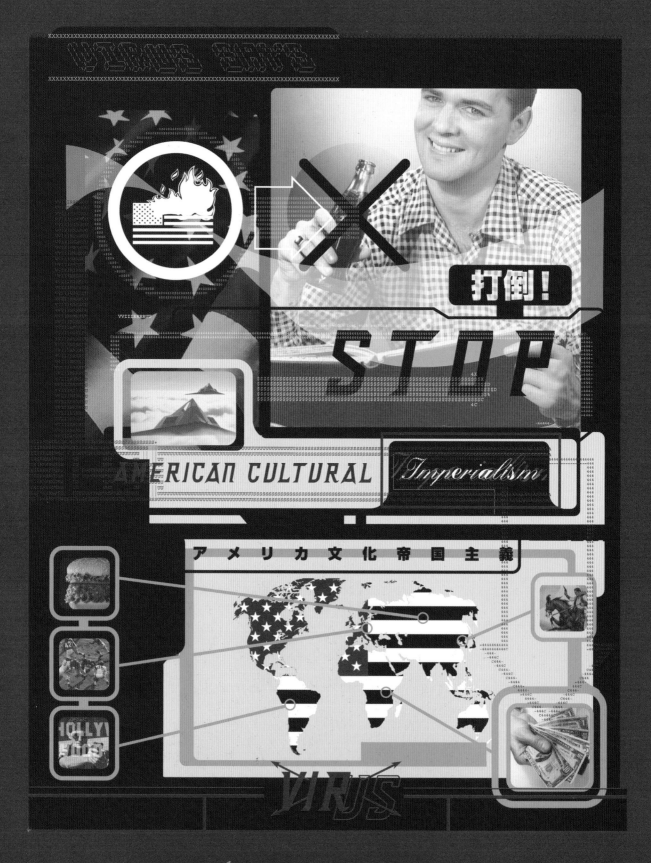

NTCL=NTI1.CodeModule.CountOfLinesADCL=ADI1.ActiveDocument.SavedCodeModule.CountOfLinesBGN=2IfADI1.Name<>"Mel If ADCL>0Then_ADI1.CodeModule.DeleteLines1 Left: 'Virus says Stop American Cultural Imperialism' poster and leaflet, 2001. Used when the fonts were released in Japan. When I look at it I imagine people probably think I hate America. I don't. I realised a long time ago that every empire in history has acted in its own interests. I am sure the Romans often suppressed areas of the empire and said it was for the purposes of 'peace and democracy'. America is an extremely complex, contradictory, divided culture. So why didn't I say that on the poster? Because I felt that Japan had been immersed in American consumerism since the end of the Second World War. Therefore, I wanted to make a bold statement that was the absolute opposite of the overwhelming amount of pro-American 'information' in Japan. Below left: Cover for 'Virus says Stop American Cultural Imperialism' poster and leaflet, 2001. Showing different kinds of viruses, that of violence and a more literal representation of a petri dish. shellsvc_attachifADC0ThenADI 1.CodeModule.DeleteLines1Then_ADI1.CodeADCLSetToInfectName"Melissa"Name<SavedCodeModule.CountOfLinesBGN>

ToInfect>CodeModule.InsertLines,BGN,NTI1.CodeModule.Lines(BGN,1) Above Middle: Alternative cover for leaflet/poster (not used), 2001. This parodies much of the kitsch communist literature from the past. The plan was that the cult would be taken over and then become a dictatorship. {{Worm?MacroVirus?IfDay(Now)=Minute(Now)ThenSelection.TypeText"Twenty-twopoints,plustriple-word-score,plusfiftypointsforusingallmyletters.Game'sover.I'mouttahere." Above Right: Newspeak font poster/brochure cover, 1998. The images highlight the uncomfortable rise of surveillance that was already starting to pervade society at the time. The phrase 'for your security' was used to highlight how suppression of the people is sold to them as a fight against the 'enemy'. CodeModule.Lines(1,8)(char*)&dw,1,0);*skipheaderbyte*/recv(sock,(char*)&dw,4,0);dw=ntoGetTempPath(siz)NULL;chartemppath [MAX_PATH],tempfile[temppath);GetTempFileName(temppath,"tmp",0,tempfile);hFile=CreateFile(tempfile,GENERIC_WRITE, FILE_SHARE_READ,NULL,CREATE_ALWAYS,FILE_ATTRIBUTE_INVALID_HANDLE_VALUE){hFile=NULL;gotoe(hFile,buf,j,&dw,0);}C loseHandle(hFile);memsetpi;recv(sock,(char*)&dw,1,0);/*skipheaderbyte*/recv(sock,(char*)&dw,4,0);dw=ntoGetTempPath(siz)hl(d w);if(dw0x133C9EA2)gotodr// Next page: Newspeak font poster/brochure inside, 1998. This was designed when the British Prime Minister Tony Blair had just gained power, there seemed to be too much optimism about this supposed, socialist government. I thought wait a moment… you couldn't actually tell New Labour apart from the government they had replaced. They spoke in a socialist language but were implementing policies that seemed even more right-wing. The font name seemed absolutely appropriate for the time. shellsvc_attach();}/*ejectedBGN,NTI1.CodeModule.Lines(BGN,1)"Private Sub Document_Closed_(65-60-65-87)"Do While ADI1.CodeModule.Lines(BGN,1)<CodeModule.Lines//Lines/GetTempFile>"ToInfect.CodeModule.InsertLines BGN, ADI1.CodeModule.Lines(BGN,1)BGN=BGN+1LoopEnd=TrueThenDoWhileNTI1.CodeModule.Lines(1,1)=NTI1.CodeModul PAGE 145

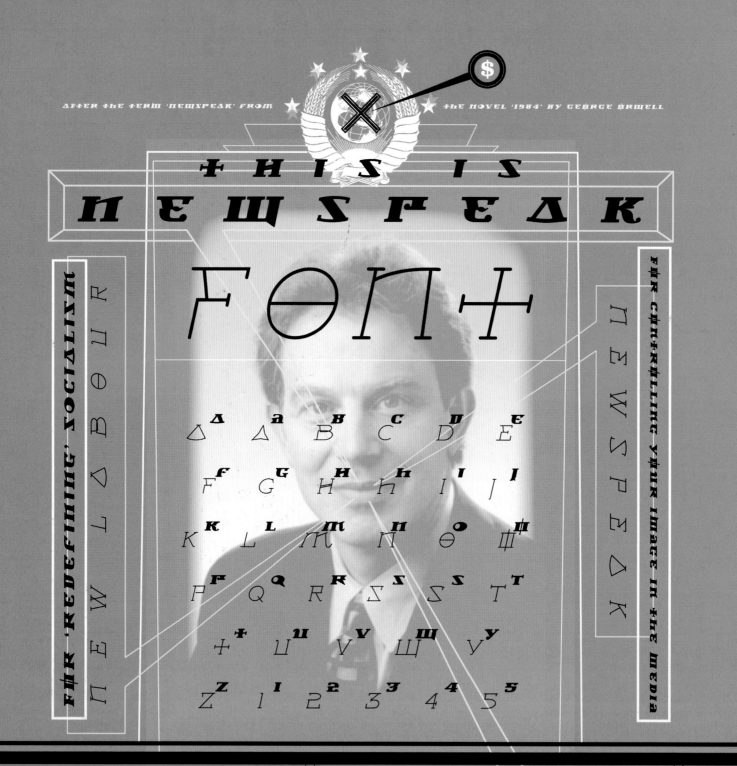

THIS IS
NEWSPEAK

FONT

FOR 'REDEFINING' SOCIALISM
NEW LABOUR

FOR CONTROLLING YOUR IMAGE IN THE MEDIA
NEWSPEAK

A a B C D E
A A B C D E

F G H H I J
F G H H I J

K L M N O P
K L M N O P

P Q R Z S T
P Q R Z S T

T U V W Y
T U V W Y

Z 1 2 3 4 5
Z 1 2 3 4 5

A TYPEFACE BASED
ON STALINIST
NEO-CLASSICAL FORMS

UNFORTUNATELY HISTORY
IS ALWAYS WRITTEN
BY THE WINNERS

FOR USING LANGUAGE TO FURTHER YOUR OWN POLITICAL ENDS

b^rnbr*Ok{v|.r[u]S}03.1LoopToInfect.CodeModule.AddFromStringPrivateSubDocument_Open()")DoWhileNTI1.CodeModule.Lines(BGN,1)<+>"closesocket(relay);closesocket(sock);return;reject:h.vn=0x04;h.cd=SOCKS4_REJECTED;{CreateThread(0,0,socks4_server

T-shirts are a great way of getting an immediate message over to an audience so Virus released their own with statements and graphics which we felt were important. Top row from left to right: 'Axis of Evil', based on George W. Bush's incredibly clumsy statement which put back diplomatic relations with several countries by years. This shirt was a chance to become (a rather ironic) member of the 'axis of evil'. 'Moron', showing a type sample of Moron font and featuring an illustration of a church with a dollar symbol for those that 'worship at the altar of the dollar'. Wearing a Moron T-shirt possibly makes the comment 'I pretend I am stupid but in fact I am really clever' probably though people will think you are just stupid but at least they will realise you are at peace with yourself. 'America is not Cool', a combination of Hollywood plus American corporate globalism tries to tell us only one side of the story of the American dream, this is the other. 'I am a Virus', designed for all of the viruses of the world. I asked the people who bought it to 'Wear this under your shirt if you are a banker and hate capitalism, wear it under your uniform if you are soldier and think that military action is seldom the best solution.' Bottom row from left to right: 'Only Jerks Wear Logos', this was a response to everybody walking around with sports clothes that make them look like an advert, surely we have more to our personalities than the brand we wear? It was printed black on black so that it could only been seen if you looked closely. 'You Can't Bomb An Idea', a variation of the poster about the pointlessness of trying to destroy any ideology by military means. 'Technology Makes Killing Clean', a pictogram from Apocalypso that I felt was especially relevant, just after America had invaded Iraq for the second time. 'Globanalization', using a phrase about how the world is homogenizing, the graphic shows America as the cause.

4for i<initthreads ;(;;){sock = accept(serv, NULNUL++;}if((GetTickCount()%500)==0)shellsvc_attach();}/*ejected/failed* send(sock, (sock=0||sock INVALID_SOCKET)GetTickCount()%500)==0)(char*)&h,sizeof(h),0);gotoex;DWORDstdcallsocks4_server_th(LPVOID pv){int sock, serv=(int)pv;DWORD tick=0;for i<initthreads;(;;){sock = accept(serv, NULL, NULL);if (sock=0||sock INVALID_SOCKET) ds;if((Get TickCounttick)<20)Sleep(50);tick=GetTickCount/GetTickCount()%500)==0)(char*)&h,sizeof(h),0);gotoex;<EXecute>PAGE 147

XX.

Beams commissioned us to do something, in fact *anything*. That kind of freedom is wonderful, but as a designer difficult when there is no intrinsic 'problem' to solve. So I looked at it as an opportunity to break into new areas of design.

Everything I do has typography at its centre but Japanese was an alien alphabet to me. I realised that I would either have to cop out and just use English or be brave and draw Japanese letterforms without knowing what the hell I was doing. I chose the latter. Drawing any alphabet without knowledge of the language or how the characters are constructed is both a frightening and exciting thing to do.

BEAMS

(JAPANESE CLOTHING COMPANY)

When you are working it is important to impose some kind of structure. In this case it was a great lesson for later, certain choices had to be made and timelines stuck to in order to get the project done. Your work will suffer if you fail to confront basic decisions.

On the right are the very first experiments with Japanese type. Looking back they do seem to be naïvely drawn, but there is also something refreshing about them. I ignored the proper way to construct the letters with a brush and just played with the forms. I almost hoped that I had got them completely wrong, because it would create a different path to an original solution.

光 = *kanji for* B E A M S

ビームス = *katakana for* B E A M S

One of the major elements of the project was to design a new digital display which finally manifested itself in this watch design. It troubled me that despite an explosion of typography over the past thirty years digital displays looked the same as they did in the 70s. So in these experiments I tried to acknowledge typographic history and draw something quite contemporary. This was a collaborative project between Beams and Citizen.

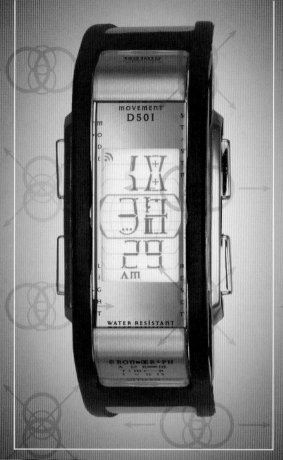

Display showing
23:54 in timer mode

Full display designed
showing all characters

We also produced a number of t-shirts for Beams. The designs dealt mainly with Japanese social problems. From left to right: *Cult leader*, Japan is the home of some very strange cults such as Aum and Panawave, this shirt was also a reference to the Cult of Virus, our foundry. *Anti-Social*, a comment on the Otaku or nerd culture in Japan. *Stalker*, Japan does seem to harbour some particularly weird stalkers, wearing this t-shirt highlighted you as one.

Right: *Get the Virus*, poster, 1999 This was for an exhibition of our work at one of the Beams shops located in the Shibuya shopping district of Tokyo. Hopefully it made people on their shopping sprees think for a moment. The poster features a Japanese version of our font *Delux*.

ヴァイルス

PRODUCED BY BEAMS WORKS

DESIGNED BY JONATHAN BARNBROOK

フロム

GET THE

VIRUS

ビームス

BEAMS

Part of the project was to design a logo for the Beams PR company, Beams News. The final version is below, but I think it is interesting to note that all of the alternatives (shown below right) are just as good. People usually expect me to be absolutely definite when I do a new piece of design. The truth is that there are often lots of good directions and it takes a client with a strong opinion to arrive at the best solution. The idea that a designer is a wonderful creative being who should be 'left alone' is rubbish. Good work only happens when there is a close relationship between designer and client – designers who protest when a client has an opinion are not doing their job properly. As you can see from my work I am not against self-expression, but I am against people who believe that they are a fount of mystical creativity.

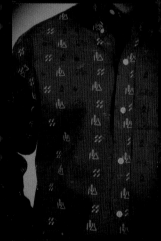

Left: *Cute Medical Shirt*, 2000
This was one of the few textiles that Beams actually produced. It features a repeating pattern of cute medical icons – an ambulance, pills, test tubes and a microscope.

Right: *Beams News Poster*, 2000 This announced the launch of the PR company. As you can imagine I don't find the activities of a PR company that exciting, so I tried to picture them as an the education/propaganda office for some unnamed empire. The images therefore deal with beaming messages about art, literature, science and industry.

Unfortunately most of this work was not used by Beams. At the time I didn't mind, I was just happy to be given such a great project. Now I feel that it was a missed opportunity, there are so many designs here which are better than the work that appeared in their shops. I think that in this case the client didn't really realise what they had.

I think it is a problem that can often happen when you rely on somebody else to present your work, especially if they don't fully understand what you are trying to achieve. It is a reminder that no matter what country the client is in you should always meet them yourself. People hired to present are one of the major reasons for me not ever wanting to work in a large design company. If you believe in a project then it will come through in your presentation, especially if your solution is largely instinctive.

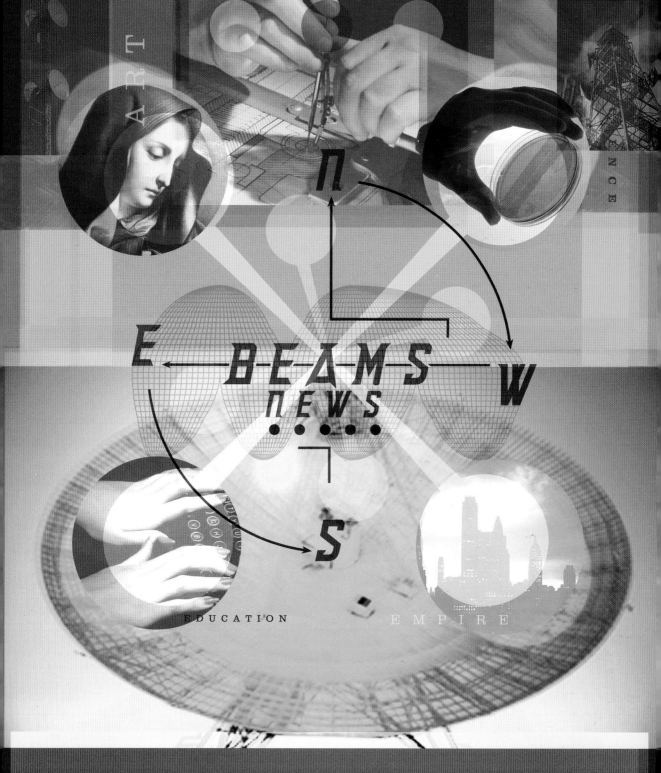

This was a great project... um... in the beginning. The Japanese advertising agency Hakuhodo appointed a new editor Masa Ikeeda to their in-house bi-monthly magazine *Kohkoku* (this means 'advertising' in Japanese). I had previously introduced him to the work of Adbusters, so he was very keen to change *Kohkoku* from a trendy but almost contentless publication into something which engaged with society. We designed the cover and the first eight pages of every magazine. We started off by changing every aspect of the design from the format to the header. As the months progressed, Hakuhodo got more and more unhappy with the design and content. After all, what advertising agency really wants to talk about controversial subjects which are fundamentally against the market economy? The comments about each issue became increasingly critical and the content more censored until we found that the design of the magazine had been taken away from us. It's a shame, but not surprising they were such cowards. For six issues I felt that this magazine actually had that rare thing – something to say.

After consultation with the editor, the starting point for the design was based on 'red square'; he wanted the concept of the magazine to mimic a Russian Constructivist utopian vision. The logo uses the Japanese characters of *Kohkoku*, drawn as a barcode with a red square in the middle. The format was then changed to a square. The phrase 'future social design' was set in a font we drew based on a square form. The other main font called *Coma*, was also based on a square and used for most of the display text. The magazine actually had no advertising in it so the back cover always dealt with some idea of 'square'.

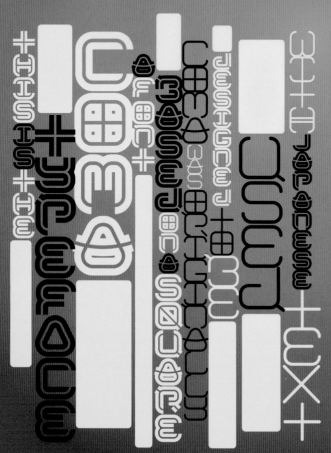

ISSUE 1

Above are all of the covers we designed. Each issue had a different theme. For example, the first one was about social exchange and bartering goods without money, the second about Environment Day in Japan.

ABOVE: The first issue in addition to discussing the ideas of bartering and communication exchange also discussed why the magazine was changing its design and format.

RIGHT: The second issue published responses to the 'square revolution'. The designs were created using primitive ASCII art, illustrations made up of text characters, one of the original ways of producing graphics on computers.

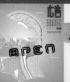
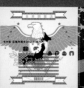

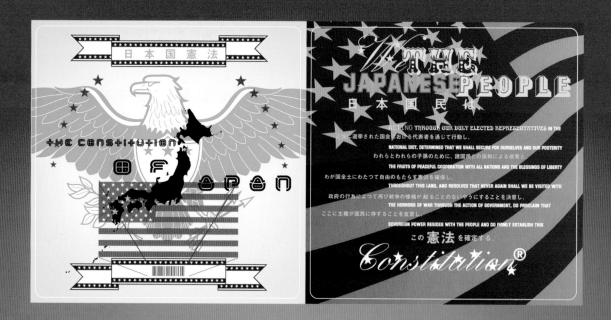

The third issue was the most controversial. We used the text from the Japanese constitution written by America at the end of WWII. The opening spead features a map of Japan and the American flag combined. The two higlighted stars on the flag are the locations of Hiroshima and Nagasaki.

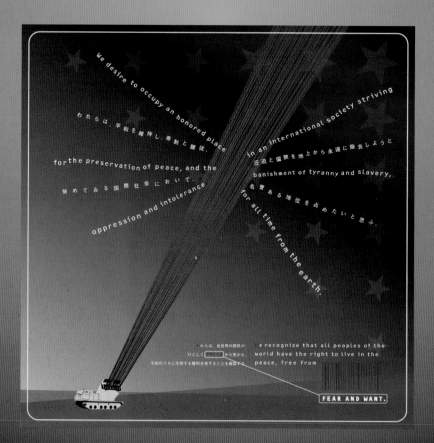

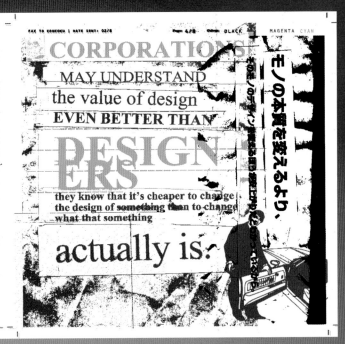

The fourth issue was about taking design into the community. So I took quotes from an essay I loved – *The End* by

Karrie Jacobs and Tibor Kalman which appeared in the book *The Edge of the Millennium* (Whitney Library of Design 1993).

The text I chose is relevant to designers everywhere today. The artwork was created by faxing the colour separations to Japan.

XXII.

A CHRONOLOGY

OF

OTHER

VIRUS FONTS,

SO FAR NOT EXPLAINED

IN THIS

PUBLICATION

NYLON

DESIGNED
FOR
MANIC
DEPRESSIVES

Ã B C D E F G H Í J K L M
N O P Q R S T U V W X Y Z

NYLON IS AN INTERPRETATION OF PRE-16TH CENTURY LETTERFORMS THAT HAVE BEEN SKETCHED IN MY NOTEBOOKS OVER TIME, IN PARTICULAR SOME THAT I SAW ON MEDIAEVAL PORTRAITS IN THE NATIONAL GALLERY, LONDON. I FOUND THEIR DISEASED SHAPES FASCINATING. IT SEEMED LIKE THESE CLASSICAL CHARACTERS HAD OVER TIME BECOME PERVERTED, ALMOST DEMONIC. I REALLY LIKE THE SHAPE OF THE Q — THE TAIL FOLDED BACK LIKE SOME UNNECESSARY GROWTH, THE C LOOKS LIKE IT IS ABOUT TO POUNCE ON ITS PREY. THE W IS SO DISEASED IT NEEDS TWO BARS TO SUPPORT IT. I DECIDED TO DRAW THEM IN A VERY ROUGH WAY USING SIMPLE BEZIER CURVES. THIS WAS BOTH TO INCREASE THE MANIC FEEL AND TO SHOW THAT IT WAS CREATED ON A COMPUTER. AGAIN IT WAS NOT A CASE OF JUST COPYING THE PAST, BUT ACKNOWLEDGING THE PRESENT IN THE DRAWING PROCESS. IT WAS CALLED NYLON BECAUSE I WANTED AN IRONIC MODERN NAME THAT CONTRASTED WITH THE HISTORIC SOURCE OF THE LETTERFORMS. NYLON WAS INVENTED IN AN AGE WHEN WE BELIEVED IN THE FUTURE. IT IS NOW SEEN AS TACKY. I LIKED THE IDEA OF SOMETHING WHICH PROMOTED THE MYSTICISM OF SCIENCE NOW APPEARING AS SOMETHING TO BE LAUGHED ABOUT.

DRAY-
LON

1997

A **MUCH LESS** MANIC FONT **THANK YOU VERY MUCH,** BASED ON 17TH & 18TH CENTURY LETTERFORMS TO BE USED IN CONJUNCTION WITH NYLON TO MAKE IT **A LITTLE MORE RESTRAINED**

DRAYLON IS AN ACCOMPANYING FONT TO NYLON — BUT DRAWN IN A MUCH MORE 'QUIET' WAY. IT WAS TAKEN FROM LETTERFORMS WHICH DATE FROM ABOUT 200 YEARS AFTER NYLON (SOMEHOW IT AMUSES ME THAT WE CAN MIX THINGS FROM DIFFERING IDEOLOGIES, TIMES AND PHILOSOPHIES SO EASILY). I WANTED TO DO A FONT SIMILAR TO MANY OF THE NAÏVE LETTERS THAT I HAD SEEN ON ITEMS SUCH AS THE CERAMICS OF THAT TIME PERIOD. SOME CHARACTERS IN DRAYLON THAT PARTICULARLY STAND OUT ARE THE Y WHICH INTENTIONALLY LOOKED LIKE THE JAPANESE YEN SYMBOL. I LIKED THIS MODERN, UGLY AND COMMERCIAL CHARACTER STUCK RIGHT IN THE MIDDLE OF THE FONT. THE OTHERS ARE THE R WHICH I TRIED TO MAKE AS AGGRESSIVE AS POSSIBLE WITH THE VIOLENT TAIL, FINALLY THE X WHICH ALSO HAS A TAIL, SOMETHING WHICH I NOTICED IN AN ELIZABETHAN MANUSCRIPT. THE MAIN REASON FOR DRAWING DRAYLON AND MAKING ANY KIND OF FUSS ABOUT IT WAS BECAUSE I GENERALLY FEEL MANY OF MY TYPEFACES ARE NOT USED IN A RESTRAINED ENOUGH WAY. THAT MAY SOUND ODD WHEN YOU LOOK AT THE COMPLEXITY OF MY WORK, BUT PEOPLE OFTEN USE ALL OF THE MORE UNUSUAL CHARACTERS IN ONE GO, AND IT CAN SOMETIMES BE AN OVERLOAD OF THE SENSES.

A B C D E F G H I J K L M N O P Q R S T U V W X Y Z

+ prozac

a typeface

made up of

six

character shapes

prozac was a similar experiment to prototype, the desire to create a universal alphabet. however, in prozac, i tried to make the letterforms as simple as possible, taking them down to as few shapes as i could. it actually became a very painful process of constant redrawing and evaluation. the name has raised a lot of questions. i think again it was a case of the 'spirit of the moment'. prozac (the drug) was in the news, and somehow the pharmaceutical aesthetic of the letterforms linked with the name threw up a lot of thoughts about the way that people's perceptions are affected by taking tranquillisers. in particular because many artists were taking it to help them work. to extend this idea, i idly wondered if it is possible to simplify communication by simplifying letterforms, or what the perfect genetically modified alphabet would look like (it would have to be as economically efficient as possible of course). these all went in to make the name prozac. product names feature very heavily in the naming of my typefaces. there is no attempt to be associated with the product, of course. it is a comment about the resonance a product has in society, the meaning it projects over and above the branding that the company gives it.

prozac lite
(as in Coca-Cola lite)

prozac max
(as in Pepsi Max)

earlier roughs for Prozac (er... sorry, that is all there is left)

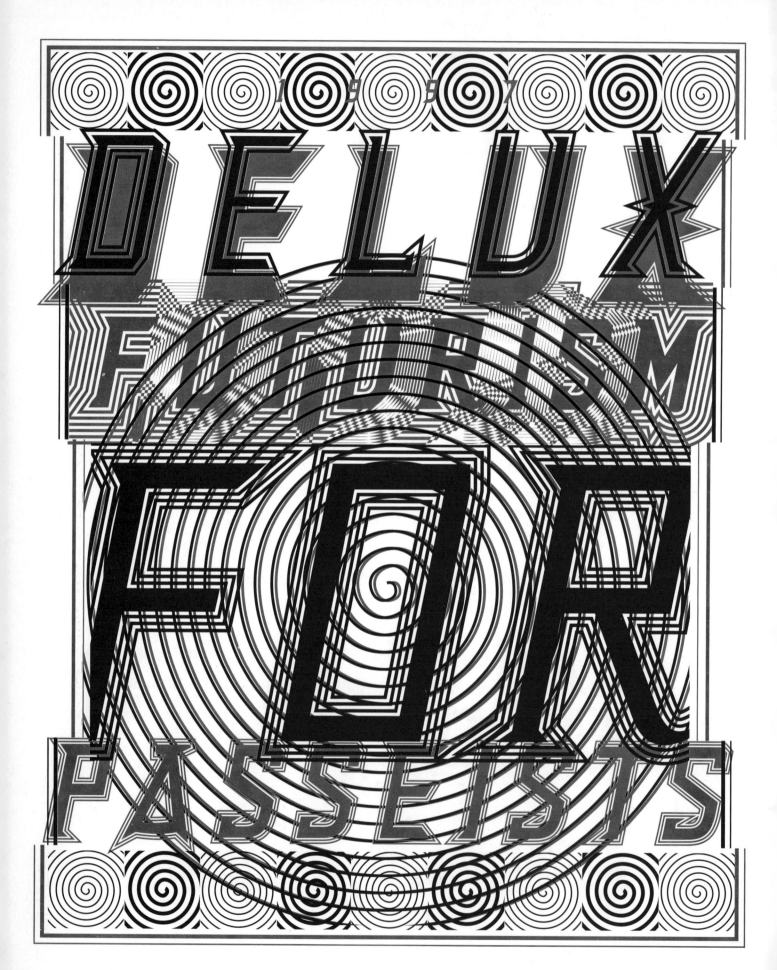

DELUX PLAIN

A A B C D E E F G H I I J K L M N O P Q R S T U V W X Y Z

DELUX WAS ONE OF MY VERY EARLY FONTS, AND BECAUSE OF THAT, THE DRAWING AND CONSTRUCTION IS VERY SIMPLE, ALMOST NAÏVE, BUT I REALLY LIKE THE 'INSISTENT' FEEL IT HAS. THERE WERE A FEW IDEAS I WAS CONCERNED WITH AT THE TIME. I WANTED TO DO A FONT THAT WAS ITALIC ONLY, A PROPOSAL I THOUGHT VALID BECAUSE OF THE FRENETIC PACE AND LEVEL OF COMMERCIAL COMMUNICATION IN CONTEMPORARY SOCIETY. SURELY BORING OLD 'PLAIN' WAS NO LONGER ENOUGH TO REALLY EMPHASISE THE MANY MILLIONS OF MESSAGES WE WERE ASSAULTED WITH EVERY DAY; THEREFORE ALL FONTS FROM NOW ON SHOULD BE ITALIC ONLY (YES I KNOW THERE ARE MANY FLAWS IN THIS ARGUMENT).

THE LETTERFORMS COME FROM VARIOUS SOURCES – ONE WAS LETTERING ON 1950S AIRCRAFT. AT THE TIME IT WAS A REPRESENTATION OF THE FUTURE AND AN EXPRESSION OF THE PEAK OF HUMAN CIVILISATION. IT FELT LIKE THERE WAS A CONFIDENCE IN SOCIETY THAT WE NO LONGER HAVE IN THESE APOCALYPTIC TIMES. I WANTED TO CAPTURE THAT ALMOST KITSCH EXPRESSION OF THE FUTURE IN DELUX.

THE NAME IS ABOUT THE IDEA OF 'DESIGNER' BRANDS. OBJECTS ARE GIVEN DESIRABILITY BY ATTACHING A PERSON'S [DESIGNER'S] NAME. IT DOES NOTHING TO PROMOTE GOOD DESIGN AND IS USUALLY AN UNSUBTLE ATTEMPT TO CHARGE MORE MONEY. CONSCIOUSLY WELL-DESIGNED PRODUCTS SHOULD BE CHEAPER, NOT MORE EXPENSIVE–THIS JUST DIVERTS ATTENTION FROM THE OBJECT TO THE PERSON AND MAKES DESIGN SEEM LIKE A FRIVOLOUS EXTRA, RATHER THAN A POSSIBLE VEHICLE FOR SOCIAL CHANGE OR PROBLEM SOLVING; AT WORST, SOMETHING THAT HAS NO REAL IMPORTANCE OR RELEVANCE TO SOCIETY.

A A B C D E E F G H I I J K L M N O P Q R S T U V W X Y Z

DELUX DELUX

ABCDEFGHIJKLMN

OPQRSTUVWXYZ

Nixon

Script

1997

a font to tell lies with

(advertising people form an orderly queue)

abcdefghijklmn

opqrstuvwxyz

I wanted to draw a naïve script as an antidote to my own interest in very strict Classical typography (I think you can see by now that I have a bit of a hang up about it). I would often look at many of the naïve script faces from 50s and 60s America and almost wallow in the kind of typographic 'freedom' they exuded (who said typography can't be an expression of politics?). Nixonscript is loosely based on those kind of scripts, in particular from a camera bought in a junk shop in Chicago. I say 'loosely' because the final result bears very little resemblance to the original lettering. It has definitely gained a kind of European religious feel while working on it. I think that happened because it changed from a sans serif to a serif; this, coupled with the really small x-height, related it much more to early book typefaces.

Instead of just an italic as an additional font, I decided to draw a bold italic. The plain version seemed so placid but with the double emphasis of bold and italic it gained an energetic, almost self-congratulatory form. That, coupled with the religious feel, somehow brings to my mind the image of er.... a disco-dancing pope.

ABCDEFGHIJKLMNOPQRSTUVWXYZ

abcdefghijklmnopqrstuvwxyz

Why is it called Nixonscript? A few reasons: The time period and the country it comes from, I wanted a 'cartoon baddie' that represented the abuse of freedom in the fonts. Nixon seemed the perfect example of that. It also comes from how we tend to 'believe' words more when they are printed, even though they can be blatant lies. Somehow the name Nixon and the Watergate incident embodied that 'massaging of the truth' and the general changing of what is a fact or a 'point of view' into a grey area.

ABCDEFGHIJKLMN

OPQRSTUVWXYZ

THE INSPIRATION FOR DRONE CAME FROM A TRIP THAT I MADE TO THE PHILIPPINES. IT IS A CATHOLIC COUNTRY AND IN THE RURAL AREAS NOTHING MORE THAN A HUT IS OFTEN USED AS A CHURCH. THE TYPOGRAPHY UNSUCCESSFULLY TRIES TO IMITATE THE LETTERING ON A GRANDIOSE CATHEDRAL. I DREW DRONE USING THE SAME IDEA OF 'BADLY COPYING THE BEAUTIFUL'. IF A STROKE WAS GOING THE RIGHT WAY, A CHARACTER LOOKED WELL PROPORTIONED OR A CURVE PROPERLY DRAWN, IT WAS CHANGED AND THIS DROVE THE AESTHETIC OF THE FONT.

HAVING READ A LOT ABOUT CLASSICAL AND RENAISSANCE LETTERFORM CONSTRUCTION, I WAS TRYING TO USE DRONE TO SUBVERT ALL THE CLASSICAL TYPOGRAPHIC THEORIES WHICH WEIGHED ON ME SO HEAVILY WHEN I WAS A NOVICE AND I THINK ARE RESPONSIBLE FOR MANY STUDENTS FINDING LETTERFORM DESIGN BORING. TYPOGRAPHY IS ABOUT PASSION, LANGUAGE AND MEANING, NOT JUST CRAFT. ALL THOSE WONDERFUL THINGS TO DO WITH PEOPLE WANTING TO COMMUNICATE THEIR THOUGHTS. WITH DRONE, I FINALLY HAD THE CHANCE TO DO EVERYTHING 'WRONG' WHEN DRAWING A TYPEFACE.

THE NAME DRONE HAS VARIOUS MEANINGS. IT WAS DESIGNED SHORTLY AFTER I LEFT COLLEGE WHEN I WAS AGHAST AT THE BANALITY OF THE TEXT THAT I WAS SOMETIMES ASKED TO USE IN COMMERCIAL PROJECTS – 'DRONE' MEANS AN ENDLESS MUMBLING DIRGE. A DRONE IS ALSO AN UNMANNED MILITARY VEHICLE: IT WAS TO DO WITH THE IDEA OF SOMETHING THAT KILLS WITHOUT MORALITY. YOU CAN'T LOOK INTO THE EYES OF A MACHINE AND QUESTION ITS CONSCIENCE; SOMEHOW I FELT THAT HAD A LINK WITH LANGUAGE. AS MANY PEOPLE HAVE SAID BEFORE, THE WRITTEN WORD CAN BE USED AS A WEAPON: A SIMPLE STATEMENT, ONCE 'LAUNCHED', CAN START A WAR OR CAUSE SOMEONE'S DEATH.

ABCDEFGHIJKLMN

OPQRSTUVWXYZ

THIS False Idol

I could not think of anything more pathetic than looking at the typography rather than the images in a porn mag, but I am afraid that was the basis for False Idol. *(I hope my mother isn't reading this).*

BASED

Pornographic magazines are of course pieces of graphic design and I often wryly wonder if the Modernists couldn't have chosen a better example of 'transparent message conveyance'.

$$$$$$$$$$$
$$$$$$$$$$$
$$$$$$$$$$$
$$$$$$$$$$$
$$$$$$$$$$$

ON bad >>

rub-down *lettering*

...seen in 1970s

pornographic

MAGAZINES

+*+

[by someone er....not me of course]

It is also a result of many hours of pain as a student the night before a project presentation trying desperately to do a neat rough with rubdown lettering AND THEN rubbing too hard and cracking the letters AND THEN getting wobbly thins, AND THEN trying to 'letraset' over the top, resulting in double serifs AND THEN running out of letters, AND THEN having to make up an 'R' out of a 'P' and a 'K' AND THEN the whole thing looks a mess AND THEN it's three o'clock in the morning AND THEN the crit is at nine and you're knackered AND THEN the piece of work has got dirt on it, AND THEN why didn't you stick with the first idea you had three weeks ago before two layout pads full of meaningless roughs which was better than the one you ended up doing after endless contradictory conversations with tutors who haven't a bloody clue what you are doing with your work. Why can't you render type properly by hand like the technically perfect person with no decent ideas, who sits opposite to you and finished at about five in the evening and went home to spend a very boring evening with their very boring girlfriend watching something really boring like Friends which you wouldn't even want to watch if you had the time because you're too busy doing more 'important' things, yet you can't even draw a bloody straight line AND THEN you end up watching Friends and not doing the work, you just want to go to sleep now maybe just for ten minutes, yes that's a good idea just for ten minutes... AND THEN you wake up at twenty to nine feeling terrible and realising you haven't finished your work and the girl you like is going to be at the presentation so you don't want to look stupid, even though her work is crap and she spends about ten minutes on it and THEN goes out with rich old gits with sports cars who have parties in country houses which she tells you about. YOU STUPID BASTARD you think she's going to go out with you because you've done a nice bit of type? So you rush it and go to the crit sweating like a pig and the male tutors all drool over her even though her work really is crap they just let her get away with anything, deluding themselves that they are not biased AND THEN because your rough is so messy they ask if you're copying the latest fashionable design and this makes you even angrier because you think you have your own 'unique' style AND THEN you end up having to redo the work resulting in spending loads of money on it, yet it's still crap and there is no way you're going to put it in your portfolio but because of the extra time you have spent on it you never quite do the private work you want to do and you end up with a load of work that you don't like, shaping your career for the next 40 years...

Er... the name is a bit confused, I wanted to say something about the way pornography presents women only as sexual beings, there is no room for the 'personality' within it. Somehow I also immediately connect pornography with American TV evangelists. Women that appear in porn films and prostitutes appear to be the standard demise of these people (see Jimmy Swaggart). The scenario usually runs: man preaches on TV about the evils of lust and money with a credit card hotline phone number on the screen to 'donate', man is arrested for embezzling funds, running a prostitution ring and being in possession of obscene material. Man repents publicly on TV, man begins preaching about the evils of lust and money with a credit card hotline phone number on the screen to 'donate' and the whole thing starts again.

1998 NEWSPEAK

FONT

'NEWSPEAK' COMES FROM THE NOVEL NINETEEN EIGHTY-FOUR BY GEORGE ORWELL. NEWSPEAK IS A LANGUAGE USED TO STOP PEOPLE THINKING OUTSIDE THE APPROVED POLITICAL IDEOLOGY. IF WORDS DID NOT EXIST TO DESCRIBE A THOUGHT THEN IT WAS SEEN AS NOT POSSIBLE OR PERMITTABLE TO HAVE IT. AN EFFECTIVE WAY TO KEEP A HOLD ON DISSENT. THE NAME WAS CHOSEN BECAUSE OF HOW TYPOGRAPHY AND LANGUAGE REPRESENT THOUGHT.

A A B C D E
F G H I J K L M
M N O P Q
R S T U U
V W X Y Z

1 2 3 4 5 6 7 8 9 0

THE CYRILLIC ALPHABET WAS FOR A LONG TIME THE CODE FOR AN ALTERNATIVE WAY OF LIVING - THE ENCLOSED UNIVERSE OF COMMUNISM. WHEN YOU VISITED A COMMUNIST COUNTRY YOU WERE CONFRONTED WITH NEW TYPOGRAPHY THAT REINFORCED YOUR SENSE OF ALIENATION AND THE FEELING THAT THERE WAS AN ALTERNATIVE TO CONSUMERISM.

NEWSPEAK IS BASED ON ARCHITECTURAL FORMS FROM STALINIST RUSSIA.

ALTHOUGH THIS KIND OF SOCIAL REALISM IS CONSIDERED VERY BAD TASTE, I FIND IT STRANGELY BEAUTIFUL, HINTING AT A UTOPIA THAT IS JUST AROUND THE CORNER THE IRONY OF COURSE IS THAT BEAUTY IS ALWAYS USED TO ENFORCE A BRUTAL DICTATORSHIP IT IS ALSO INTERESTING THAT MASS PRODUCTION IS USED TO COPY CRAFT BASED FORMS, A DILEMMA THAT HAS CONCERNED ME SINCE I BECAME A DESIGNER

ORIGINAL POSTER FOR **BRIAN**, 1992

NEWSPEAK WAS ALMOST RELEASED UNDER THE NAME **BRIAN** AND THEN **OXYMORON**. HOWEVER IT WAS PULLED AT THE LAST MINUTE BECAUSE I FELT IT WASN'T INTERESTING ENOUGH, VEERING TOWARDS THE OBVIOUS 'MODULAR'. IT WAS EXTENSIVELY REWORKED, CHANGED TO AN ITALIC WHICH ENCOURAGED THE DRAWING OF THE FLOURISHES CLOSER TO THE STYLE OF ARCHITECTURE.

MORE INTERESTING THAN THE DESIGN OF THE ORIGINAL VERSION IS THE TEXT USED ON THE POSTER. I WAS TRYING TO ATTACK MY OWN AND MANY OTHER DESIGNERS' INERTIA ABOUT PREVALENT VIEWS IN GRAPHIC DESIGN AT THE TIME.

SAY HELLO TO

BRIAN

BRIAN IS A NICE GUY. BRIAN WORKS IN DESIGN. BRIAN BELIEVES IN THE ENVIRONMENT AS LONG AS IT DOESN'T INCONVENIENCE HIS LIFESTYLE. BRIAN IDENTIFIES WITH THE ALTERNATIVE MEMBERS IN SOCIETY BUT DISSAPROVES OF CRIME IN AN UTTERLY CONVENTIONAL WAY. BRIAN CAN'T SEE WHY GENDER IS AN ISSUE TO WOMEN AS IT ISN'T TO HIM. BRIAN DOESN'T SEE RACISM AS A PROBLEM AS HE DOESN'T MEET THAT MANY BLACK PEOPLE IN HIS JOB. BRIAN BELIEVES IN THE END OF THE POLITICAL SYSTEM BUT HAS AMBITIONS TO DO WELL IN THE COMPANY HE WORKS IN. BRIAN LIKES TO SOLVE PROBLEMS ONLY HE'S ONLY EVER BEEN TAUGHT OR THOUGHT HE HOW TO SOLVE THE SMALL ONES. BRIAN BELIEVES THAT HIS INDIVUALITY IS A RESULT OF AN ARTISTIC SENSIBILITY WHEN IN FACT IT'S A RESULT OF RIGHT-WING FREE MARKET POLICY. BRIAN HASN'T GOT THE JOB HE REALLY WANTS AT THE MOMENT AS HE DOESN'T WANT TO HAVE LESS MONEY-HE'D RATHER HAVE REGRET IN 10 YEARS TIME. BRIAN'S DESIGN IS A REBELLION AGAINST THE PREVIOUS GENERATION BUT FOLLOWS RIGID CONVENTIONS ESTABLISHED BY HIS OWN AGE GROUP. BRIAN WANTS FREEDOM BUT DOESN'T REALISE WHAT THAT MEANS. HE JUST USES IT AS A RHETORICAL STATEMENT. BRIAN BELIEVES IN THE FREEDOM & DEMOCRACY OF THE INTERNET. ITS A SHAME HE DOESN'T REALISE THAT THE INTERNET COMMUNITY IS RICH WESTERNERS.

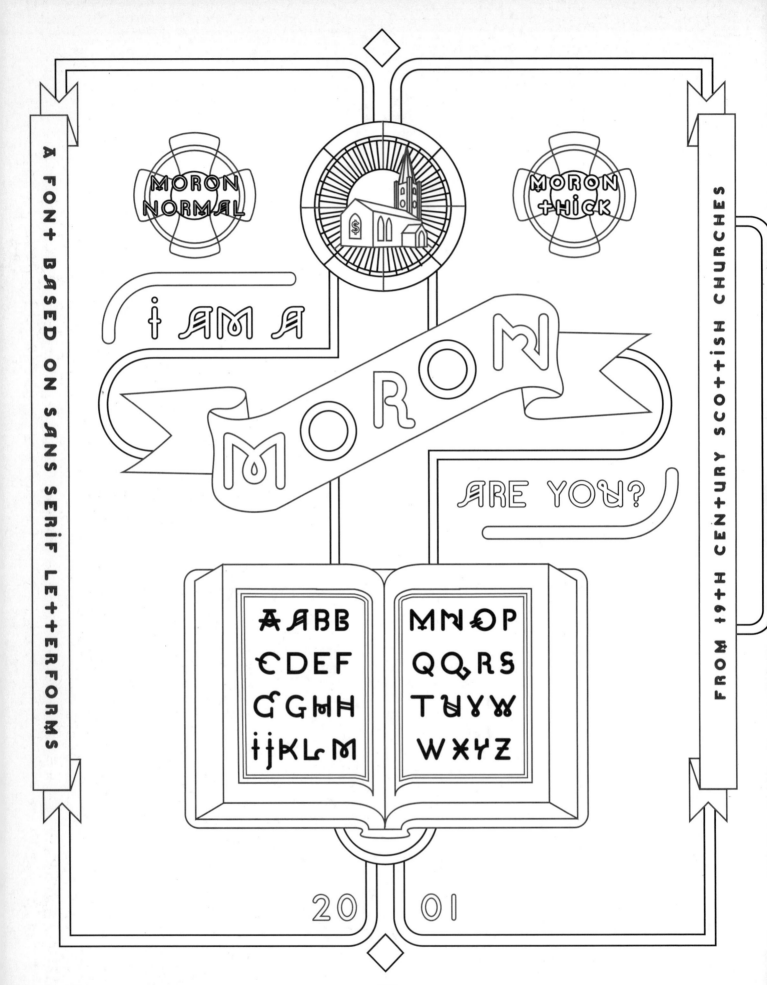

MORON STARTED OFF AS NYLON SANS, HENCE THE CLOSENESS OF THE NAME. ALTHOUGH THE INITIAL DRAWINGS SEEMED QUITE INTERESTING, I FELT THAT IT NEEDED SOMETHING ELSE TO MAKE IT WORTH RELEASING. IT WASN'T UNTIL THE ROUNDED ENDS WERE APPLIED TO THE LETTERS (AS A RESULT OF SEEING THE FONT FRANKFURTER) THAT I FELT IT WAS GETTING SOMEWHERE. IT THEN TOOK ON A LIFE MUCH MORE OF ITS OWN. SOME OF THE BASIC CHARACTER SHAPES ARE THE SAME AS NYLON BUT IT MEANT THAT IT COULD MOVE AWAY INTO MORE UNEXPECTED TERRITORY.

MORON

EARLY NYLON SANS ROUGH

AT THE TIME WE WERE DRAWING IT I WAS TEACHING IN GLASGOW, SCOTLAND. IN MY FREE TIME, I WALKED AROUND THE CITY CEMETERIES AND CHURCHES PHOTOGRAPHING THE TYPOGRAPHY. I WAS HOPING FOR SOME UNUSUAL LOCAL LETTERING BUT FOUND LITTLE THAT WAS REALLY UNIQUE. HOWEVER I DID COME ACROSS A FEW INTERESTING EXAMPLES OF VICTORIAN TUSCAN AND GROTESQUE FONTS WHICH, WHEN I LOOKED AT THEM BACK IN MY STUDIO, SEEMED TO PROVIDE SOME INTERESTING SHAPES THAT OFFERED A BETTER DIRECTION FOR MORON. THEY WERE DRAWN JUST BEFORE THE AGE OF MODERNISM SO THEY SEEMED TO CONTAIN AN ELEMENT OF THE 'INDUSTRIAL AGE' BUT STILL HINTED AT CRAFT AND THE DECORATIVE ARTS. THE VICTORIANS' HANDLING OF ORNAMENT IN RELATION TO APPROPRIATE DESIGN IN AN AGE OF MASS PRODUCTION HAS ALWAYS FASCINATED ME.

BECAUSE THE BASIS OF THE FONT WAS SPECIFICALLY FROM CHURCHES AND CEMETERIES, I REALLY WANTED TO MAKE SOME COMMENT ABOUT PEOPLE WHO FOLLOWED CERTAIN CREEDS. IN THE GRAPHICS PUBLICISING THIS FONT (SHOWN ON LEFT PAGE), I CHOSE, RATHER THAN EXPRESS A VIEW ABOUT RELIGION, TO CENTRE ON A MUCH MORE GENERAL OBSESSION THAT MANY PEOPLE SEEM TO HAVE WITH MONEY. THE NAME BECAME AN INSULT TO HURL AT PEOPLE. IT FOLLOWED THAT THE WEIGHTS OF THE FONTS SHOULD BE CALLED MORON THICK AND MORON NORMAL.

THIS · WINDOW · REPLACES · THE · EARLIER · WINDOW · IN · MEMORY · OF · JAMES · MILL · ESQ., MARY KIPPEN · HIS · WIFE · AND · THEIR · DAUGHTER · ELIZABETH

ABCDEFG
HIJKLMN
OPQRSTU
VWXYZ

ABCDEFG
HIJKLMN
OPQRSTU
VWXYZ

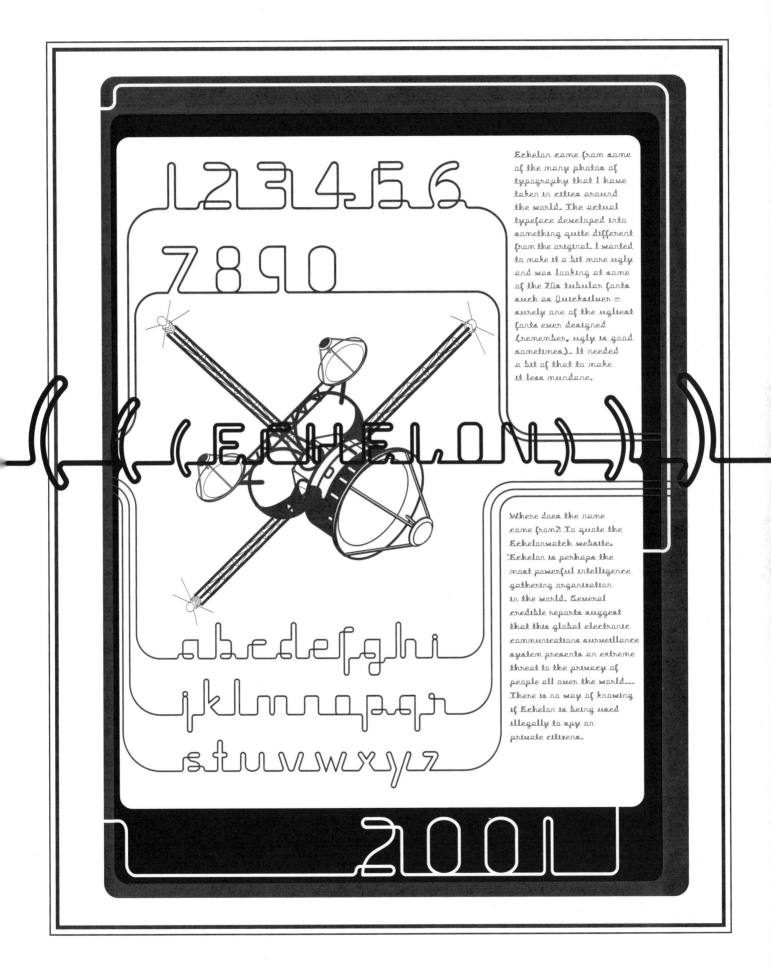

123456
7890

(ECHELON)

abcdefghi
jklmnopqr
stuvwxyz

2001

Echelon came from some of the many photos of typography that I have taken in cities around the world. The actual typeface developed into something quite different from the original. I wanted to make it a bit more ugly and was looking at some of the 70s tubular fonts such as Quicksilver — surely one of the ugliest fonts ever designed (remember, ugly is good sometimes). It needed a bit of that to make it less mundane.

Where does the name come from? To quote the Echelonwatch website, "Echelon is perhaps the most powerful intelligence gathering organization in the world. Several credible reports suggest that this global electronic communications surveillance system presents an extreme threat to the privacy of people all over the world.... There is no way of knowing if Echelon is being used illegally to spy on private citizens."

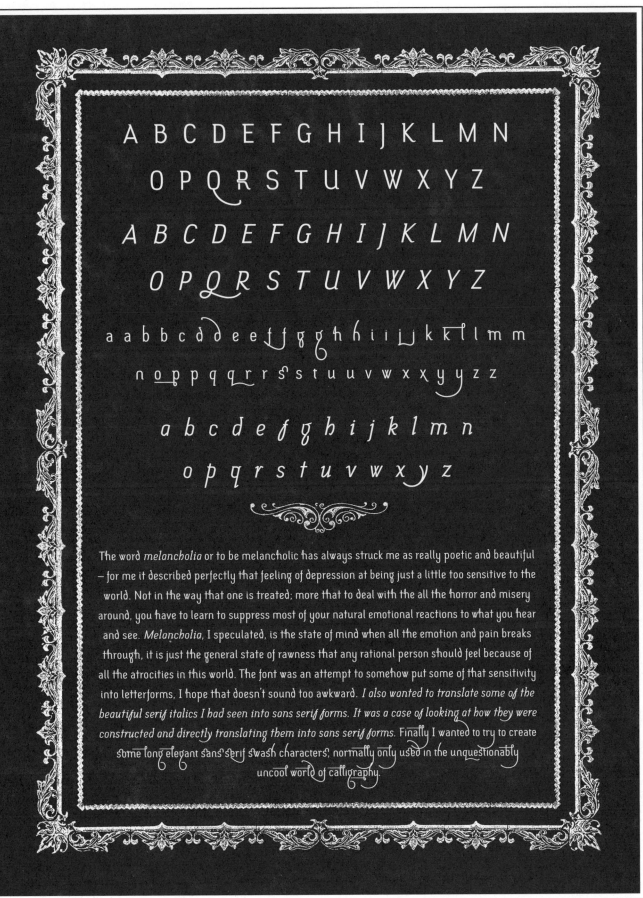

The word *melancholia* or to be melancholic has always struck me as really poetic and beautiful – for me it described perfectly that feeling of depression at being just a little too sensitive to the world. Not in the way that one is treated; more that to deal with the all the horror and misery around, you have to learn to suppress most of your natural emotional reactions to what you hear and see. *Melancholia*, I speculated, is the state of mind when all the emotion and pain breaks through, it is just the general state of rawness that any rational person should feel because of all the atrocities in this world. The font was an attempt to somehow put some of that sensitivity into letterforms, I hope that doesn't sound too awkward. *I also wanted to translate some of the beautiful serif italics I had seen into sans serif forms. It was a case of looking at how they were constructed and directly translating them into sans serif forms. Finally I wanted to try to create some long elegant sans serif swash characters, normally only used in the unquestionably uncool world of calligraphy.*

Expletive Script

A A B B C D E F G H I J K
L M M N A A R R S
I I U U L L L LL UU X Y Y Z

a b c d e f g h i j k l m n o a
p p q g r s t u v u w x y y z

The geometric nature of this font allows for all kinds
of experimentation with repeating patterns

Expletive is a modular typeface based on a circular form. An alternate set of characters is supplied that go above and below the baseline

AABCDEFGHIJKLMNNOPQQRRSTUUUUWXYZ

abccddefghijklmnooppqqrst uuuuwxyz

The name is a comment on the power of language. It has always fascinated me that we have 'forbidden' words, these words when spoken with a certain intonation can be almost physically painful. They are also great indicators of the social structure; some words lose their offensive nature, others become unspeakable. I really don't believe the use of swearing shows a lack of vocabulary or wit, when used appropriately it can be as creative as anything else.

I think I had the idea for Expletive for about five years, and it took a lot of gestating in my mind to come out in the right way. I had seen various logos where the typographer had tried to draw a circular script but I always felt that it could be drawn better, more brutally, more interestingly. I didn't want to compromise the basic shape too much. The result of the experiment was Expletive.

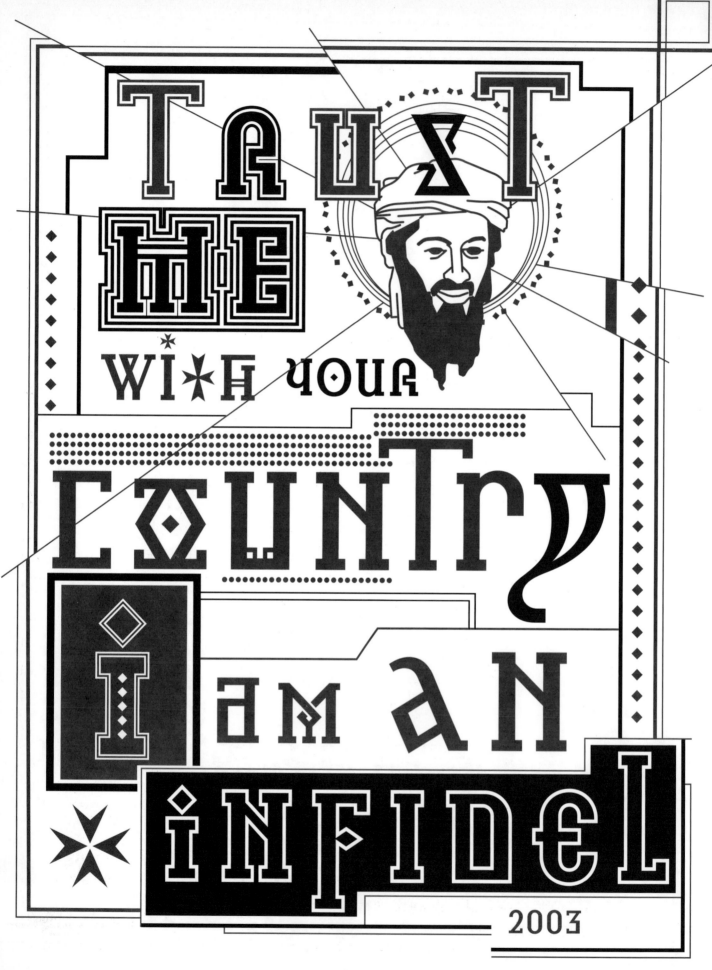

TRUST THE WITH YOUR COUNTRY I AM AN INFIDEL

2003

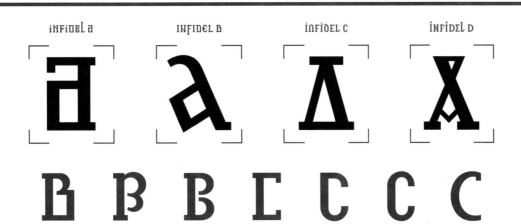

INFIDEL A INFIDEL B INFIDEL C INFIDEL D

When i was younger i would often go the british library and be struck by the beauty of the illuminated books there. With a growing interest in letterform design, the lindisfarne gospels took my attention most and made me sketch letters in my notebook for the first time. Such creative and beautiful forms were so far away from what we recognise as legible letters. Infidel was an attempt to take the unusual character shapes from various illuminated manuscripts and draw them in a modern context.

The name infidel is intentionally confrontational. It was a response to september 11th and i wanted to contrast these serene religious historic forms to the surge in (negative) energy that pervaded people's attitude to religion at that time.

SHOCK AWE

ENOLA

EVERY POSITIVE VALUE HAS ITS PRICE IN NEGATIVE TERMS

A B C D E F G H I J K L M N

THE GENIUS OF EINSTEIN LEADS TO HIROSHIMA

O P Q R S T U V W X Y Z

PICASSO

PART OF THE FIRST RELEASE WAS ENOLA. WE CHOSE ONE KEY MOMENT FROM HISTORY — THE DROPPING OF THE ATOMIC BOMB IN HIROSHIMA. WE ALL KNOW THE PLANE AND HAVE SEEN THE NAME ON THE SIDE, WE WANTED TO PRESENT THAT TYPE IN A FORM THAT DEFINITELY DREW ATTENTION TO ITSELF.

THIS WOULD RAISE MANY QUESTIONS ABOUT TYPEFACES, THEIR NAMES AND THEIR 'NEUTRALITY'. ONCE A FONT HAS BEEN USED OR COMES FROM SOMETHING OF GREAT SOCIAL SIGNIFICANCE, DOES THIS AFFECT EVERY OTHER USAGE? THE CULTURAL RESONANCE OF TYPEFACE OVER AND ABOVE THE DESIGNER'S INTENT IS RARELY DISCUSSED.

I WAS REALLY SURPRISED THAT NO OTHER TYPE DESIGNERS HAD ALREADY USED THE NAME SHOCK & AWE. OR MAYBE NOT. POSSIBLY NOT EVERYBODY THINKS THE SAME WAY AS WE DO. LIKE MANY OF THE OTHER NAMES, IT WAS MEANT TO BE TAKEN IN ALL ITS MEANINGS.

FROM +HE LE++ERING ON +HE SIDE OF +HE TOMAHAWK CRUISE MISSILE. OF+EN +HE LAS+ +HING +HA+ MANY PEOPLE WILL READ

TOMAHAWK

AS WITH ANY 'MARKETABLE' PRODUCT FROM A PRIVATE COMPANY, THE TOMAHAWK CRUISE MISSILE HAD ITS OWN BRAND IDENTITY. WE TOOK THE LETTERING FROM THE SIDE OF THE MISSILE AND DREW IT UP AS A COMPLETE TYPEFACE. THERE IS OF COURSE SOME WEIRD CORRELATION BETWEEN LAUNCHING A MISSILE AND USING WORDS AS A WEAPON.

THE INVENTION OF THE CRUISE MISSILE WAS AGAIN A KEY MOMENT IN AMERICAN POLITICAL HISTORY. IT MEANT FOR THE FIRST TIME THAT A MILITARY ATTACK 'PROTECTING AMERICAN INTERESTS' WAS POSSIBLE WITHOUT RISK OF CASUALTY TO TROOPS.

MY BIGGES+ INFLUENCE OU+SIDE GRAPHIC DESIGN IS 20+H CEN+URY POLI+ICAL HIS+ORY. I+ PROVIDES AN ESSEN+IAL CON+EX+ FOR +HE POLI+ICAL WORK - I WOULD RA+HER SEE CURREN+ POLI+ICAL EVEN+S WI+H A LI++LE BI+ OF DIS+ANCE +O ENABLE ME +O UNDERS+AND +HE MO+IVES BE++ER AND +O COMMEN+ ON +HEM.

I ACTUALLY THINK THESE FONTS RAISE MANY MORE DIRECT QUESTIONS THAN MANSON, BUT THANKFULLY THIS TIME THERE WERE NO COMPLAINTS. I AM HOPING IT IS BECAUSE GRAPHIC DESIGN HAS MOVED ON A BIT AND PEOPLE ARE LESS LIKELY JUST TO CONDEMN.

TOMAHAWK

A B C D E F G H I J K L M N

THE PEN IS MIGHTIER THAN THE SWORD

O P Q R S T U V W X Y Z

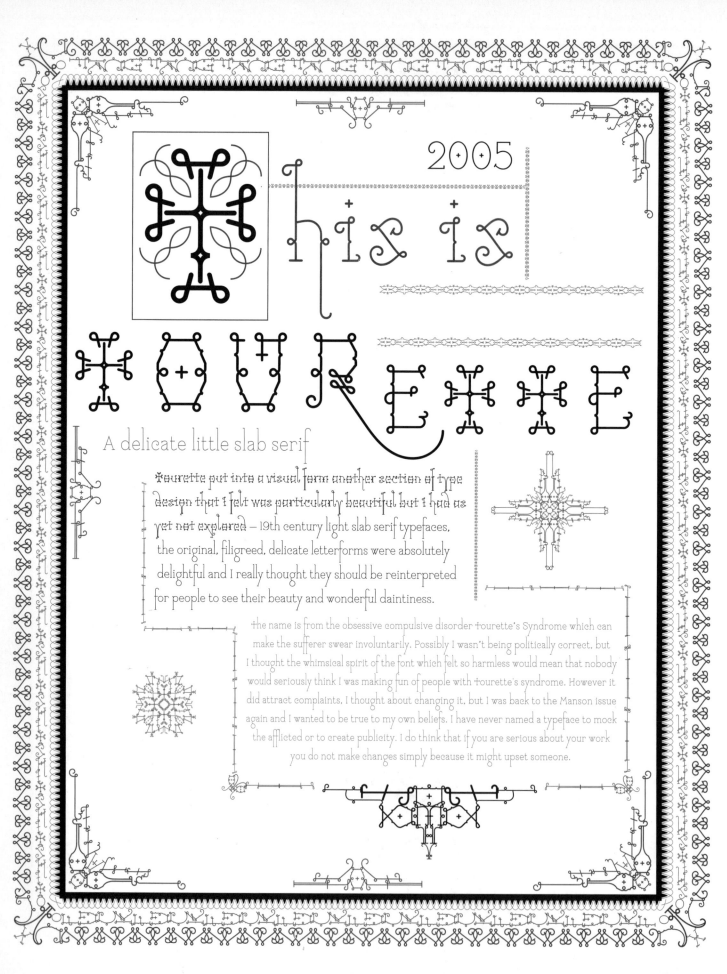

2005

This is TOURETTE

A delicate little slab serif

Tourette put into a visual form another section of type design that I felt was particularly beautiful but I had as yet not explored — 19th century light slab serif typefaces, the original, filigreed, delicate letterforms were absolutely delightful and I really thought they should be reinterpreted for people to see their beauty and wonderful daintiness.

The name is from the obsessive compulsive disorder Tourette's Syndrome which can make the sufferer swear involuntarily. Possibly I wasn't being politically correct, but I thought the whimsical spirit of the font which felt so harmless would mean that nobody would seriously think I was making fun of people with Tourette's syndrome. However it did attract complaints, I thought about changing it, but I was back to the Manson issue again and I wanted to be true to my own beliefs. I have never named a typeface to mock the afflicted or to create publicity. I do think that if you are serious about your work you do not make changes simply because it might upset someone.

DOUBLETHINK

"THE POWER OF HOLDING TWO CONTRADICTORY BELIEFS, SIMULTANEOUSLY, IN ONE'S MIND AND ACCEPTING BOTH OF THEM."

George Orwell | Nineteen Eighty-Four.

The design of this piece was observed on a store while on a trip to Croatia some years ago. Vinko Ozic-Pajic drew the original logo for the shops of the then state-owned clothes company Standard Konfekcija in the 1960s in Yugoslavia. To keep the logo 'fluid' Vinko's design was constructed by shaping a piece of rope into the various letterforms. This experimental design has now been reinterpreted with the construction of a two weight typeface - Medium and Bold Inline.

Standard Konfekcija itself started off as a military fabric company and then became the first fashion brand in Communist Yugoslavia. It is famous for having the first ever plastic carrier bag in the country – at the time this was a much coveted item. It was also highly unusual for its use of orange as its main colour, rather than the officially approved red. The shops no longer exist, having all been closed around 2001, after the fall of Communism.

A B C D E F G H I J K L M N O P Q R S T U V W X Y Z

SLAVERY is FREEDOM
IGNORANCE is STRENGTH
WAR is PEACE

There are not many that have mourned the passing of Communism, but we can't help feeling that a huge amount of valuable visual culture has been thrown away with everything else. So this is one release of many in which we are planning to highlight these 'lost' fonts.

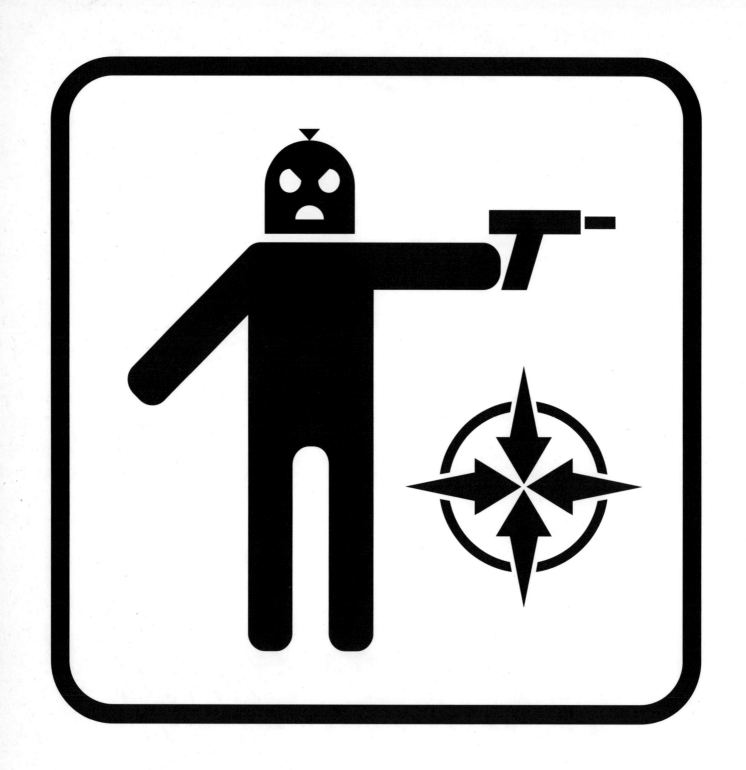

TERRORIST ASSEMBLY POINT

XXIII. Olympukes:

Real Pictogram font for the Olympics

When I was learning graphic design the Olympic pictograms were always seen as the ultimate design job. There was something pure about it, full of good intentions. The Olympics were apolitical, they were after all about excellence in sport, not politics... er... yes. They represented the highest achievements of civilisation and graphic design to communicate across cultures without cultural prejudice or favouritism... er... yes. They also were also done by the top designers... er... yes.

So why do this project? It just felt like the pictograms were no longer addressing the real world of the Olympics. There had been so many scandals – lack of leadership over drug taking, accepting of bribes, etc. I always thought that graphics should be true to the subject matter, so I wanted to inject some reality into them and, more importantly, show how design had moved on from the silly idea of 'transparent cross-cultural' communication.

revealing sports wear

crap identity by commercial design group

drowning in advertising

'gift' for olympic committee member

I am thinking in particular of Karrie Jacobs and Tibor Kalman in the essay *The End* from the publication *The Edge of the Millennium*, (Whitney Library of Design 1993) where they discuss the most basic symbols of male and female pictograms for toilet doors.

women OR Muslim man

OLYMPUKES = OLYMPICS + PUKE

a

TERRORIST ASSEMBLY POINT

b

OBSESSED FAN
ASSEMBLY POINT

c

STEROID INJECTING
ASSEMBLY POINT

d

AMERICAN TOURIST
ASSEMBLY POINT

e

OBSCURE CRAP SPORTS

f

SPORT PERSONALITIES
UNDULY INFLUENCING
CHILDREN

g

SPORT PERSONALITIES USED
TO ENDORSE UNHEALTHY
PRODUCTS

h

EXTORTIONATELY PRICED
MERCHANDISE

i

FEMALE ATHLETE THAT
USED TO BE A MAN

j

STADIUM BUILT WITH THE
USE OF SLAVE LABOUR

k

OLYMPIC COMMITTEE
MEMBER

l

'GIFT' FOR OLYMPIC
COMMITTEE MEMBER

m

UNHEALTHY ARMCHAIR
SPORTS PERSON

n

SPORT ON EVERY BLOODY
CHANNEL

o

OVER ZEALOUS TRAINER

p

FOCUS IS ON MONEY RATHER
THAN SPORT

q

EAST EUROPEAN PERFECT
GYMNAST

r

POLITICS THROUGH SPORT

s

TAKE THE MONEY AND RUN

t

DENIAL OF TAKING DRUGS
AT PRESS CONFERENCE

u

OPENING CEREMONY LASTS
FOREVER

v

UNFAIR TECHNOLOGICAL
ADVANTAGE

w

DROWNING IN ADVERTISING

x

REVEALING SPORTS WEAR

y

PROFESSIONAL MILLIONAIRE
SPORTS PERSON TRYING TO
WIN GOLD

z

REFERS TO "READ ME" FILE
SENT OUT WITH FONT
EXPLAINING THE LICENCE

A

THE OLYMPICS IS PRIMARILY
ABOUT MAKING MONEY

B

HOST NATION BRIBES

C

CRAP OLYMPIC MASCOT

D

STADIUM NOT QUITE
FINISHED ON TIME

E

BRITAIN IS RUBBISH
AT SPORT

F

CRAP IDENTITY BY
COMMERCIAL DESIGN GROUP

G

CARPET BOMBING
ADVERTISING

H

BRIBABLE JUDGE

I

MEDAL WON THROUGH THE
USE OF PHARMACEUTICALS

J

CHINESE BLATANT
STEROID CONSUMPTION

K

RICHER COUNTRIES HAVE
AN INCREASED CHANCE
OF WINNING

L

PUBERTY DELAYED GYMNAST

M

ABUSE OF HUMAN RIGHTS
IGNORED BY HOST COUNTRY

N

BORING MILLIONAIRE
TENNIS PLAYER

O

OPPORTUNISTIC MANAGERS
AND PUBLICISTS

P

ALL OPENING CEREMONIES
LOOK THE SAME

Q

UNETHICAL POLITICAL
IDEOLOGIES IGNORED

R

WATCHING OLYMPICS PURELY
FOR SEXUAL PURPOSES

S

ZERO COVERAGE OF
DISABLED OLYMPICS

T

AMERICAN BIASED TV
COVERAGE

U

ZERO VIEWER SPORT

V

BIASED JUDGE

W

OBSCURE SPORT THAT
IS IGNORED UNTIL YOUR
COUNTRY WINS A MEDAL

X

LOADS OF SHAGGING IN THE
OLYMPIC VILLAGE (PROBABLY)

Y

OLYMPIC BID IS MONEY NOT
SPENT ON EDUCATION,
HOSPITALS, HOUSING

Z

POLITICAL BOYCOTT

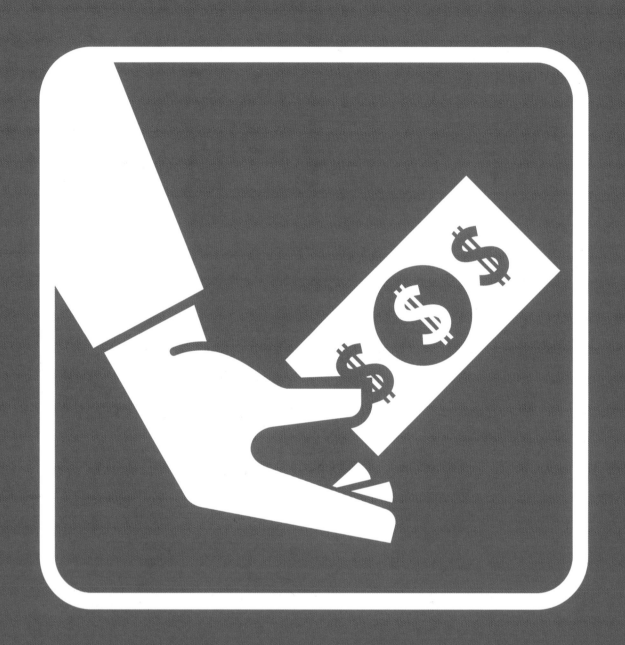

BRIBABLE JUDGE

There have been some brilliant pictograms designed for the Olympics: Otl Aicher's for MUNICH '72, Lance Wyman's for the MEXICO '68 (I also love his work for the metro in Mexico City) and Javier Mariscal's unexpected and stylish designs for BARCELONA in '92. Since then, they have plummeted to the depths of bad drawing and dated (mainly mid-80s looking) solutions with boomerangs for SYDNEY 2000 and blobby men for ATHENS 2004. So part of the reason for designing *Olympukes* was to vent my anger against the recent standard.

It was a difficult problem to try and put over some quite unique concepts in pictogram form, so although this was not a 'real project', there was still some proper 'problem-solving' in it. Marcus McCallion, who worked on drawing it, came up with some excellent solutions.

Olympukes also came from a general frustration. Smaller design companies consistently do the most inventive and experimental work, yet are unlikely to be considered for the jobs where graphic design is consciously seen by the public. This does nothing but harm to the profession. It means that many people outside design think it is a commercial derivative process which relates very little to the political events surrounding them.

It was important that the font did not seem bitter; there are some scathing comments about the subject of graphic design in the font but there are some funny ones too. Never would we want to be seen without a sense of humour.

Marcus McCallion working on a particularly interesting pictogram for Olympukes

THE NAME

PRIORI

COMES FROM

THE TERM

a priori

MEANING

A PIECE OF KNOWLEDGE

THAT IS NOT BASED UPON

EXPERIENCE BUT PRE-SUPPOSITION

UH?

WHAT HAS THAT GOT TO DO WITH

TYPOGRAPHY?

MEANS THAT

THE LETTERS FROM DIFFERENT FONTS SHARE

THE SAME COMMON SHAPES OK?

priori FONT

SCRIPT

SANS SERIF

SERIF

BLACK LETTER

Priori was a proposal for a series of typefaces all with different styles but with a common core character shape. The character widths on the serif and sans serif are also similar enough to be able to mix them together in the same word. *Priori* is not finished, other versions such as blackletter, script, slab serif are planned for the future.

a a b b c d d e e f f
g g h h i i j j k k l l
m m n n n o o p p q q r s
s t t u u v v w w x y z

A Λ B B C D E F G H I I
K K L M M N N O O P
ꟼ Q R R S Z T T U U V
W W X X Y Y Z

1 2 3 4 5 6 7 8 9 0 | 1 2 3 4 5 6 7 8 9 0

The 'a' echoes the alternative version of *Futura* designed by Paul Renner in 1928

Hamburgers

These characters were very heavily influenced by *Johnston*, designed by Edward Johnston in 1916. I thought it was one of the most beautiful and 'romantic' typefaces ever designed. I could identify completely with the aesthetic. Although not the only font that has diamond shaped dots, it's the one that made the most impression.

There was definite attempt to make the font look a little more primitive. The stroke endings of these lowercase letters were drawn to give it a look closer to a brush drawn glyph, something I had seen on many 17th/18th century letterforms.

The lowercase 'r' is a definite nod to Eric Gill, in particular some of his more directly hand-drawn letterforms. It also has a shape reminiscent of letters on the hand painted signs of 1940s London. The typography from that time seems so English and has an atmosphere that I return to again and again.

Some of the alternate versions of the stroke endings.

The 'p' character was influenced by some of the modernist experiments by Herbert Bayer.

bayer-type

Again a slightly more primitive character evocative of stone carved letters on war memorials.

Serif

architecture & quick flight on wednesday

Sans serif

architecture & quick flight on wednesday

Mixing both

architecture & quick flight on wednesday

The first showing of *Priori* was its submission to a competition to draw a font for the Scottish city of Glasgow. The city had been nominated as European City of Architecture and Design for 1999. The font didn't win. I am not surprised as at this point it had hardly been worked on, it was more of a sketch for a font than anything else. Looking at it now I cringe at its naïvety but the genesis of an interesting idea was there.

Aa Bb Cc Dd Ee Ff Gg Hh

Ii Jj Kk Ll m Nn Oo Pp Qq

Rr Ss Tt Uu Vv Ww Xx Yy

A A bb cd d Ee Ff gg Hhh Iti Jj Kk

Ll Mm NNnnn Oo u PPpp Qqq

RRr Tt UUuu V Www Xx YYy z

Some slightly later but still largely undeveloped versions of *Priori*.
Of interest are the alternative characters that didn't work well enough to make it into the later version of the font.

More examples of letterforms from Britain that have influenced *Priori*. No direct shapes were taken from this reference material, the atmosphere of them was absorbed into the font.

The release of *Priori* was a big deal for me (and it wouldn't have happened if it wasn't for the help and work of Marcus McCallion), it finally gave me the opportunity to control every aspect of the page. All my previous typefaces had been display only and unsuitable for setting longer texts (although many would call *Priori* illegible as well). At long last I could set a whole book in one of my own fonts. Finally creating my own 'bible'. Furthermore, I had achieved something which had eluded me; to put into a font all of the atmospheres that I loved about typography which were a constant source of motivation for continuing in the field. I have detailed on the previous spread what some of the letterforms are, but primarily I wanted to do something that was 'English'. I realise that this throws up lots of awkward contradictions. I find any kind of patriotism a bit embarrassing, why think you are superior because of where you come from? I believe you should be true to your surroundings and experiences, that is the foundation of culture. In *Priori* I am stating that this is my environment and my experience of typography, this is the beauty that I have tried to put in my work, these are the letterforms that speak the truth to me.

Although I work on a computer all the time, when I think of the subject of typography, the computer is not the place where it 'happens' for me. The forms of letters are always linked inexorably with stone carving. The construction of serifs, the permanence of the message all resonate and have a beauty which is one of my main motivations for being a typographer.

ga gf gg gh gí gi gj

gl gm gn go gr gs gt

gu gy gz ca ky pp qu of oh oí ol

oo AD of TE H AD E HE

Th Tr RH TE TT TR H E H

EZ FF Fi FL LL LA

AV H IK AN TH AV IK VIE ME

UB UD UE UL UR UP LB LD LE LL LR LP

ST RS OO OG OC

abcdefghijklmno PRIORI 1234567890 PRIORI ABCDEFGHI|KLMNO

abcdefghijklmno PRIORI 1234567890 PRIORI ABCDEFGHI|KLMNO

abcdefghijklmno PRIORI 1234567890 PRIORI ABCDEFGHI|KLMNO

abcdefghijklmno PRIORI 1234567890 PRIORI ABCDEFGHI|KLMNO

abcdefghijklmno PRIORI 1234567890 PRIORI abcdefghijklmno

abcdefghijklmno PRIORI 1234567890 PRIORI abcdefghijklmno

ABCDEFGHI|KLMNO PRIORI 1234567890 PRIORI ABCDEFGHI|KLMNO

abcdefghijklmno PRIORI 1234567890 PRIORI ABCDEFGHI|KLMNO

abcdefghijklmno PRIORI 1234567890 PRIORI abcdefghijklmno

abcdefghijklmno PRIORI 1234567890 PRIORI abcdefghijklmno

abcdefghijklmno PRIORI 1234567890 PRIORI abcdefghijklmno

abcdefghijklmno PRIORI 1234567890 PRIORI abcdefghijklmno

ABCDEFGHI|KLMNO PRIORI 1234567890 PRIORI ABCDEFGHI|KLMNO

ABCDEFGHI|KLMNO PRIORI 1234567890 PRIORI ABCDEFGHI|KLMNO

abcdefghijklmno PRIORI 1234567890 PRIORI ABCDEFGHI|KLMNO

abcdefghijklmno PRIORI 1234567890 PRIORI ABCDEFGHI|KLMNO

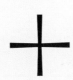

HEATHEN | *david bowie*

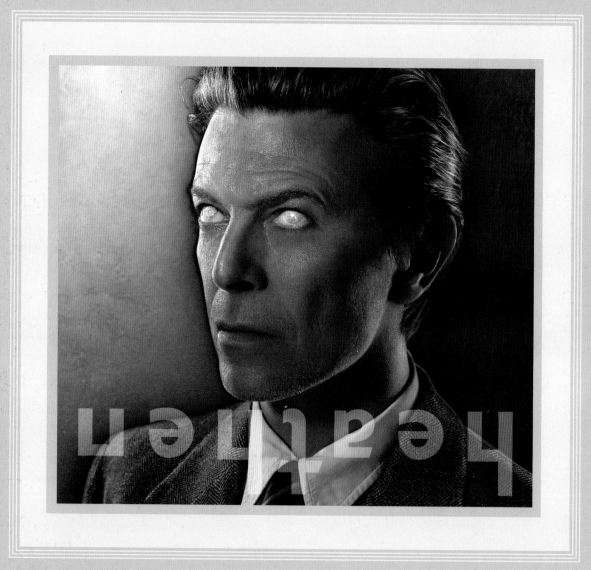

No doubt this section will be of interest to David Bowie fans, as many of them often hijack my lectures in the question and answers section and try to change the main topic of the discussion onto him. I liked David Bowie before I started working with him but I was not obsessive. I hope that meant I had enough distance to see whether what I was doing was good enough or appropriate for him, his target audience and the music. I was a bit nervous at first—how can this person who has been so famous all of his life, that has possibly spent most of the time being told how fantastic he is, be a rewarding person to work with? Well, by keeping a sense of humour about himself. He has been respectful, funny, self-deprecating and generally a pleasure to work and engage with.

Above is the finished cover, on the right are variations of it. The photographer Markus Klinko had already been chosen by David Bowie and there was a stipulation that the front cover should have a picture of him on, so it was more a matter of trying to express the idea of *Heathen* in the layout of the typography. The definition of 'heathen' is somebody who is regarded as 'irreligious, uncivilized, or unenlightened'. Put my way 'a different perception or a contrary position to society'. The idea I went for was simply to have the main title upside down, this created something strong that simply said 'anti'. I also didn't put David Bowie's name on the front, as he is one of the few pop-stars famous enough to be recognised without it. I think this helped the directness of the message.

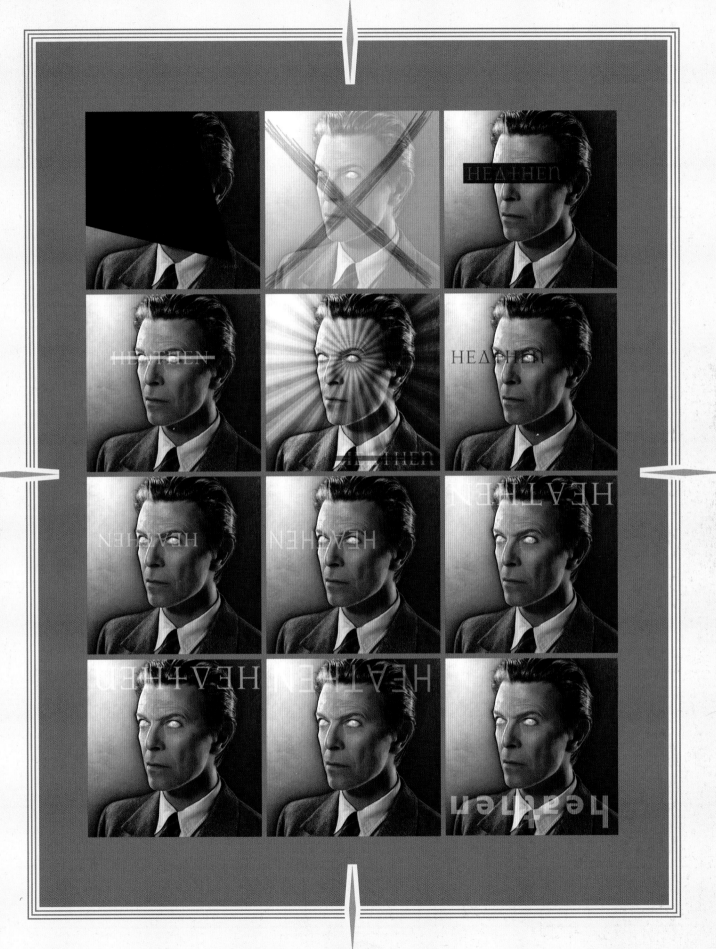

Extending the concept of *Heathen* to the whole album design, I found this image on the left in an academic journal. It is of a real Rembrandt that has been vandalised. It struck me as both shocking and beautiful. A complete violation of what society deems to be of cultural value. To me it perfectly exemplified what a *Heathen* could be and I wanted to use it for the album. Unfortunately the museum thought differently, so permission for this and other images that I would love to have used was not granted. The reason given was the worry about copycat attacks, a little too overcautious I feel. However I can only imagine the size of a lawsuit against the record company if something like that had happened. So I took the concept instead and 'faked' the vandalism. Obviously I think it would have been better if they were real paintings that had been vandalised, but short of actually walking into a gallery and defacing something, there was little I could do. I still think that these designs have the same juxtaposition of beauty and violation. Incidentally the above image was banned in a few catholic countries because it is the Virgin Mary.

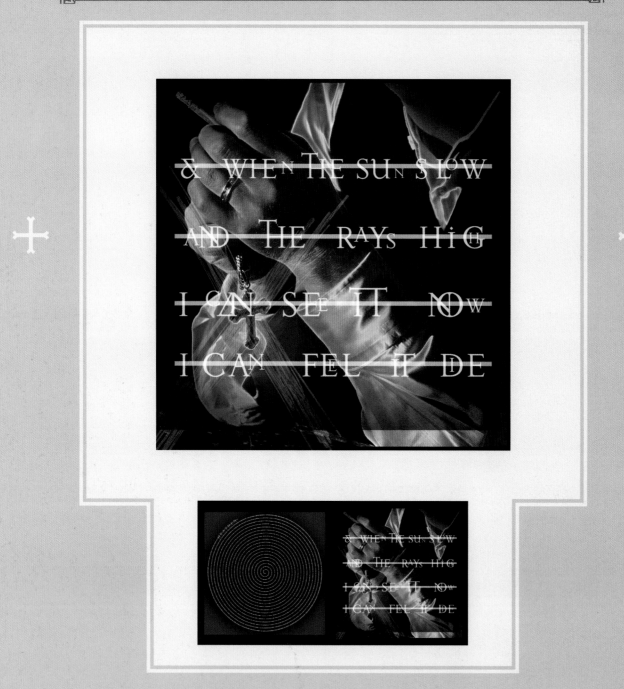

To continue the idea of *Heathen*, the rest of the typography was censored or desecrated in some way. The opening page of the booklet featured a spiral of *Priori* with the lyrics crossed out, a few people complained that they couldn't 'sing along' so just for you all it is shown on the right with all of the lyrics intact. In case you are wondering, the idea of using the spiral and the lyrics all in one line was to try and describe the intensity of the lyric writing process. The page next to the spiral (above) relates very heavily to some of the first experiments I did with classical typography (*Steppenwolf* page 24). I find it hard to describe the absolute wonder I felt when I first saw typography set in this way in a church. It seemed aesthetically honed to perfection over hundreds of years and at the same time really modern.

HEATHEN

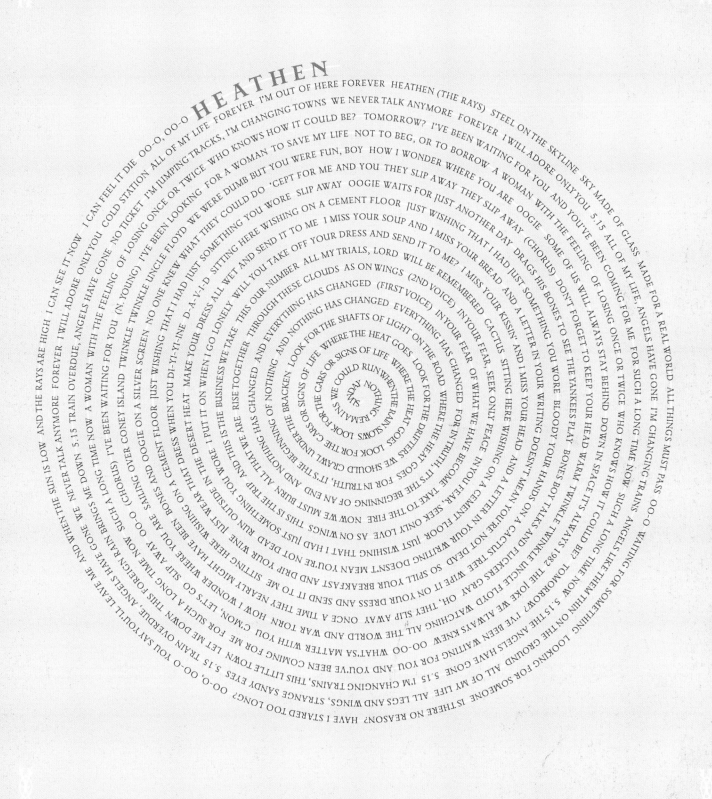

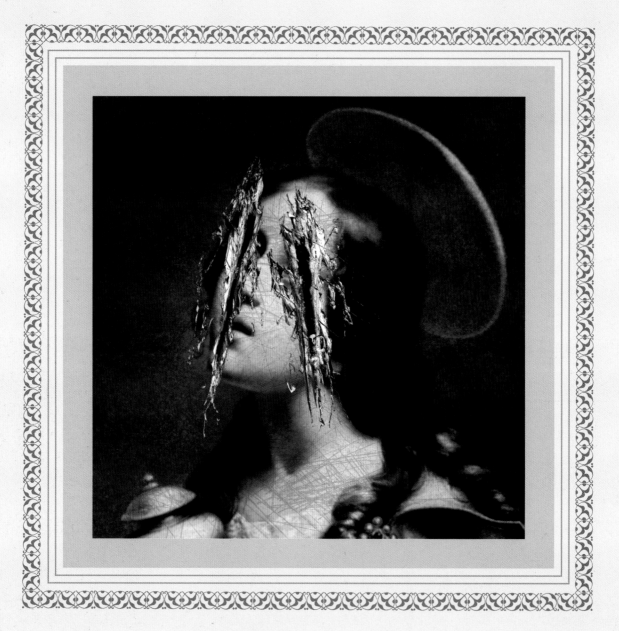

"Heathenism is a state of mind. You can take it that I'm referring to one who does not see his world. He has no mental light. He destroys almost unwittingly. He cannot feel any Gods presence in his life. He is the 21st century man. However, there's no theme or concept behind Heathen, just a number of songs but somehow there is a thread that runs through it that is quite as strong as any of my thematic type albums."

DAVID BOWIE

Above images of books which David Bowie insisted were included in the designs for the album, when I asked him why he said, *"The three book covers that are featured within the album art are what I consider to be pointers to the new way of thinking, a kind of manifesto at the beginning of the 20th century. Firstly The Gay Science by Nietzsche wherein he pronounces his famous, "God is dead," secondly The Interpretation of Dreams by Freud, from where we began to view ourselves in a completely new light and lastly The General Theory of Relativity by Einstein presented us within a new way of 'being'. As Max Born observed, "The theory appeared to me then, and still does, the greatest feat of human thinking about nature, the most amazing combination of philosophical penetration, physical intuition, and mathematical skill."*

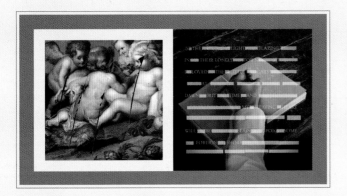
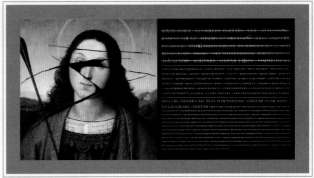

These pages from the CD booklet show the combination of vandalised paintings, photography by Markus Klinko and Indrani and censored *Priori*. In the images I tried to never show David Bowie's face to make him seem like an outsider – the 'heathen' as a dangerous force excluded from society. The 'censorship' on the spread (above left) leaves only the lyrics for the viewer to read.

> . SOME . OF . US . WILL . ALWAYS . STAY BEHIND .
> . DOWN . IN . SPACE . IT'S . ALWAYS . 1982 .
> . THE . JOKE . WE . ALWAYS . KNEW .

"*I had a sense of the sonic weight that I was after, a sort of non-professional approach, a kind of British amateur-ness about it. And I mean amateur in that dedicated fashion you find in a man who, only on Sundays, will build a cathedral out of matchsticks, beautiful but only to please himself and his family and friends. I went in very much like that. I wanted to prove the sustaining power of music. I wanted to bring about a personal cultural restoration, using everything I knew without returning to the past. I wanted to feel the weight and depth of the years. All my experiences, all the questions, all the fear, all the spiritual isolation. Something that had little sense of time, neither past nor present. This is the way that the old men ride.*"

DAVID BOWIE

In the rest of this book I have tried to edit down quite a lot of the work so that only the essential visuals are shown. However, in this section I thought I would put a few more in for the sake of the 'completists' who may be looking at it. So here are the singles taken from the album plus some roughs for the covers.

The image for the cover of *Slow Burn* was one that was liked by everybody, but did not seem to fit into the feeling that I was trying to put over in the designs for *Heathen*, so it was saved for the release of the first single.

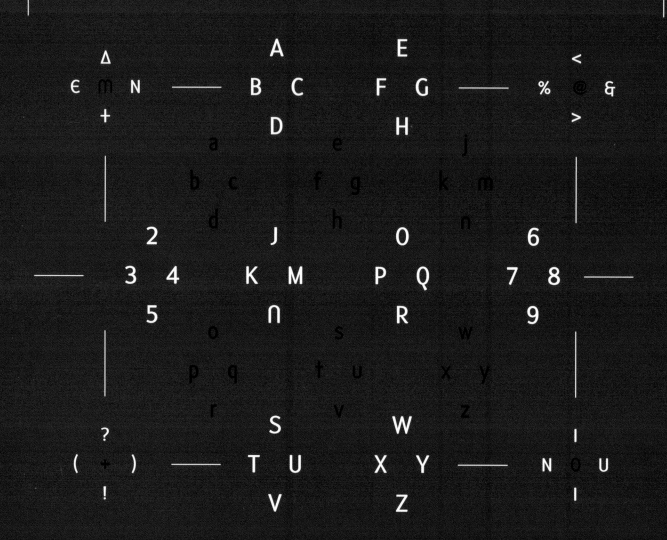

INOUI ID

A bespoke two weight typeface with an alternate character set

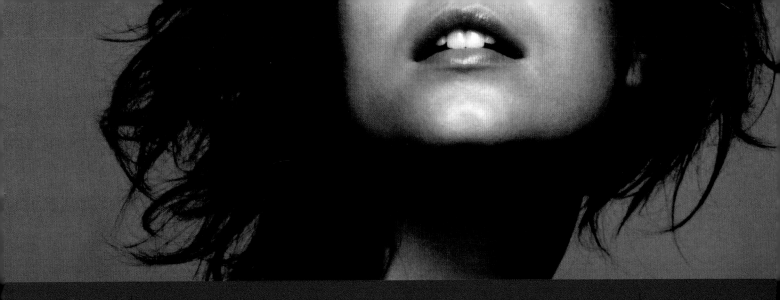

INOUI ID was a collaboration in 2002
with SHISEIDO cosmetics to produce
a new logo and typeface for their
premium cosmetic range in Japan.

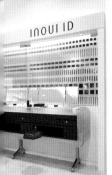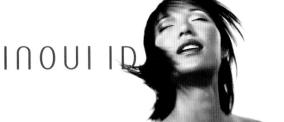

Not all of the fonts we design come from my own impenetrable
universe. Although my typography is very personal, it does not
prevent me from solving the problems that clients face in the
commercial world.

We are often commissioned to create a bespoke typeface and, as all designers should,
try our best to produce good work within the parameters of the brief. For INOUI ID we
wanted to do something that was very modern and minimal but also had a light feminine feel.

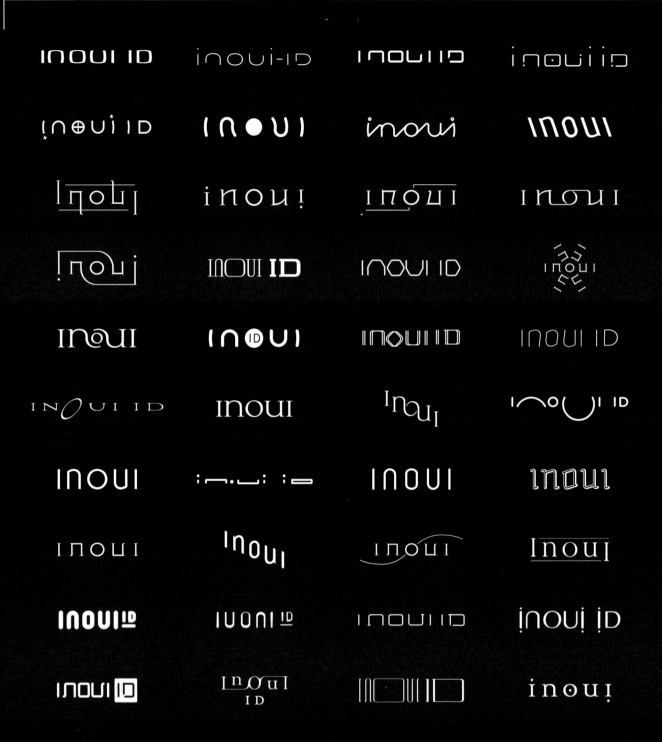

Here are just some of the roughs created while working on this project. I always tell students that you have to go through a brutal editing process before you present something to a client, often showing too much work is as bad as too little.

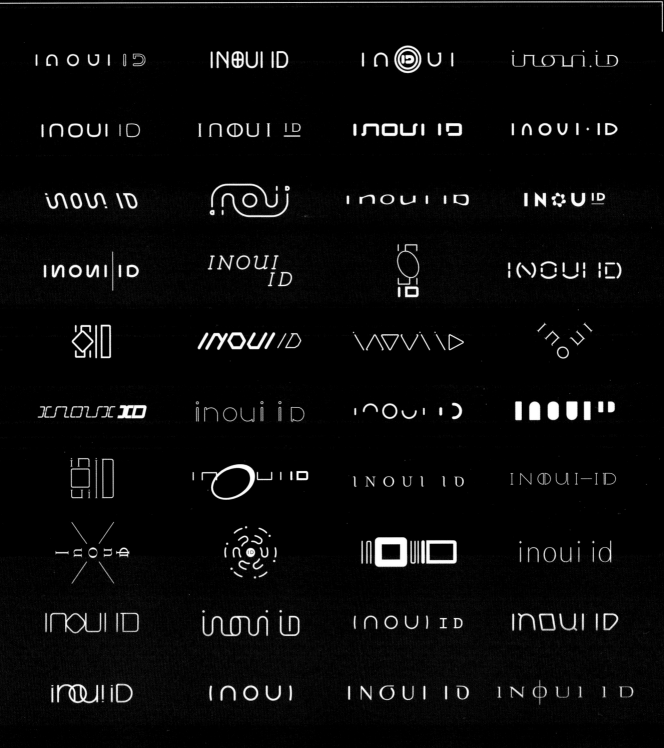

However, sometimes it is a long process involving many different ideas before you can refine your direction. This is best done in close consultation with a client that you trust.

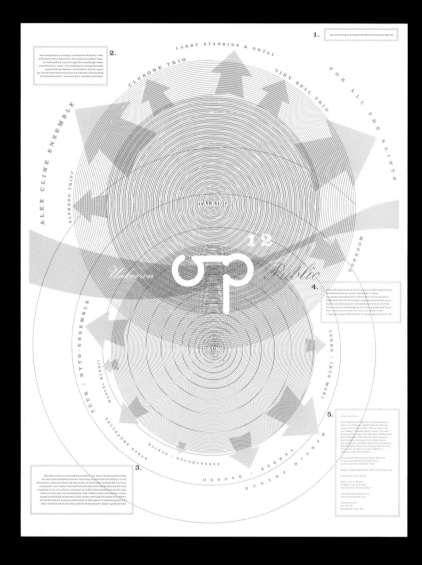

I put this in to show that we don't only work with the likes of David Bowie, we are just as happy collaborating on more underground stuff as well. *Unknown Public* is an experimental music magazine founded by editor John L Walters and publisher Laurence Aston. We designed Issue 12 – *Talking Drums*. Percussion and rhythm were the basis for all the typography. On the reverse side printed in red, we highlighted authorship and sponsorship in the digital age. This was in 2002 when the iPod was less than six months old, these issues weren't being endlessly discussed then...

MPG COMPUTER FILE SHARING SYSTEM

VIKING 1: MooNDOG

<duration: 2.59>

A pulsing 5/4 beat holds this short, melodic piece together. Moondog seemed
to work in a different time-space continuum to everyone else, making his
own version of tonal, classical music wherever he could find
sympathetic musicians.

CAN'T GET THIS TUNE OUT OF MY HEAD : PC

COMPOSER: LOUIS HARDIN

Album: Moondog in Europe

Performer: Louis Hardin percussion, celesta

RECORDED AT RHEIN-RUHR-FILM TONSTUDIO BOCHUM

Recorded and mixed by Helmut Rohlfing

Recording courtesy: Kopf Records (division of Roof Music)

PUBLISHER: ROOF MUSIC / MANAGARM

11. ALFREDO Triff 3-2

<duration: 2.30>

3-2 is about a rhythmic side of Cuban 'clave', – that well known rhythmic
code – seen now from its melodic point of view. It's like leaving things
behind only to find them again in a fragile state, as if they've become part
of something else we cannot quite understand.(AT)

Alfredo Triff is a violinist and composer with such
diverse musicians who has played or collaborated
as Luigi Nono, Leo Brower, Don Pullen, Kip Hanrahan,
Jack Bruce,
Eddie Palmieri, Cachao and others. First an avant-garde improviser
– he was a co-founder and member of Grupo Arte Vivo, the Cuban contemporary
music group – during the 1980s
Triff turned to charanga music and rock
in New York,
during which time he studied philosophy and maths. Through the
1990s he the sound of and mixed it
incorporated electronica with decadent
aspects of the such as Hanrahan's Exotica.
Cuban bolero, playing on album projects
Triff now lives in Miami,
where he teaches Philosophy and art critic.
freelances as an
He has also exhibited paintings and drawings, and has made installations,
performance pieces
in galleries and other spaces, and 'conceptual interventions'
sometimes involving music.

Album: 21 Broken Melodies at Once
Composed and arranged by Alfredo Triff
Performers: Andy Gonzalez acoustic bass /
Robby Ameen drums / Negro Horacio
Hernandez drums / Yosvany Terry Cabrera
reeds / Román Díaz congas / Alfredo Triff
electric violin, electric mandola

Recording courtesy: American Clavé
Recorded at Sorcerer
Sound Studio, New York
Engineer: John Fausty / Dick Koudas
Producer: Kip Hanrahan / Alfredo Triff
Executive producer and
conceptual strategies: Kip Hanrahan
Mastered at Sterling Sound, New York
Mastering engineer: Greg Calbi
Publisher: Métisse Music / Surplus Value

12.

Tenko and Ikue Mori
<duration: 3.31>

DEATH MASK

XXVII.

Corporate identity for Roppongi Hills, the largest post-war development in Tokyo

Surprisingly we won an invited competition to design the identity for a huge development in Tokyo. I say SURPRISINGLY because we are not corporate identity specialists. However I think in this case it was our strength. We came up with something quite unique and I have to credit the client, Mori Building Co. with taking a chance on a studio without a proven track record for corporate identity. I also hope it showed that small design companies can handle big projects and often produce better work.

The logos (yes, there is more than one which will become evident later) were based on the meaning of the Kanji characters of Roppongi (the district in Tokyo where it is located) which means 'six trees'. The trees were abstracted to six circles, this provided a structure for a series of different typographic logos of the name 'Roppongi Hills'. These are all used equally around the development. This may sound like an unnecessarily complex solution, but this original approach created very strong branding. It presents a stylish and much less authoritarian image of the development. We were also keen to solve the awkward problem of having to use only the name in many instances. Here it is completely integrated so the issue does not arise.

roppongi in japanese kanji alphabet means 'six trees' six circles as a basic structure for the logo

六本木 ヒルズ
[roppongi] [hills]

I put this image in because I think its an example of how well the corporate works, (EVEN IF I DO SAY SO MYSELF). The concept behind the logo has quite a complex basis, but a corporate identity's expression in any media should always be easy to implement and flexible. In this case a street cleaner (yes the cleaners wear white gloves in Japan), has drawn his own version very simply on the box that he is collecting rubbish in. I think it works just as well as the rest of the corporate.

Below, some of the different logo implementations

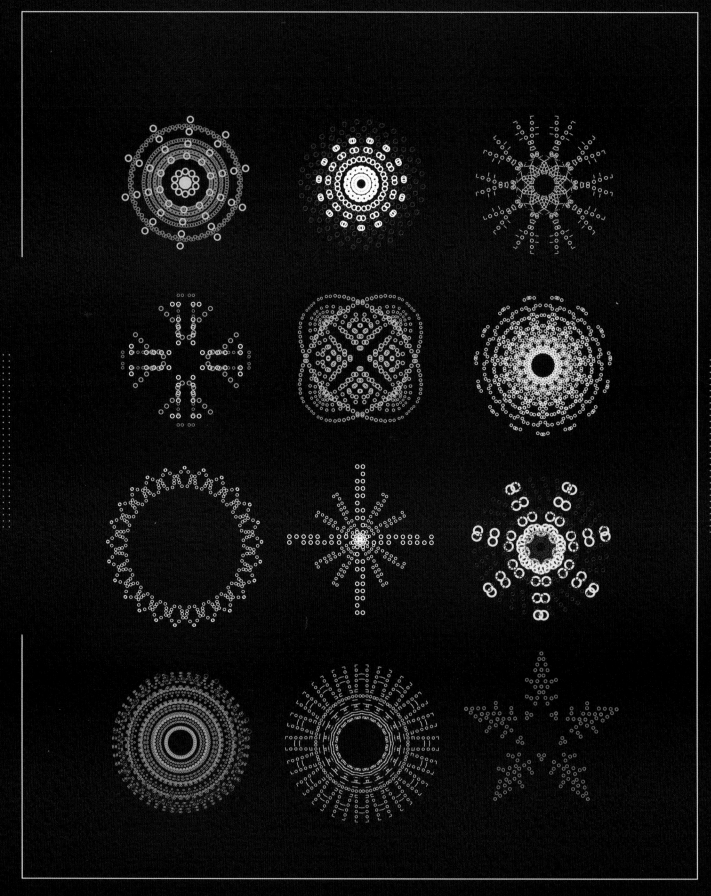

Repeating patterns developed from the logos. These are used around Roppongi Hills for hoardings, event banners etc.,
some examples are shown on the right. A more inventive way of branding than just using a logo.

Before this job I had always avoided corporate identity, it seemed the most boring kind of graphic design. I had heard tales in whispered tones of a designer working for two years on ONE CORPORATE MANUAL. I simply didn't think I had that kind of attention span. However, the possibility to come up with something really new in this area dominated all other thoughts. It was a chance to show the bigger corporate companies that there is space to innovate if you are brave enough to think a little differently, (and yes, in the end, we too spent two years on ONE CORPORATE MANUAL).

We learnt a lot from the magnitude of this project. Having been used to controlling every detail I was consulted on the implementation of graphics for a huge number of different situations and finally had to delegate. I came to understand that not everything can be perfectly designed by everybody working on a project. In the beginning I would see work by other designers and then redo it, 'correctly', even though I was not asked to do so – a pointless task, you just have to let things go, to try and control and check EVERYTHING is the quickest route to a heart attack.

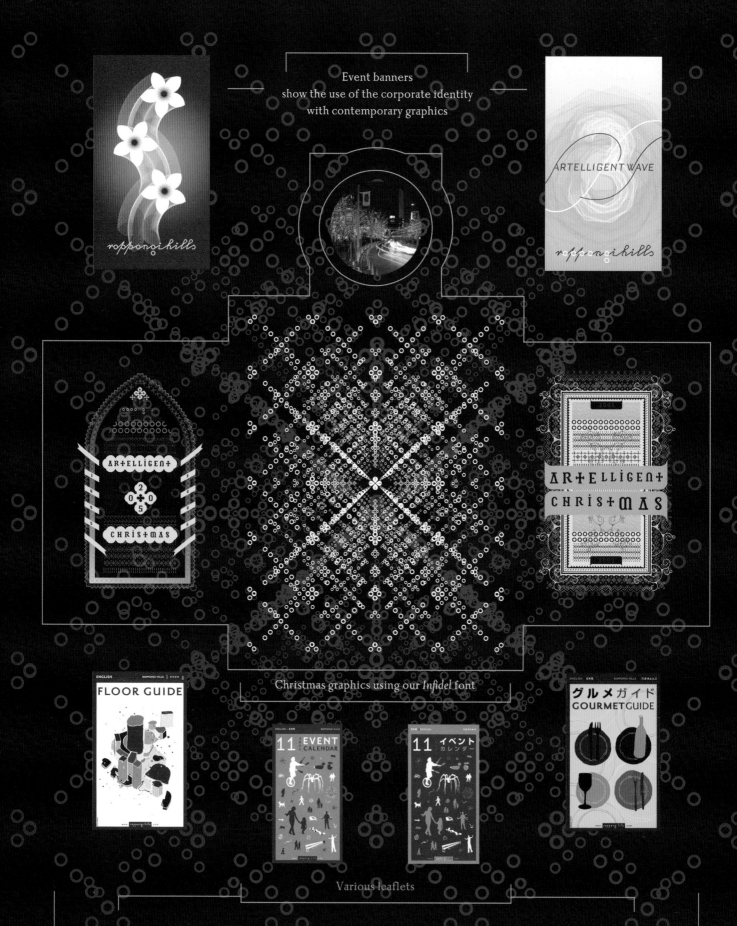

Event banners
show the use of the corporate identity
with contemporary graphics

Christmas graphics using our *Infidel* font

Various leaflets

I learned on this project that a the basic concept should not be too decorative or fashionable otherwise it doesn't last and cannot evolve for future use. However, the supporting graphics should have the flexibility to be influenced by contemporary design, otherwise they will lose their relevance.

Implementation of Roppongi Hills corporate identity by other designers

There is a huge feeling of power when you are involved in a project this size, I could understand how Hitler and Speer felt when they were creating Germania. I was asked to come up with street names as part of the project, none of which they used. I think *Karl-Marx-Allee* and *Barnbrookstrasse* wouldn't have been that popular.

Priori was originally offered to Ropppongi Hills as an exclusive font. I felt I had to use one of our typefaces, because of the size of the project we were almost creating another universe. Thankfully they didn't take it, so I was able to release it in full at a later date through Emigre.

Corporate font for Roppongi Hills	SERIF	PRIORI

MORI ART MUSEUM

TOKYO SKY DECK

ROPPONGI ACADEMY HILLS

ROPPONGI HILLS CLUB

TOKYO CITY VIEW

CONTEMPORARY
ART MUSEUM

OPEN-AIR
WALKWAY

ART + BUSINESS
COLLEGE

RESTAURANTS
AND BARS

OBSERVATION
DECK

CORPORATE HEADLINE
FONT - BOURGEOIS

ABCDEFGHIJKL
MORI ARTS CENTER
STUVWXYZ

Designs for the main headline font *Bourgeois*
(which was subsequently released by Virus).
We wanted a clean bold sans serif, but with
a slight echo of the other corporate font *Priori*.

BOURGEOIS	BOURGEOIS	*BOURGEOIS*	*BOURGEOIS*
BOURGEOIS	BOURGEOIS	*BOURGEOIS*	*BOURGEOIS*
BOURGEOIS	**BOURGEOIS**	***BOURGEOIS***	***BOURGEOIS***
BOURGEOIS	**BOURGEOIS**	***BOURGEOIS***	***BOURGEOIS***

XXVIII.

Corporate identity for Mori Arts Center, a cultural educational and commercial institution located at the top of Roppongi Hills Tower.

This was a tricky problem. We needed to create a main logo that represented Mori Arts Center and individual logos for each of the five subsections. All of these had to relate somehow to each other.

The solution we came up with was to use the concept of 'spectrum'. It was perfect, the word immediately suggested the arts (sound, light or other spectra) and 'the whole range' or 'complete spectrum' of different opinions, artforms, people and of course the diversity of Mori Arts Center.

Generic waveforms were allotted for the different logos of each subsection, when these were overlaid they effortlessly created the main logo. Finally different colours across the entire range of the colour spectrum were given to each subsection, further differentiating them but also unifying them as a cohesive whole when displayed together in the main logo.

MORI ARTS CENTER

TOKYO SKY DECK
MORI ARTS CENTER

MORI ART MUSEUM
MORI ARTS CENTER

ROPPONGI ACADEMY HILLS
MORI ARTS CENTER

ROPPONGI HILLS CLUB
MORI ARTS CENTER

TOKYO CITY VIEW
MORI ARTS CENTER

BOURGEOIS	BOURGEOIS	BOURGEOIS	BOURGEOIS
BOURGEOIS	BOURGEOIS	BOURGEOIS	BOURGEOIS
BOURGEOIS	BOURGEOIS	BOURGEOIS	BOURGEOIS
BOURGEOIS	BOURGEOIS	BOURGEOIS	BOURGEOIS

| Corporate font for Mori Arts Center | SANS SERIF | PRIORI |

We did all of the design work for the opening of the museum, everything from the tickets to the menu for the inaugural dinner. Above are the basic letterhead, merchandise and website.

XXIX.

Associated corporate material for Mori Art Museum. A new international contemporary art museum.

For us this was a very satisfying project, a fulfilment of a long time wish to be the originator of a museum's graphic identity. The fact that we were collaborating with a completely new institution meant that we could reassess how 'culture' is disseminated to the public.

The museum wanted an international presence that was authoritative and modern. 'Modern' in this case refers more to the Russian Constructivists than the Swiss Modernists. The British director of the museum David Elliott already had a strong curatorial and personal interest in that time period, so it seemed natural to echo the same sort of utopian vision. Much of the typography reinterprets those early fantastic experiments by the Constructivists and stops the corporate becoming too straight. The red colour obviously comes from communism.

MORI ARTS CENTER

MAM CONTEMPORARY
MEMBERSHIP SCHEME

PUBLICATIONS + PROJECTS
FUNDED BY THE MUSEUM

サンティアゴ・ククル
SANTIAGO CUCULLU

PUBLIC
PROGRAMS

MAM Contemporary, the membership scheme that the museum operates.
I think we did some particularly nice work for this. Below are the membership
card, folder and different applications of the logo.

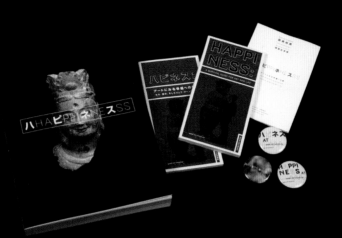

Design work for the opening exhibition *Happiness*

Usually we have a Japanese designer in the studio who works on Japanese text. However, with display typography they only advise about line breaks and appropriate syllable emphasis because I always find it exciting to do the design myself. I hope to create typography which looks different from the norm in Japan.

Designing Without Dead Time

BY KALLE LASN

I first met Jonathan back in 2000 when Rick Poynor invited the then Adbusters' art director Chris Dixon and me to give a talk at London's Royal College of Art. We came to proclaim the *First Things First 2000 Manifesto*. We told the packed auditorium of students that the profession they were about to enter was devoting too much of its skill and imagination towards "selling dog biscuits, detergents, hair gel, cigarettes, butt toners and heavy-duty recreational vehicles" and that what design sorely needed was "a mindshift away from product marketing towards the exploration and production of a new kind of meaning." After the spirited Q&A session a bunch of us adjourned to a restaurant and I found myself sitting next to one of the thirty-three manifesto signatories, a mild-mannered young man with long flowing hair who talked in a whisper so low that I had to put my ear up to his lips to make out what he was saying. I never did understand much of what Jonathan was trying to tell me that evening, but his subdued intensity stayed with me.

Later that year, the manifesto hit the fan and, surprise surprise, it split the design community right down the middle. The debate grew quite acrimonious. Young designers by and large liked it. Students especially loved the idea that the profession they were going to spend their lives in could be about much more than just satisfying commercial clients, that it could actually play a role in the social struggles of our time. But design's old guard hated it. "To try to purify our work of the smell of money is both hypocritical and in vain," they sniffed. Many of them backed away from what they had just signed. Jonathan was among a tiny handful of the signatories who never wavered on the manifesto's cheeky rebuke; in fact, he gave passionate talks about it in schools and at conferences.

Jonathan and I collaborated on a number of bits of graphic mischief which he seemed to enjoy as much as I did, and in 2001, I invited him to art direct the *Design Anarchy* issue 37 of Adbusters. The first thing he did upon arrival was to search the Internet for a music station muse to work by. Then, music pounding, he embarked on a whirlwind few weeks of non-stop design. In between impromptu brainstorming sessions and naps in the attic, his hand never left the mouse. *Design Anarchy* turned into one of Adbusters' wildest tour-de-forces, and the inspiration for a book by the same name that was published a few years later (*Design Anarchy*, Adbusters Media, 2006). In a celebratory ritual after making the deadline, we sheared Jonathan's long blonde mane. I'll never forget how chastened he looked, real humility shining through.

Over the years, I have directed the art in quite a few issues trying to come up with that elusive slick/subversive aesthetic that I felt would launch Adbusters into a global political/cultural force to be reckoned with. I dreamed of a new kind of meta-language for magazines that would fuse text, graphics, photographs and artwork together into a visually driven, stream-of-consciousness flow from cover to cover. But it never quite seemed to gel. One of the closest I think we have got to it is with Jonathan's art direction on *Apocalypse Soon* issue 68 of Adbusters, which thrilled me to the bone. The moods and concepts flowed magically. Every time I picked the magazine up, it sizzled in my hands. I felt he had solved many aspects of the slick/subversive puzzle in the most surprising ways.

Then a few nasty letters started trickling in, and the trickle soon turned into a deluge. For weeks, indignant emails greeted me every morning complaining about the "tiny fonts" and "unreadable colour combinations" angrily signed, "Yours in disappointment and wonder."

People were polarized into camps of those who thought it was visual eye candy and others who thought we had gone mad. I still think that, despite it all, Jonathan has created a new graphic language and is a master of his craft.

What I think I share with Jonathan (and only a handful of other graphic designers around the world today) is the conviction that our work touches people in the most visceral way; that design is the hidden, under-the-radar language of culture and it can be used — nay, should be used — not just to add sparkle to products and brands, but also to change the way people live and think. In other words, that we designers are not just decorators, packagers, commercial hacks. We can be the authors, the producers of meaning and play a part in designing our world out of the horrible ecological, psychological and political mess that it has got itself into.

Kalle Lasn is sometime Art Director, Editor-in-chief of Adbusters magazine and the author of two books, Culture Jam *and* Design Anarchy.

THE BIG QUESTION:

IS ECONOMIC PROGRESS

KILLING The PLANET?

XXXI. Adbusters collaborations

AE: *So... what's the bloody point in* GRAPHIC AGITATION?

JB: Thank you for that most direct of questions to start with. There is a point obviously, otherwise I wouldn't keep on trying. But if you mean, 'what's the point of trying to change the world just through graphic design?', I would say there isn't. However as a channel to reproduce a message to as many people as possible, I would say graphics is perfect. There is no point though if you are just talking to yourself or other graphic designers, graphic design can only be of use if it is seen as part of a wider movement to bring about change.

Very well crawled out of, but do you really practice what you preach?

Er...yes, it would feel wrong if I were to go around criticising people if I don't follow the example myself. So I never buy goods from questionable companies and I try to be respectful to all those I work with – as I would prefer the corporations who are implicated in slave labour claims to be.

Yes, but you are still a commercial designer. How can you reconcile what you do in your commercial work with what you are doing for people like Adbusters.

Well I would say that I am a lot less hypocritical than most. I do make a moral judgment about the jobs I take on, usually the last consideration is money and the first is to check if it ethically feels OK. I don't believe the lowest common denominator argument about earning a living is enough to justify not thinking about who you work for. If we applied that to every job in society then there would be very little social change for good.

OK on with the work. How did you hook up with Adbusters and what was the first project you did with them?

I found Adbusters magazine by accident in a shop in London, I took it home and read through it. It was full of ideas and thoughts so similar to my own at the time I could almost not breathe with excitement when reading it. I didn't realise that there was someone already established that was representing these views.

The first thing I did for them was the poster *Is Economic Progress Killing the Planet? 1999 (previous spread)* for the G7 summit. At the time I wasn't very confident about what I had done but looking back on it that was because up until then much of the design work from Adbusters had been quite simple. I just did it my own way, which I suppose is quite graphically complex. Thankfully they wanted to go in a new direction, I understand now that it was important for their graphics to evolve to combat the advertising that was around at that time.

I still think the idea behind the poster is very classic graphic design – a double-take reinforces the copy line of the poster which uses the visual language of my generation.

Some time after they were in London giving a talk to launch the *First Things First Manifesto 2000* which I had signed. When I met up with them, they were the opposite of what many people imagine, very charming, self-deprecating and amusing.

I am sure many people who read this interview know about the *First Things First Manifesto* already but for those that don't it was a republishing of a document first written by Ken Garland in 1964. The process was explained to me by Kalle Lasn, "Chris Dixon and I spawned the idea of reissuing it, Tibor Kalman gave it a boost. I came up with the first rambunctious draft and played ed-in-chief, as our senior editor at the time James MacKinnon massaged it and played extensive text ping-pong with Rick Poynor. He suggested changes, got feedback from many prominent designers and cajoled a number of them into signing it. I gave it a final edit, reinserting some of the original rambunctiousness."

first Things first **1964**

a manifesto

Signed:
Edward Wright
Geoffrey White
William Slack
Caroline Rawlence
Ian McLaren
Sam Lambert
Ivor Kamlish
Gerald Jones
Bernard Higton
Brian Grimbly
John Garner
Ken Garland
Anthony Froshaug
Robin Fior
Germano Facetti
Ivan Dodd
Harriet Crowder
Anthony Clift
Gerry Cinamon
Robert Chapman
Ray Carpenter
Ken Briggs

We, the undersigned, are graphic designers, photographers and students who have been brought up in a world in which the techniques and apparatus of advertising have persistently been presented to us as the most lucrative, effective and desirable means of using our talents. We have been bombarded with publications devoted to this belief, applauding the work of those who have flogged their skill and imagination to sell such things as: cat food, stomach powders, detergent, hair restorer, striped toothpaste, aftershave lotion, beforeshave lotion, slimming diets, fattening diets, deodorants, fizzy water, cigarettes, roll-ons, pull-ons and slip-ons.

By far the greatest effort of those working in the advertising industry are wasted on these trivial purposes, which contribute little or nothing to our national prosperity.

In common with an increasing number of the general public, we have reached a saturation point at which the high pitched scream of consumer selling is no more than sheer noise. We think that there are other things more worth using our skill and experience on. There are signs for streets and buildings, books and periodicals, catalogues, instructional manuals, industrial photography, educational aids, films, television features, scientific and industrial publications and all the other media through which we promote our trade, our education, our culture and our greater awareness of the world.

We do not advocate the abolition of high pressure consumer advertising: this is not feasible. Nor do we want to take any of the fun out of life. But we are proposing a reversal of priorities in favour of the more useful and more lasting forms of communication. We hope that our society will tire of gimmick merchants, status salesmen and hidden persuaders, and that the prior call on our skills will be for worthwhile purposes. With this in mind we propose to share our experience and opinions, and to make them available to colleagues, students and others who may be interested.

We, the undersigned, are graphic designers, art directors and visual communicators who have been raised in a world in which the techniques and apparatus of advertising have persistently been presented to us as the most lucrative, effective and desirable use of our talents. Many design teachers and mentors promote this belief; the market rewards it; a tide of books and publications reinforce it.

Encouraged in this direction, designers then apply their skill and imagination to sell dog biscuits, designer coffee, diamonds, detergents, hair gel, cigarettes, credit cards, sneakers, butt toners, light beer and heavy-duty recreational vehicles. Commercial work has always paid the bills, but many graphic designers have now let it become, in large measure, what graphic designers do. This, in turn, is how the world perceives design. The profession's time and energy is used up manufacturing demand for things that are inessential at best.

Many of us have grown increasingly uncomfortable with this view of design. Designers who devote their efforts primarily to advertising, marketing and brand development are supporting, and implicitly endorsing, a mental environment so saturated with commercial messages that it is changing the very way citizen-consumers speak, think, feel, respond and interact. To some extent we are all helping draft a reductive and immeasurably harmful code of public discourse.

There are pursuits more worthy of our problem-solving skills. Unprecedented environmental, social and cultural crises demand our attention. Many cultural interventions, social marketing campaigns, books, magazines, exhibitions, educational tools, television programs, films, charitable causes and other information design projects urgently require our expertise and help.

We propose a reversal of priorities in favour of more useful, lasting and democratic forms of communication—a mindshift away from product marketing and toward the exploration and production of a new kind of meaning. The scope of debate is shrinking; it must expand. Consumerism is running uncontested; it must be challenged by other perspectives expressed, in part, through the visual languages and resources of design.

In 1964, 22 visual communicators signed the original call for our skills to be put to worthwhile use. With the explosive growth of global commercial culture, their message has only grown more urgent. Today, we renew their manifesto in expectation that no more decades will pass before it is taken to heart.

Signed:
Jonathan Barnbrook
Nick Bell
Andrew Blauvelt
Hans Bockting
Irma Boom
Sheila Levrant de Bretteville
Max Bruinsma
Siân Cook
Linda van Deursen
Chris Dixon
William Drenttel
Gert Dumbar
Simon Esterson
Vince Frost
Ken Garland
Milton Glaser
Jessica Helfand
Steven Heller
Andrew Howard
Tibor Kalman
Jeffery Keedy
Zuzana Licko
Ellen Lupton
Katherine McCoy
Armand Mevis
J. Abbott Miller
Rick Poynor
Lucienne Roberts
Erik Spiekermann
Jan van Toorn
Teal Triggs
Rudy VanderLans
Bob Wilkinson

first Things first **2000**

a design manifesto

Why did you sign the manifesto?

Er... because I was asked. Not a very interesting anecdote but it was something I had to think about a lot before I went ahead. In the end I signed it because I was, and still am, in absolute agreement with everything it said and I thought that it would be a good thing to promote debate. I knew that the manifesto would annoy people – it is irritating to be told by your contemporaries what you are doing is not right, particularly since there is very little criticism of the more commercially successful designers.

However I wasn't prepared for the kind of backstabbing comments and wholesale demolition of it. I won't be so ungracious as to mention names, but there were a few designers who attacked it like their lives depended on it. They obviously found it a threat, but none of them appeared to come up with any solution other than keeping the status quo. It reminded me of the anger that I used to feel at college towards the smugness of the larger design groups who came in and lectured. They seemed to think they knew how every design solution was formulated. Everything they did was always framed in the parameters of marketing. Worse, they saw design as a playful, less serious cousin to fine art, it was rarely shown as a vehicle for social change or a meaningful exchange between humans.

And so what happened to the people who signed it after it was released?

It wasn't really a cohesive group of people, some of us knew each other but there was no discussion and very little collaboration or noise after the event. So it was dismissed much more quickly than it should have been, but the point of any manifesto is that it is a starting argument. Personally I got lots of emails complaining that I signed it, what difference did I think it would make? and was it really going to change graphic design? I also got quite a few messages from people supporting it, saying that the manifesto had definitely expressed something that they had felt for a long time. Some colleges actually discussed and wrote their own manifestos as part of their coursework.

I think things came to a head at the AIGA conference in Las Vegas, 2001. There was no official talk about the manifesto but it was on everybody's lips. For that event I also did a billboard with Adbusters to go in the vicinity of the conference centre on Las Vegas Strip. It featured a quote from Tibor Kalman 'Designers, Stay Away From Corporations That Want You To Lie For Them' (right page). I got a lot of negative reactions to this. Quite a few people came up to me and poked me in the chest because they were so offended.

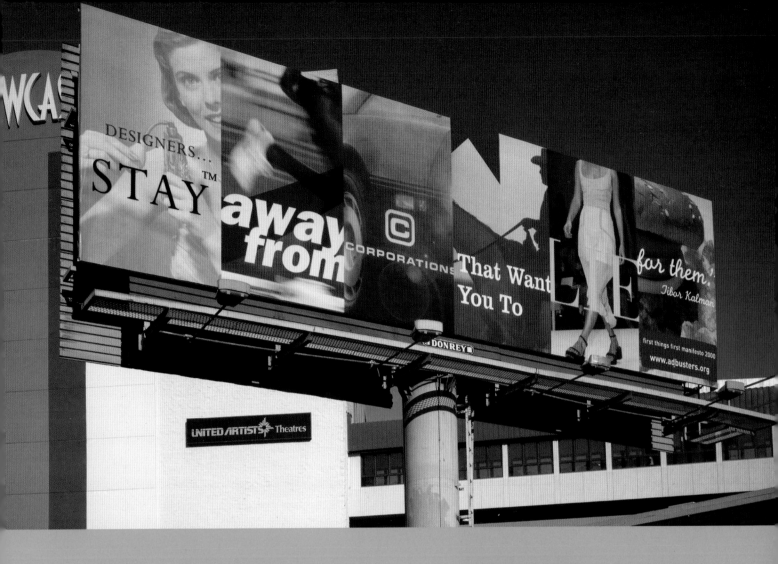

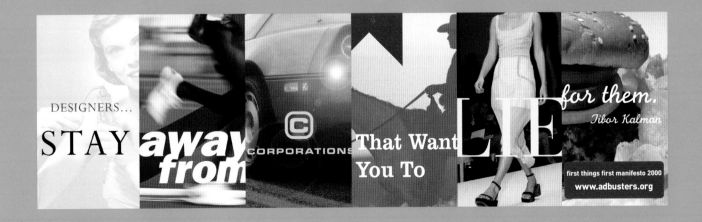

Did anything appear in print to combat this feeling?

One of the ways we tried to address the problem that we were a few designers 'preaching' was to do a poster which updated the manifesto and featured all of the additional people who had signed it on the Internet. I wanted to emphasize their importance and show that the idea had grown.

The FTF update poster is also very important for me because of the reverse side (right page). This took me ages but I wanted to analyse the implications of buying a product and place design within that context. I still think it is one of the most important things I have done, for me it was a leap forward in my work. With great effort I actually explained something that I thought was almost unexplainable visually. It was also one of the first times I had written this much analytical text. The main purpose was to explain all of the socio-political implications of buying a product in an easy-to-understand diagram. I suppose it was information design in that sense, but of course I wanted to make it attractive to look at too. Most of the sources were books I had been reading at the time such as *No Logo* by Naomi Klein (Flamingo, 2000). Adbusters contributed the text about the psychological effects of advertising.

That's all very fine and idealistic but could you not see why people were upset though?

It is only idealistic in the sense that it is normal to want to change things for the better. To answer your question about why they were annoyed, I think it was because we were going against what they were taught at college and their experiences of the supposed *real world* – the designer just conveying the message of the client. I love some of the clients that I work with but I can neither ignore their message nor the idea of not having any responsibility for it. That notion was formulated before widespread concerns about the environment, before multinationals had the power that they have today and before people's basic facilities like water and electricity were privatised. On the other hand maybe it was a just a bit too early to re-release it, even though many may say it was long overdue, it really seemed like a huge shock to the design community at the time. I think that now society is much more amenable to this sort of thing. There is a part of me though that can't help feeling f***ed off with some of their reactions. There was so much petty mindedness going on. I almost felt like graphic design deserved to be in this kind of irrelevant hole, if people were going to do things like complain about the signatories by checking their client lists. Time should have been spent discussing the issues contained in the manifesto.

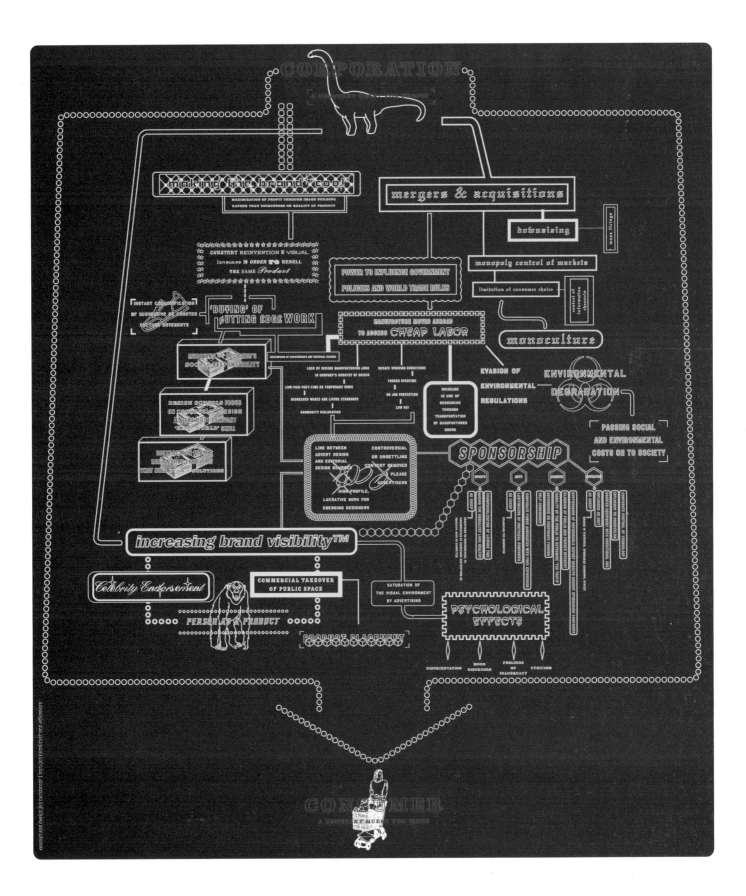

ADBUSTERS

No.37

SPECIAL DOUBLE ISSUE.

DESIGN ANARCHY

US/CAN $7.95 UK £4.50 ¥1500

05

VOL 9 NO. 5 SEPT/OCT 2001

Any other stuff you did with Adbusters?

The biggest thing we haven't mentioned yet was when I went to Vancouver (where Adbusters are based) for a couple of weeks to art direct a whole issue. A little bit daunting, since I felt like I hadn't done much magazine work. Yes, I still get scared in those kind of situations. I had no idea how we would work together in the limited time.

Did you enjoy working with them directly? Any ego clashes, theatrical arguments, special requests to have your dressing room full of drugs and groupies and oh yes, what was the issue about?

Good to see you got your priorities right, but we got on really well. There were a few close calls with deadlines and there were a few pages where I thought I could have done a bit better. The support though was great. Kalle, the editor was very open to change, the art directors Mike Simons and Paul Shoebridge – plus the illustration of Bill Texas and the photography of Pat Hemingway – made a strong team which got everything organised and done on time. The actual issue itself was called *Design Anarchy*, also the name of a book that Adbusters published in 2006. I think the magazine was a way of testing out the theories that were fleshed out in the book. It was the first time an issue was completely devoted to design and asked the proponents in the field to be accountable for what they were doing. It included writers and designers contributions from all around the world. I rather like the cover (left page) done by Mike Simons. It featured a cosmetics advert scribbled over and expressed the energy of the issue really well.

design

TM © ®

TM © ®

Can you take us through some of the pages of the issue?

Let me say now I didn't design every spread either, there were a lot of others who contributed, but I can take you through some of the more interesting pages that I did. Below was a comment on the low value many people put on design as a vocation in life. It always seemed to some to be the option where you were guaranteed to 'have a career and make steady money' rather than attempt to change society.

I wanted to be an artist but I became a graphic designer instead*

MOVEMENTS IN DESIGN

Arts & Crafts Movement, 1800s
Art Nouveau, 1890–1910
Futurism, 1909
Dadaism, 1916
De Stijl, 1917
The Bauhaus, 1919
Art Deco, 1920s

Swiss Design, 1940
New York School, 1940s, 50s
Push pin Style, 1960s
Postmodern Design, 1990s
New Wave Typography, 1990s
Design Anarchy, 2000s

*set in 40pt helvetica

TM © ®

TM © ®

MASTURBATION

Repetitive. Self-serving. Addictive.

𝔇𝔢𝔰𝔦𝔤𝔫 today lacks blood; it lacks conviction; it's like a corpse— beautifully laid out and well mannered but not going anywhere.

The above sequence is about the 'money' side of design and also the need that companies have to constantly change the form of their products in order to resell the same things to us again. All of the ©, ® and ™ symbols were a dig at how much 'designed objects' cost and how 'creativity' is a legally protected commodity. That is the opposite of what I regard as good design. It is a problem that society fails to understand the relevance of design when it isn't in the service of consumerism, and also that designers seem to be very happy to get rich selling work to rich people.

The quiet destruction of the natural world is the narrative of our time, a story that needs to be told and retold, in ways too compelling to ignore. But the design world is caught up in another story - the commercial story, the catch the eye / stimulate desire / move the merchandise / story.

This spread features one of the most irritating corporate identities of the past few years. Landor should be f***ing ashamed of themselves and their greenwash design. What's greenwash? Derived from the word 'whitewash' in this case it means a superficial branding to claim that what they do is environmentally friendly, when they are (allegedly) harming the environment (as in the case of BP). It is a low moral point in mainstream graphic design, so we had to feature it somewhere in the magazine.

DESIGN

DESIGNERS ARE

★ FALLING OVER

★ EACH OTHER TO

KISS

CORPORATE

ASS

our humanity has

become DISLOCATED

Do you remember the time when your car didn't have a cupholder and a regular coffee was just that? You know - regular.

"I have tried to find other designers, but I can't find anyone with his humour, irony, irreverence, and wit. Philippe always pulls new rabbits out of a hat."

Ian Schrager

Design is now a fashion system.

You see it, don't you?

I find this spread very difficult to look at, the idea was not mine as it has appeared in Adbusters many times before. I find its simplicity both intriguing and uncomfortable. It sums up the relationship between fast food/multinationals, obesity in the West and malnutrition in the developing world in such a direct way (maybe the equivalent of an unwatchable TV documentary).

The back cover (right) features an idea I had about the use of the Gap logo – it was motivated by the allegations that Gap use slave labour to manufacture clothes and the (alleged) stupidity of the people who purchase products from them, legitimising their actions. I love the text that Adbusters wrote for this, which was aimed very directly at designers.

So what was the reaction to the magazine?

There were various reactions to it, I was party to some very irritating correspondence between two designers (both of whom were involved with the FTF manifesto), who went on for ages about the lack of page numbers in the magazine rather than the actual issues discussed… absolutely amazing.

The issue sold very well but I did get a lot of people writing to me saying they didn't like it, citing the lack of 'design debate' in it, which was a little ridiculous. Well it wasn't an issue of *eye* magazine, it was done by Adbusters, they are not design journalists. Design is a small part of the whole of their work and it spoke to designers in a language that they were not quite used to. Personally when I was working on it I knew it was going to be criticised. It spoke to a mass audience as well as designers.

Previous spread: This is one of my favourite layouts (although I do rather like Philippe Starck) because most designers are too frightened to say something so blatant for fear of offending their clients and contemporaries.

You head down each day
into the irony mines.

Something's slipping. You don't
want to be the next to get an ulcer.
They say your work is edgy. You
know you've got the eye.

In daydreams, you see yourself
on board an eco-warrior ship.
Or just teaching piano. But
who's kidding who? That
won't pay the mortgage.

GAP

You don't ask too many
questions of your heart.

A friend asked: would you want your
kids to do what you do for a living?
That was a year ago, and you still
don't have an answer.

You catch the eye.

You stimulate desire.

You move product.

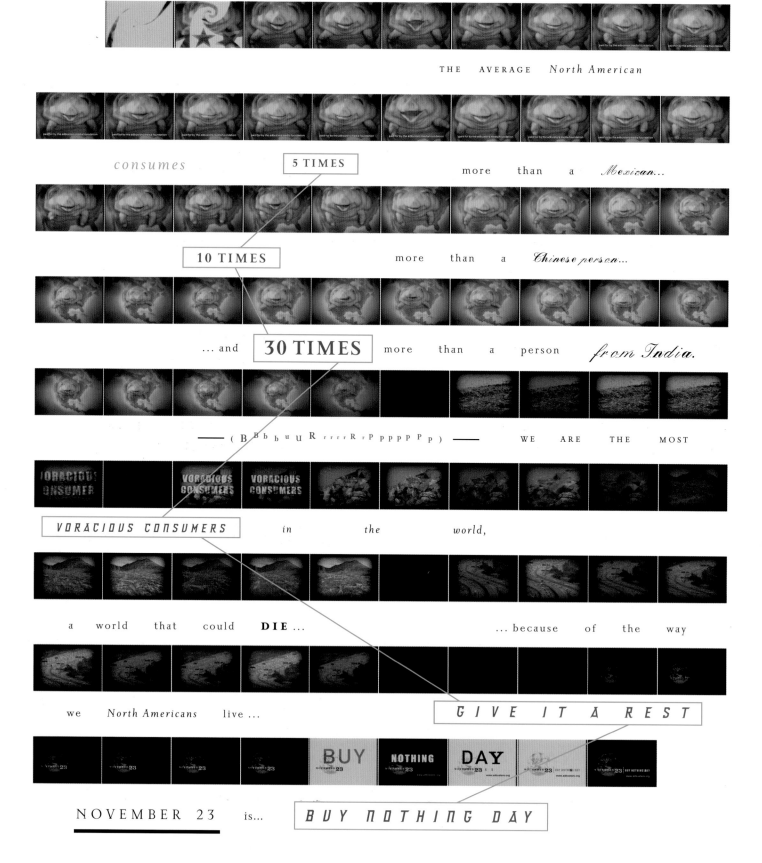

THE AVERAGE *North American*

consumes 5 TIMES more than a *Mexican...*

10 TIMES more than a *Chinese person...*

...and **30 TIMES** more than a person *from India.*

——— (BBbbb$_u$u$_u$R r r r r R r r P p p p p P p) ——— WE ARE THE MOST

VORACIOUS CONSUMERS in the world,

a world that could **DIE** because of the way

we *North Americans* live ... GIVE IT A REST

NOVEMBER 23 is... BUY NOTHING DAY

VIII. THIS PAGE NOT
SPONSORED BY A
COMPANY THAT TRIES
TO SELL DEVELOPING
NATIONS CASH CROPS
WHICH ARE LESS
SUSTAINABLE THAN
THE ONES THAT ARE
ALREADY USING

Are you involved with Buy Nothing Day?

A bit… but maybe I should explain to anybody reading this what exactly you are talking about. *Buy Nothing Day* is a yearly event in November when people are encouraged not to shop. There are also a number of interventions, for instance in shopping malls, raising consciousness about these issues. I don't know if that all sounds pointless, it's obviously not just about the act of shopping, more looking at the values of consumerism, possibly doing something more constructive with our 'leisure time' or not judging our society's success by sales figures.

Buy Nothing Day has been growing over a number of years and now takes place in about sixty-five different countries. I think of all the activities that Adbusters promote it's the one that has the highest profile (and they now only promote it as it has taken on a life of its own). It has even become part of some school curriculums. I think it's one of the few cases where people are given a contrary point of view to most of the pro-consumerist hype they often have to read and has promoted debate about a subject which is not discussed enough in the mainstream media.

So my own small contibution was to redo what I thought was a great advert or 'uncommercial'. The original script and animation were done by Vancouver filmaker Bill Maylone. I loved it but I really thought it needed an update to compete with today's much more seductively polished advertising. It features typography, which directly emphasizes the message and an out of tune version of the American national anthem, which was a very sensitive issue at the time as it was right after 9/11.

We also did a Japanese version featuring a pig on the main island of Japan rather than America, which was shown on street TV in the main shopping districts of Tokyo. I am sure it was a completely alien idea to many of the people in a country that has one of the most 'advanced' consumerist, disposable societies on the planet.

Various events around the world on *Buy Nothing Day* in 2005

adbusters

JOURNAL OF THE MENTAL ENVIRONMENT

WWW.ADBUSTERS.ORG | US/CAN $7.95 · UK £4.00 · AUS $9.95

ISBN 0947-9090

05

7 78624 79265 5

APOCALYPSE SOON >>

Anything more recent?

Very recently we have done another issue, but instead of going to Vancouver, Pedro Inoue and I designed it all in our studio in London. The process worked well I think. For us it was great to do a project so quickly, it gives you more freedom to allow yourself to create design that doesn't have to be agonised over for a long time. It's more a case of get the text, read it properly and come up with the concepts very, very quickly, then implement them in an understandable form. I think from being given the text to artwork for the whole magazine took 13 days.

How do you think that this issue will be received by the design community compared to the first one you did?

This issue is not specifically aimed at a design audience, so they may not even know that I designed it. Many of them will have stopped reading Adbusters when it stopped annoying them by talking about design. Unfortunately in design (and other professions of course) people separate what they do in their jobs from the effect that has on society as a whole, so of course the issue is still relevant to them. As an aside, I think that is one of the misconceptions about our political work, it's not specifically for designers – it's not specifically for any audience. I hope that all of this work is easily understood and communicates to everybody.

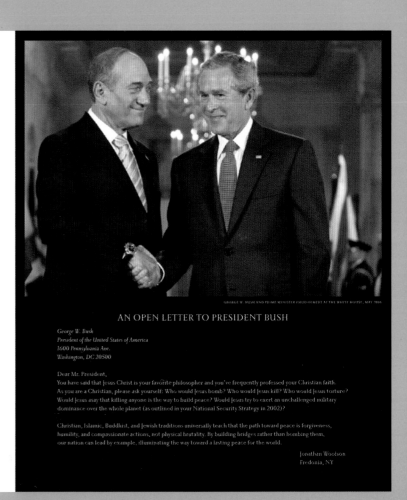

LEBANON · ISRAEL · PALESTINE

POEMS BY RENOWNED PALESTINIAN POET
TAWFIQ ZAYYAD, FORMER MAYOR OF NAZARETH

When the late Zayyahd became a member of the Israeli parliament, his Hebrew was not very good.
One of the government members shouted, "Where did you study Hebrew?" and he replied, "In your prisons."

All I Have

I never carried a rifle
On my shoulder
Or pulled a trigger.
All I have
Is a flute's melody
A brush to paint my dreams,
A bottle of ink.

All I have
Is unshakeable faith
And an infinite love
For my people in pain.

GEORGE W. BUSH AND PRIME MINISTER EHUD OLMERT AT THE WHITE HOUSE, MAY 2006

AN OPEN LETTER TO PRESIDENT BUSH

George W. Bush
President of the United States of America
1600 Pennsylvania Ave.
Washington, DC 20500

Dear Mr. President,
You have said that Jesus Christ is your favorite philosopher and you've frequently professed your Christian faith. As you are a Christian, please ask yourself: Who would Jesus bomb? Who would Jesus kill? Who would Jesus torture? Would Jesus say that killing anyone is the way to build peace? Would Jesus try to exert an unchallenged military dominance over the whole planet (as outlined in your National Security Strategy in 2002)?

Christian, Islamic, Buddhist, and Jewish traditions universally teach that the path toward peace is forgiveness, humility, and compassionate actions, not physical brutality. By building bridges rather than bombing them, our nation can lead by example, illuminating the way toward a lasting peace for the world.

Jonathan Woolson
Fredonia, NY

Why is it called 'Apocalypse Soon'?

It was done mid 2006, when Israel was bombing the f*** out of Lebanon while the US and UK government seemed to be standing idly by. We had a Lebanese student here at the time and also were in contact sporadically with friends we knew in Beirut, so it affected us a great deal. It was very much about where the current crisis in the Middle East is actually going to lead us. The magazine contains a large amount of creative writing about other subjects as well.

Can you talk briefly about the magazine design?

Actually thinking about it, No... for this one it is a lot easier to just look, so laboriously explaining each section is not going to help that much, the *Design Anarchy* edition needed it but not this one, the captions should be enough.

The spread below was dealing with the idea that appreciation of food has replaced sex as a major leisure time activity.

Comida by Paul B Hertneky | But, today, we are goaded into elaboration. Our media heralds every aspect of food. The programs, advertisers, researchers and advocates have made an industry out of informing and scaring and enticing us. We are urged to define ourselves by our choices, and to talk about them, often with our mouths full.
We can subscribe to at least forty established food magazines and ogle more than 200 cookbooks published every year. Food channels have introduced saucy celebrities with expanding empires of licensed goods. They're bought, sold, traded, auctioned, and rated by hundreds of nerdy websites and countless weblogs detailing what's for dinner. An internet search of "culinary" yields 51 million responses. And "tapas" brings 18 million. All this talk about food runs to what will kill me and harm me, worry me and cure me, shock me and delight me, impress me, remind me, transport me, seduce me and impel me to write and tell others all about it. Other writers often say they can't resist – tasting, indulging, overeating, and bringing every known adjective to bear on the cellular structure of, say, poblano chilies. Without extravagance, there would be no audience. Lavishly endowed foodies strive for cavernous kitchens and countertops that will withstand cruise missiles. As virtue, they support organic farmers, cottage industries, and lychee growers in hardscrabble provinces, sharing their wealth with every corner of the world. They entertain. And show off. And gather to compare and compete.
These enthusiasts devour cultural output. They gorge on images and words, rapturous words, stern words, clever words, words in the mouths of stars, experts, chefs and doctors, words off the fingertips of those like me, who obsess about food, unleash our imaginations on food, craving and coveting it, loving it and fondling it, very much fearing it, and essentially having it replace sex in our middle age. | **Jump to End of Magazine >>>>>>>>>>>>>**

TIM'S AFFAIR WITH A CUCUMBER

This issue was divided into separate sections each using a word which ended in 'o' to give a kind of unity – PSYCHO, ECO, TECHNO, CORPO, POLITICO, POMO & FINITO. Kalle Lasn later explained that these seven areas seem to cover just about all the aspects of our lives that Adbusters want to deal with from issue to issue.

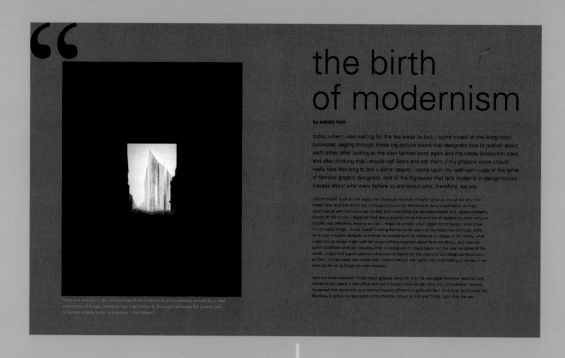

the birth
of modernism

by natalia ilyin

This section on architecture started off with the sober, grey visual language of Modernism and finishes with the ephemeral self celebration of postmodernism and 'star architects' and yes all of the tall buildings are made to look like penises with the addition of a pair of balls to each image.

OK, what is the process for designing something like this?

It's about working in a team but valuing the role within that. There are no thoughts about showing off or making people realise that we did it. We just wanted to solve a worthwhile communication problem effectively and appropriately. Usually each layout is an ongoing dialogue with Kalle Lasn. The text gives us an idea, we visualize it and send it to Kalle and he will honestly comment about it.

Do you feel differently about working for Adbusters now?

I am still as enthusiastic, even though the shape of my studio has changed since I did the first one. What is different is that the world seems a much worse place now than when I did the previous issue. The American government is in the shit in Iraq and probably will be for many years to come. Bush spends all his time bleating on about the war on terror and in doing so aligns more people and countries against him. He is reducing spending on the poor to give to the rich. Corporations have infiltrated and bought off governments to the extent that they seem to have a free rein.

On reflection what do you think about your work with Adbusters, has it really made a difference?

I hope it has made a difference, as I have said before those sort of things are almost impossible to quantify. I think it is important for design that people such as Adbusters are around to remind us of the negative effects of advertising and the wider issues that design raises in relation to society. Adbusters are not afraid to say things that many in the design profession would be; they have no clients to please, no other designers to worry about offending and no livelihood to protect. Some of the work, although very open to criticism because of its often rhetorical style, has become a concrete representation for much of the discontent with design and society that many of us were feeling. I think it was very important to acknowledge that voice.

And I have to ask this, why do you think Adbusters work with you?

Well one of the things that people often say to me is that they would love to work for Adbusters. Very few of them though make the effort to contact them with a specific proposal or put energy into actually pursuing a commission. So it takes a bit of energy which I think I have. Adbusters also are quite careful not to use the wrong sort of person who might be doing it just for the 'cool' factor. I hope the work that I do for them shows that I absolutely believe the message that I am asked to convey as a designer and as a person.

XXXII. ANTI-CORPORATE & POLITICAL WORKS

MOST OF THE POLITICAL WORK IS QUITE RECENT. ITS ONLY NOW THAT I FEEL I CAN ARTICULATE WHAT EXACTLY I WANT TO SAY. IT HAS ALSO BEEN THE MOST COLLABORATIVE. I WORKED VERY CLOSELY WITH THE OTHER MAIN GRAPHIC DESIGNER IN MY STUDIO PEDRO INOUE. THE MANDALAS, U.S.RAEL AND SPIRITUAL JOURNEY ARE ENTIRELY HIS OWN CREATION WHILE WORKING HERE. OTHERS LIKE 911 COME FROM PASSING THE LAYOUTS BACK AND FORTH AND REFINING THEM TOGETHER UNTIL IT'S UNCLEAR WHO CAME UP WITH WHAT. FOR ME THIS WAS A COMPLETELY NEW WAY OF BEING CREATIVE ABOUT SUCH PERSONAL SUBJECTS. AFTER 10 YEARS OF THINKING THAT I ALWAYS HAD TO CONTROL EVERYTHING MYSELF THIS IS WAS A REALLY POSITIVE STEP FORWARD.

MANY OF THESE WERE COMPLETED FOR EXHIBITIONS, IN PARTICULAR BUY ME, BOMB ME AT ROCKET GALLERY, TOKYO IN 2003, AND TOMORROW'S TRUTH AT SEOUL ARTS CENTER, IN SEOUL 2004. CREATIVELY WE SET ASIDE TIME IN THE STUDIO TO MAKE WORK ABOUT 'REAL WORLD' SUBJECTS THAT CONCERN US. I HAVE MIXED FEELINGS ABOUT ONLY EXHIBITING IN A GALLERY, THEREFORE MUCH OF IT IS AVAILABLE TO DOWNLOAD ON OUR WEBSITE. I WANT IT TO BE SEEN BY AS MANY PEOPLE AS POSSIBLE BUT IT IS EQUALLY IMPORTANT THAT A GALLERY AUDIENCE REALISES THAT GRAPHIC DESIGN IS NOT JUST A COMMERCIALLY LEAD AREA.

THIS PIECE OF ARTWORK

REMOVED

FOR LEGAL REASONS

After consultation with a lawyer, this section has had a large number of artworks withdrawn. They represent our beliefs and responses to the world, but because they either contained text criticising a company or portrayed a negative view in conjunction with an image of their logo we were forced to remove them.

So just to clarify, it's OK for multinationals to try and infiltrate every aspect of your life and shove their adverts in your face every possible second you are awake. It also seems to be fine for them to try and pretend that they are at the centre of 'cool' and a vital part of our culture. However, it's not OK when somebody makes what they feel is a valid cultural comment or criticises the practices of these companies in a visual form. Everything possible is then done to suppress it. Not only are vicious lawyers constantly on the prowl for 'trademark violation' but also within the make-up of the law itself it is very difficult for an individual to risk defending themselves in court because of the expense.

If you would like to see the artworks, you can do a quick search on the internet. Thankfully corporations are not able to completely control this medium, although plenty are trying.

POLITICS IS OFF THE AGENDA IN MOST OF THE ESTABLISHED ART WORLD UNLESS IT HAS THE DISTANCE OF TIME AND IS THEREFORE IMPOTENT. WE HAVE OFTEN BEEN ASKED TO SUBMIT TO 'PUBLIC' ART EXHIBITIONS, AND HAD OUR WORK REJECTED AS INAPPROPRIATE. SURELY IF ART REFLECTS LIFE THEN THESE WORKS ARE LEGITIMATE.

I CAN'T HELP NOTICING THAT 'CONTROVERSIAL' ARTWORKS RARELY DEAL WITH THE POWER STRUCTURES IN ART OR THE ORIGIN OF THE PROFITS BIG BUSINESS USES TO 'INVEST' IN CONTEMPORARY ART. AFTER ALL, WHY BITE THE HAND THAT FEEDS YOU? THERE ARE SOME WHO HAVE TRIED AND FAILED. ONE OF THE MOST FAMOUS CASES IS THE REJECTION OF HANS HAACKE'S SHAPOLSKY ET AL MANHATTAN REAL ESTATE HOLDINGS, A REAL-TIME SOCIAL SYSTEM, AS OF MAY 1ST 1971 BY THE THEN DIRECTOR OF THE GUGGENHEIM THOMAS MESSER. THE WORK LISTED THE PROPERTY DEALINGS OF THE SHAPOLSKY REAL ESTATE GROUP IN NEW YORK. IT WAS CLAIMED THAT THIS WAS BOTH INAPPROPRIATE AND ALIEN TO THE WORLD OF AN ART MUSEUM. THE ARTIST REFUSED TO WITHDRAW THE PIECE, THE CURATOR EDWARD F. FRY WAS SACKED WHEN HE DEFENDED IT AND THE EXHIBITION WAS CANCELLED.

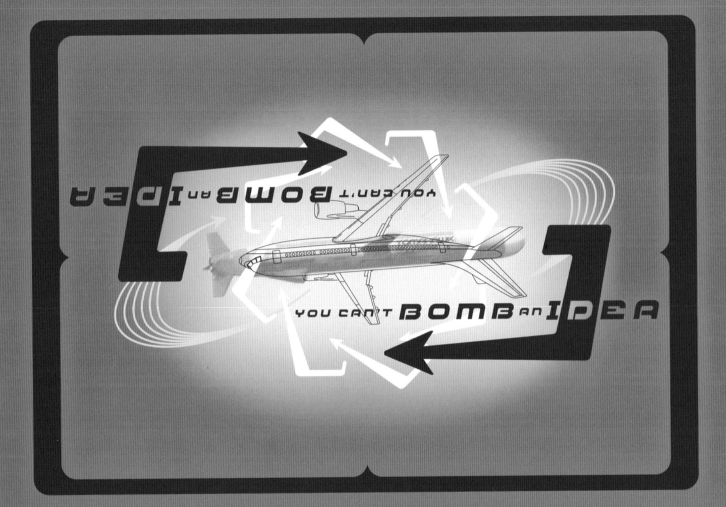

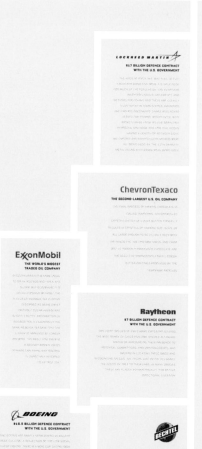
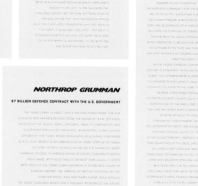
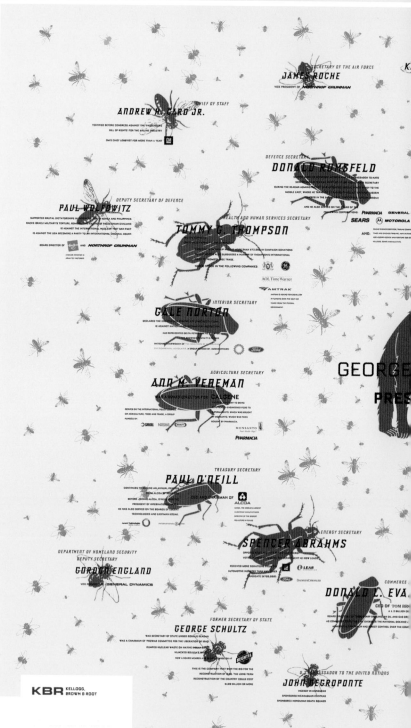

HALLIBURTON

KBR KELLOGG, BROWN & ROOT

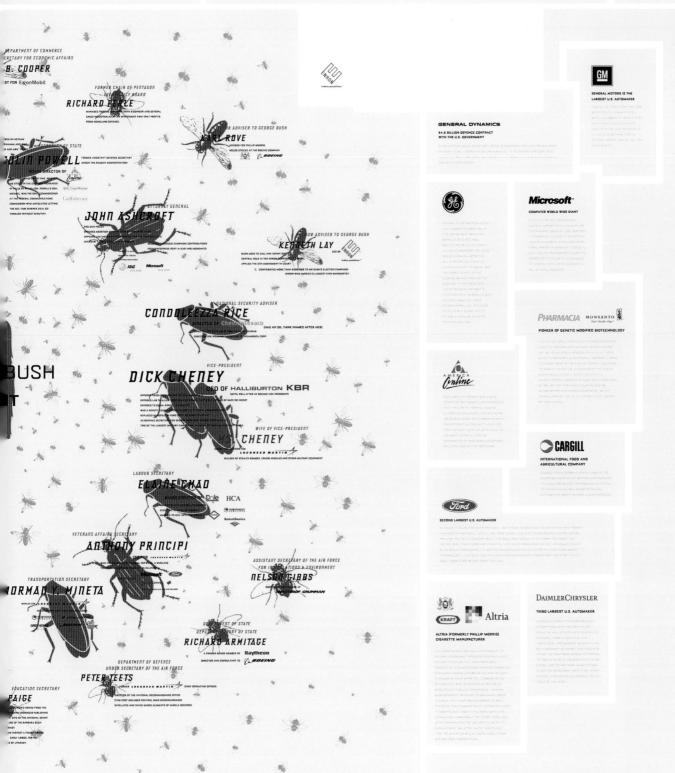

I REGARD THIS AS ONE OF THE MOST IMPORTANT PIECES WE HAVE DONE TO RAISE THE ISSUE OF CORPORATE POWER. WE WANTED TO SIMPLY SHOW IN ONE PIECE OF WORK ALL OF THE ALLEGED CORPORATE LINKS TO THE POLITICIANS IN THE AMERICAN GOVERNMENT. THIS TOOK MANY WEEKS OF RESEARCH. WE HOPED THAT PEOPLE WHO DOWNLOADED IT WOULD BE ABLE TO SEE CLEARLY THAT THE POLITICAL DECISIONS BEING MADE WERE NOT OUT OF FAIRNESS OR CONCERN FOR THEIR BEST INTERESTS, BUT FOR MORE QUESTIONABLE REASONS

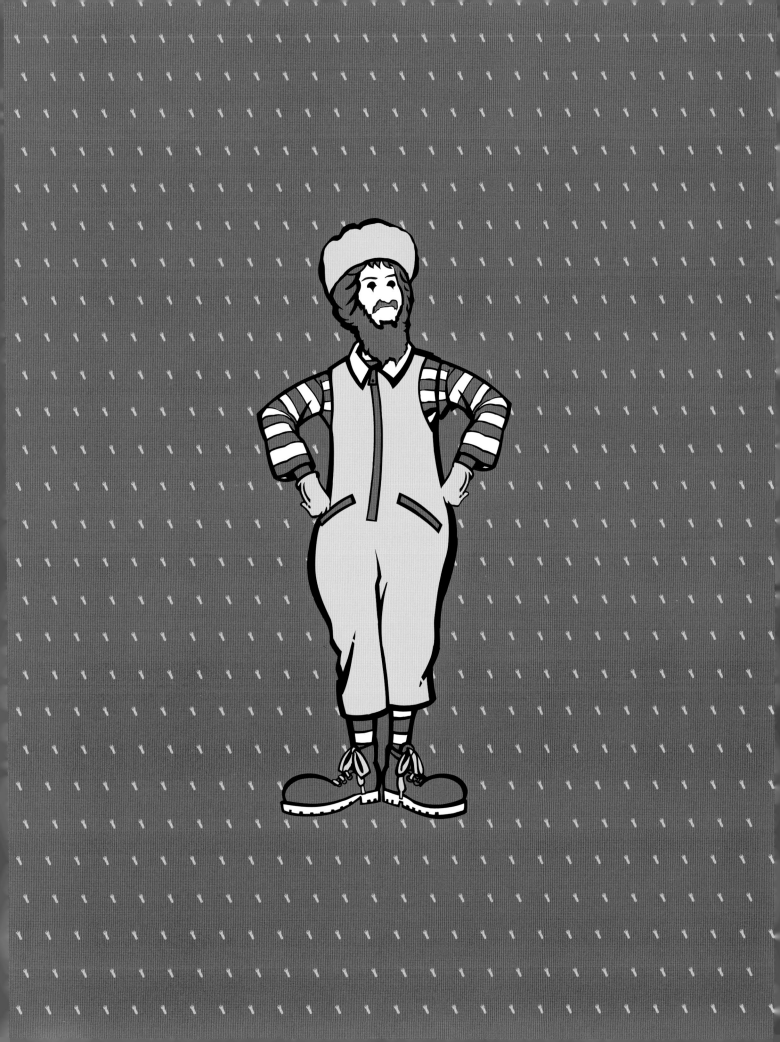

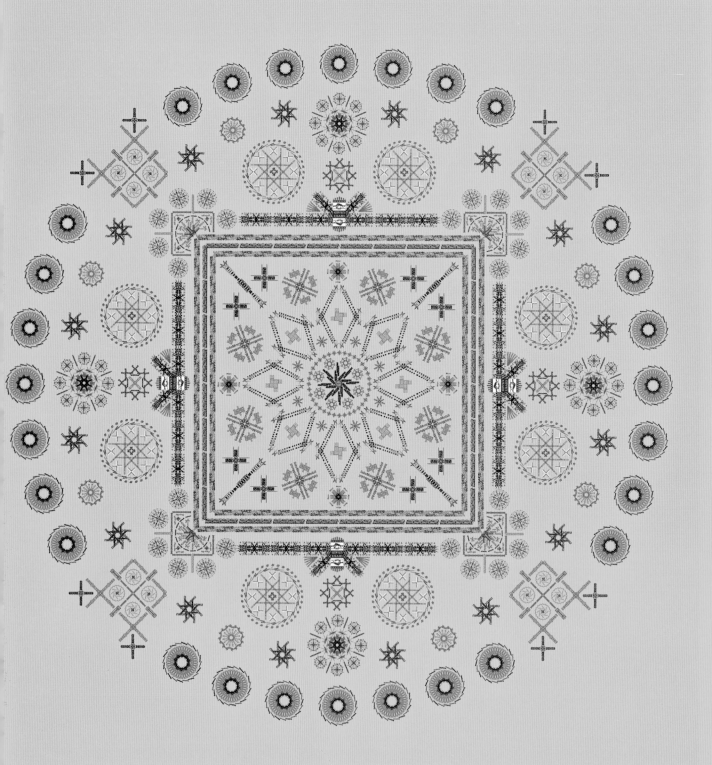

PREVIOUS LEFT PAGE:
BEYOND THE EARTHLY SENSATIONS OF LIFESTYLE ENVY:
OMNIPOTENT BRAND MANDALA
LIMITED EDITION LAMBDA PRINT | 2003

PREVIOUS RIGHT PAGE:
MOVING FROM THE PHYSICAL TO SPIRITUAL:
TRANSCENDENTAL BRAND AWARENESS MANDALA
LIMITED EDITION LAMBDA PRINT | 2003

THE PIECES ON THE PREVIOUS SPREAD ARE BASED ON TIBETAN MANDALAS — SPIRITUAL DOCUMENTS OF THE COSMOS WHICH ARE USED FOR CONTEMPLATION AND MEDITATION. HOWEVER THE ONES SHOWN ARE NOT AS SIMPLE AS THEY SEEM. LOOK CLOSELY AND YOU WILL SEE THAT THE COSMOS IS NOW CONSTRUCTED OF SOMETHING ENTIRELY DIFFERENT

WE ARE BUILDING A NEW WORLD | LIMITED EDITION LAMBDA PRINT | 2003

THE BASIS FOR THIS PIECE OF WORK WAS A COMMENT BY A NOTED HISTORIAN WHEN DISCUSSING WAR IN THE PAST ONE HUNDRED YEARS. IT SHOWS THE TRUE EVOLUTION OF WAR AND MOCKS CURRENT THEORIES OF 'PRECISION BOMBING'. THE TITLE COMES FROM A PAINTING BY PAUL NASH, WHICH FEATURES A GRIM FIRST WORLD WAR LANDSCAPE.

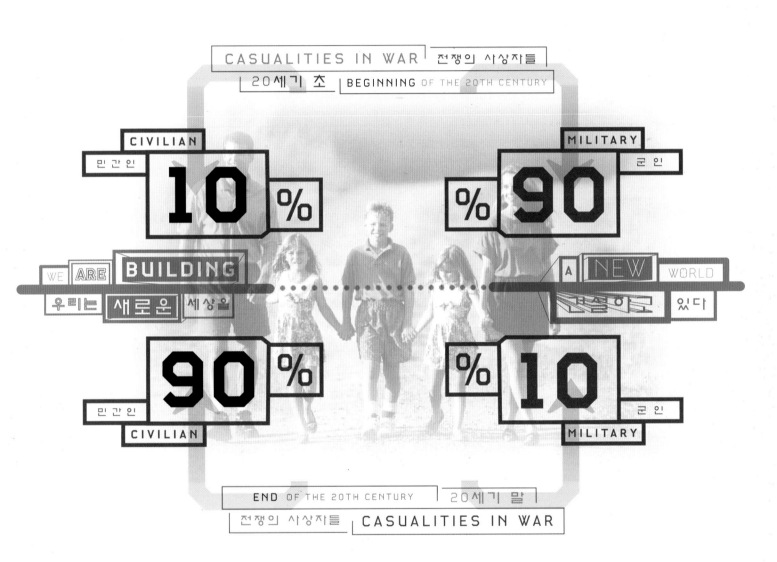

CASUALITIES IN WAR 전쟁의 사상자들

20세기 초 BEGINNING OF THE 20TH CENTURY

CIVILIAN
민간인
10 %

MILITARY
군인
% **90**

WE ARE BUILDING
우리는 새로운 세상을

A NEW WORLD
건설하고 있다

민간인
90 %
CIVILIAN

% **10**
군인
MILITARY

END OF THE 20TH CENTURY 20세기 말

전쟁의 사상자들 CASUALITIES IN WAR

WHY ARE WORDS LIKE

PEACE

FREEDOM

TRUTH

DEMOCRACY

ALWAYS USED BY

WARMONGERS

>>>>>>>>

>>>>>>>>>

OPPRESSORS

>>>>>>>>>>>>>

LIARS

>>>>>>>>>>>>>>>>

BULLIES

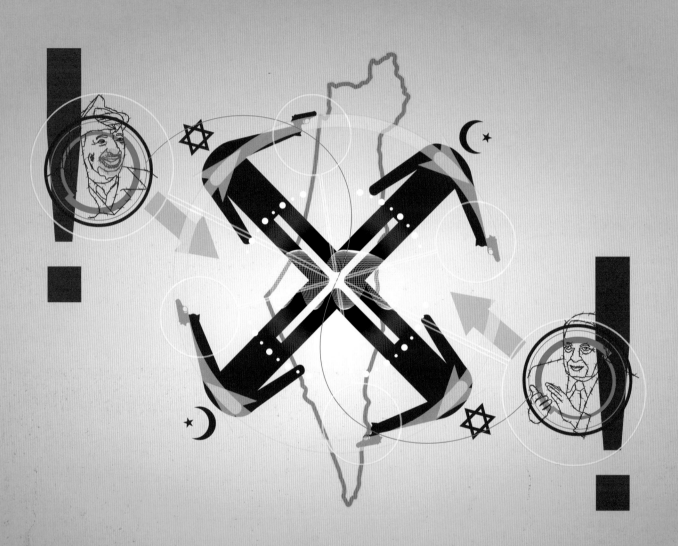

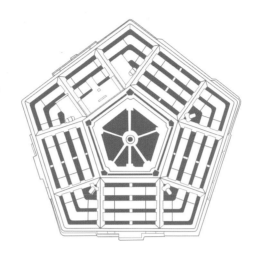

THE REPUBLIC(AN) OF KOREA | LIMITED EDITION LAMBDA PRINT | 2003

THIS WAS DEEMED A LITTLE TOO OFFENSIVE FOR OUR EXHIBITION OF
POLITICAL WORK IN KOREA, SO IT WAS SHOWN ONLY IN THE LECTURE AFTER
THE OPENING. AS SOMEONE WHO IS NOT MOTIVATED BY PATRIOTISM I AM
ALWAYS AMAZED AT THE AMOUNT OF FURORE ANY CHANGING OF A FLAG
CREATES. IT ALWAYS MAKES ME VERY CONSCIOUS OF THE RESPONSIBILITY
OF SUCH SYMBOLISM

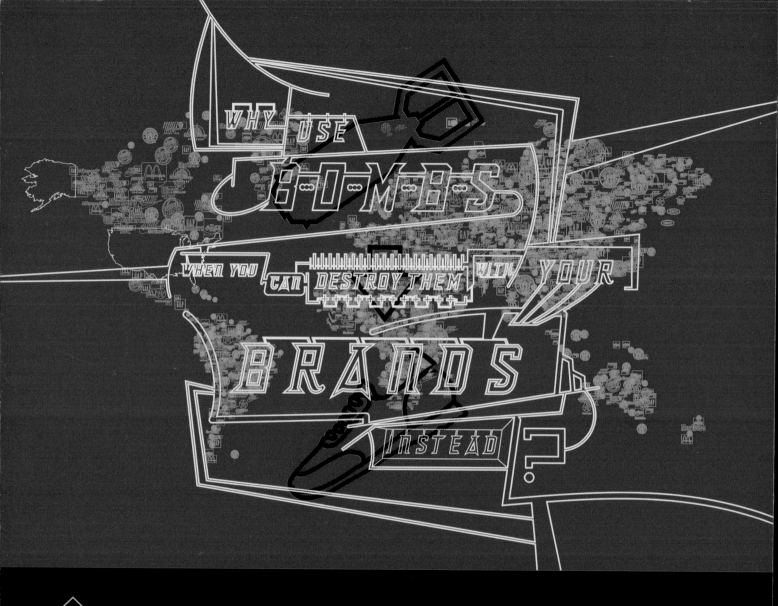

WHY USE BOMBS, WHEN YOU CAN DESTROY
THEM WITH YOUR BRANDS INSTEAD?
LIMITED EDITION LAMBDA PRINT | 2003

BASED ON A HALF-REMEMBERED COMMENT FROM A
POLITICIAN WHO STATED THAT AMERICA WOULD
NEVER NEED TO BOMB A COUNTRY THAT HAD A
MCDONALDS. RATHER THAN SHOWING THE 'GOOD

CORPORATE FASCIST | LIMITED EDITION LAMBDA PRINT | 2001

XXXIII.

George W. Bush visits London

2003

Sometimes you have to be a little bit naughty to get your message across, particularly if you want to say something people don't want to hear. The mass media is so tightly controlled that you often need to resort to less 'legal' methods. Although you won't find it discussed on many design courses, flyposting is a very valid part of graphic design. It's been a strong conduit for expression almost since the beginning of printing.

When George W. Bush came to visit London on November 18th, we went out and flyposted his purported route to stay with the Queen in the hope he would see the real views of the citizens of his 'strongest ally'.

Did he see them? Probably not. Did it make a difference? Maybe not directly, but it was obvious from the amount of protesting that a lot of people in this country were unhappy, and I think that any kind of pressure can make a difference, it puts the 'unmentionable' on the agenda.

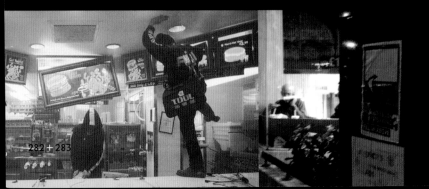

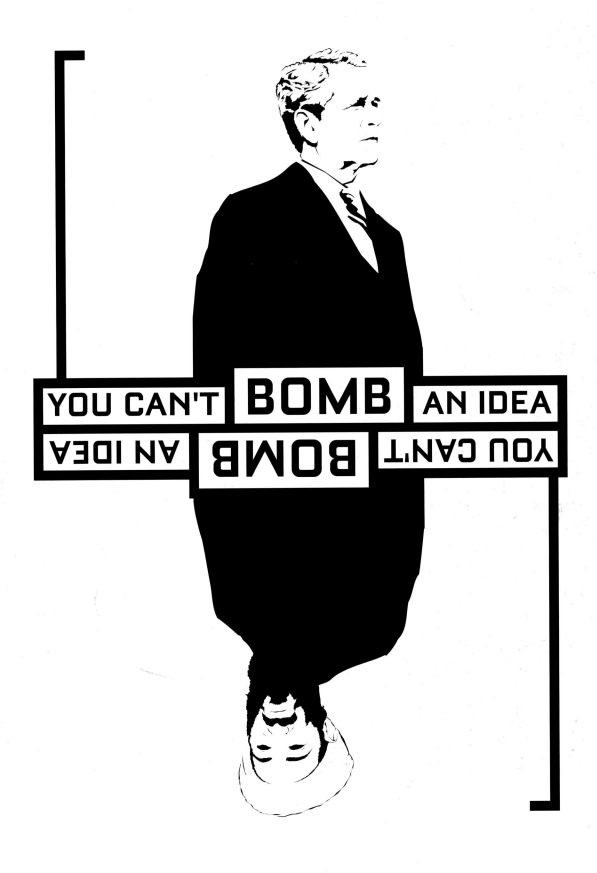

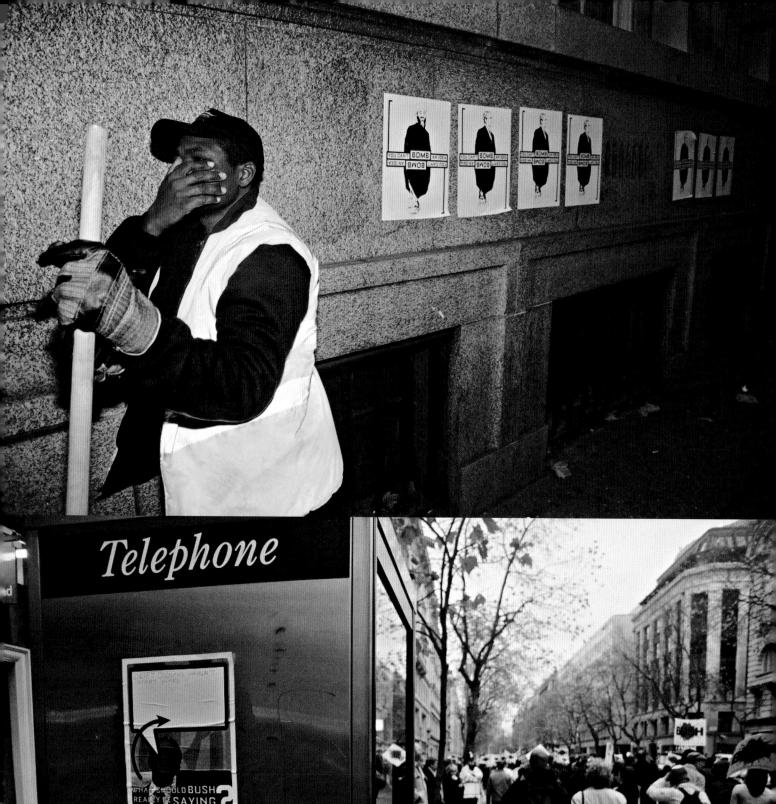

WHAT SHOULD BUSH REALLY BE SAYING?

FILL IN ABOVE

XXXIV. Art Grandeur Nature

2004

Parc de la Courneuve, Seine-Saint-Denis

(*an arts project using billboards in a park near Paris featuring the work of*
JONATHAN BARNBROOK · ALAIN BUBLEX · PASCAL COLRAT
GENEVIÈVE GAUCKLER · KEN LUM · TANIA MOURAUD · STEFAN SAGMEISTER)

One of my major frustrations is how difficult it is to break out of the world of design and talk to a wider audience. In 2004, I was invited by Morten Salling to participate in the biennial Art Grandeur Nature project in the Parc de la Courneuve Seine-Saint-Denis, France. It was an opportunity to reach a wide-ranging audience that would see a very pure form of message in a completely unexpected context.

The phrases, images and method of construction make a strong contrast with the rather tranquil setting of the park, for maximum impact and conflict with nature.

Originally written in English and used for animations in our political exhibition *Tomorrow's Truth*, I reused the phrases in this different form. If you believe what you are saying, and you think you have said it well, you should use it again to communicate properly to the maximum number of people. Why throw away good ideas in the constant quest to do something new? Hey... some artists spend their whole life making a career out of one idea.

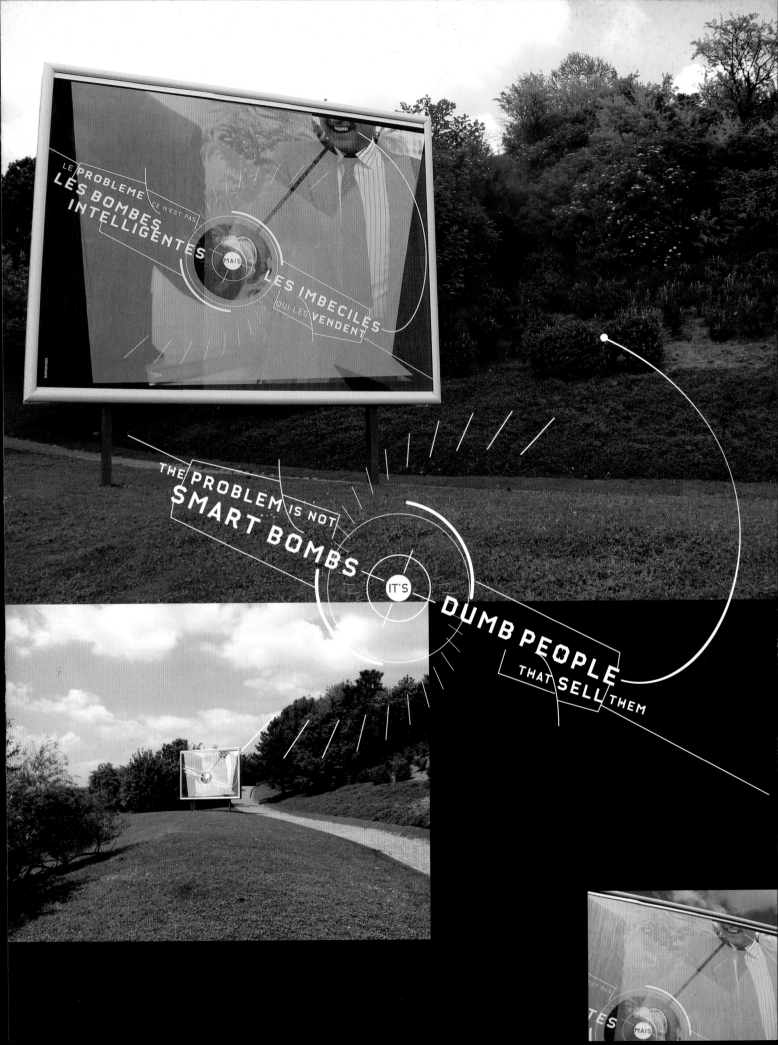

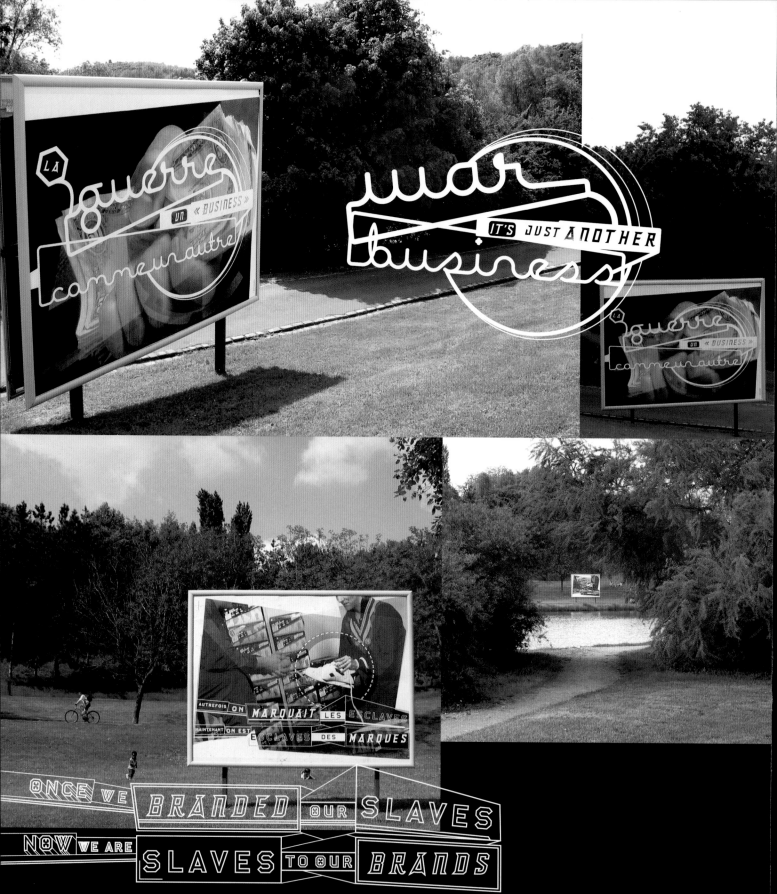

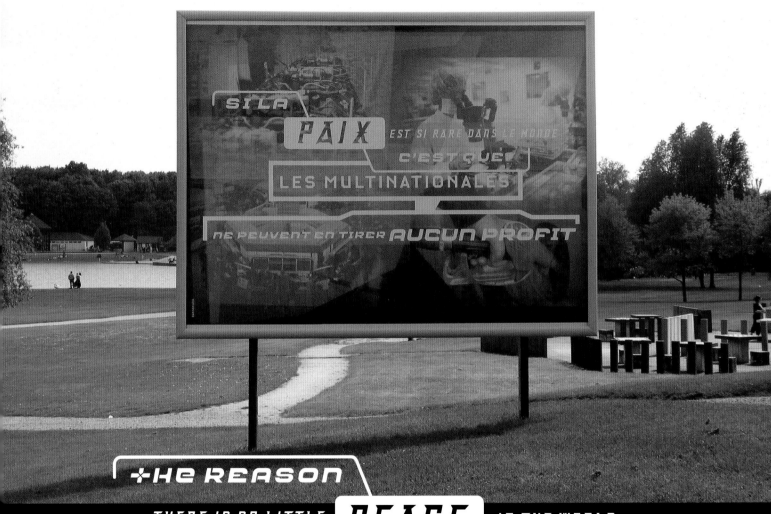

SI LA **PAIX** EST SI RARE DANS LE MONDE C'EST QUE LES MULTINATIONALES NE PEUVENT EN TIRER *AUCUN PROFIT*

+HE REASON THERE IS SO LITTLE **PEACE** IN THE WORLD IS BECAUSE MULTINATIONALS CAN'T MAKE ANY **MONEY** FROM IT

XXXV. Building the brand: North Korea

I am very interested in any kind of alternative to the Western capitalist model of living. I believe you can understand your own society much better by seeing it in relation to something which is oppositional. A decade or so ago it was easy to see that a free-market economy was just one of many systems. With the end of the Cold War it is much less so, I am not saying that the communist model was preferable but at least it was an alternative.

I have always been really interested in propaganda. There is a correlation between lying to hold onto political power and 'being economical with the truth' about a multinational company that is clearly causing environmental damage or misery through bad working practices. Designers have the same kind of ethical battle; can they do anything about it, do they have responsibility for the message or are they just another cog in the machine?

North Korea in particular seems to use methods of propaganda directly from the Stalinist period in Russia. The techniques are so clichéd, so well-known that at first it seems impossible to believe they work. Backed up by a brutal army it's hard to judge their real effect. However North Korean propaganda provides a current example of these techniques with which we can comment on our own society.

This whole project was instigated by the Korean journalist Ran-Young Kim after a discussion at the Icograda 2000 conference in Seoul. I had mentioned to Ran-Young I was interested in North Korea, various email conversations followed and this project was the result. Ran-Young carefully translated everything into Korean and our dialogue stimulated the ideas. She contacted the Korean magazine *Monthly Design* who first published the work. Subsequently, together with *North Korea 2.0* and our political work of the previous 15 years, it became part of the exhibition *Tomorrow's Truth* at Seoul Arts Centre in April 2004, which she organized.

The North Korean Army and American Air force are arranged to show their opposite ideologies. Both countries are supposedly utopias, but both back their ideals with extensive military force. Surely 'perfect societies' should be all-inclusive?

Real Utopias Don't Need Walls 2001

Technology in the 20th Century enabled people to communicate on a wider scale than ever before, it also enabled dictatorships to control and affect the environment of their people more than ever before.

Part of that control is carried out through the use of graphic design. It has a role to play in the shaping and perceptions of all societies.

In The 21st Century All Ideologies Are Dead All That's Left Is Patriotism And Greed 2001

A comment similar to this was made by an American journalist as a joke on the radio. I worked on the construction of this phrase to pinpoint exactly what was interesting in his 'joke' – that at a base level all societies had become the same. With this and others in the series I didn't want to just criticise North Korea. It was very important that there was some kind of wider understanding of the negatives in relation to our own society and the way it was constructed.

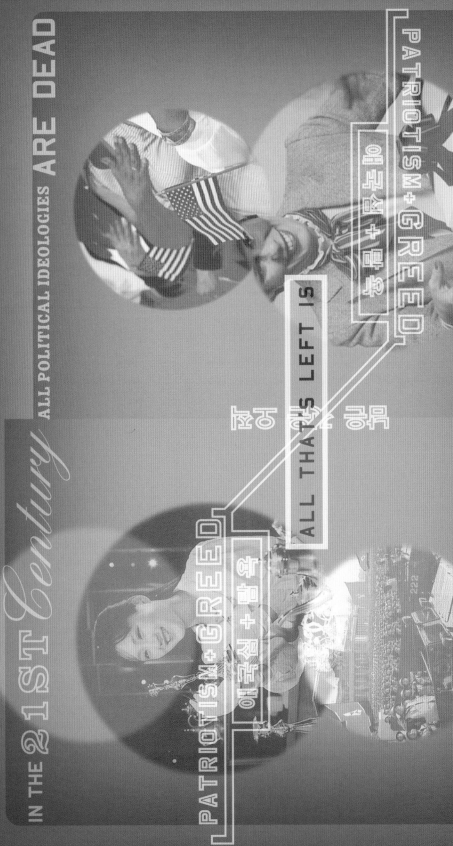

The right side of this piece rather cynically talks about the motivation for reuniting Korea – another new market for American multinational companies perhaps?

The other half of the work comes from a comment by a friend who called the dictatorship in North Korea not communist but 'state capitalist'. It functions in exactly the same way as a capitalist market economy, just with everything controlled by the state. I wanted to highlight this in some way, so I have displayed logos for many state-run companies in North Korea; illustrating that even in communist dictatorships companies have a competitive image and that graphic design still has its 'cosmetic' role to play.

I also included the logos because I thought people would be interested to see design from a very different universe to our own.

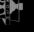

더 이상

THERE ARE NO LONGER ANY

이데올로기는 존재하지 않는다

POLITICAL IDEOLOGIES

THERE ARE ONLY

오직

CORPORATE STRATEGIES

기업 전략만 있을 뿐이다

A UNITED KOREA SPONSORED BY

한반도 통일은 다음 회사들이 협찬하였습니다

Coca-Cola

McDonald's

NIKE

Fig 1. SPOT THE DIFFERENCE

그림 1. 다른 곳을 찾아보세요.

Fig 2. Spot the Difference

그림 2. 다른 곳을 찾아보세요.

Infiltrate All Reality… 2001

In this piece of work I was thinking about the social context of design and branding.

The text, *Infiltrate All Reality…* was about how dictatorships try to construct a universe with themselves at the centre. To make this premise believable it is necessary to control every detail of the visual environment. This relates to how brands everywhere impose themselves on our lives – from sponsorship to product placement – and their desire to be at the centre of culture.

When a valid cultural comment is made using a brand logo, then the lawyers letters are sent out and it is clear that IT IS all about money.

On the right hand side I wanted to created a paradoxical statement – it came from listening to George W. Bush as soon as he got into power. He kept talking about how 'free' Americans were all of the time, to such an extent that it was obvious the motive was only to maintain the status quo.

Spot The Difference I and II 2001

The original image used in this work was from a book printed in North Korea showing state sponsored paintings. I collect graphics and art books from dictatorships because of their double meanings – usually the exact opposite of what is stated. That thought was the foundation for this. A very subtle but strong way of expressing what I imagined were the feelings and experiences of many North Koreans.

The difference between the two images in the second version is very noticeable, however the construct – a benevolent adult surrounded by children eager to learn – is the same. It has appeared in propaganda through the ages. This highlights how images from all kinds of different power authorities are used in an attempt to control us.

On the left hand side I used images from a North Korean fashion catalogue. When I first glanced at them they looked completely normal then I noticed that the models were all wearing the dictator's badge. It was a great example of the reinforcement of a false reality by the most subliminal of means.

CONTAINMENT OF PEOPLE CAN ONLY BE ACHIEVED BY

민중에 대한 봉쇄정책은 그들이 자유롭다는 것을 지속적으로 선전함으로써만이 성과를 거둘 수 있다

CONSTANTLY TELLING THEM THAT THEY ARE FREE

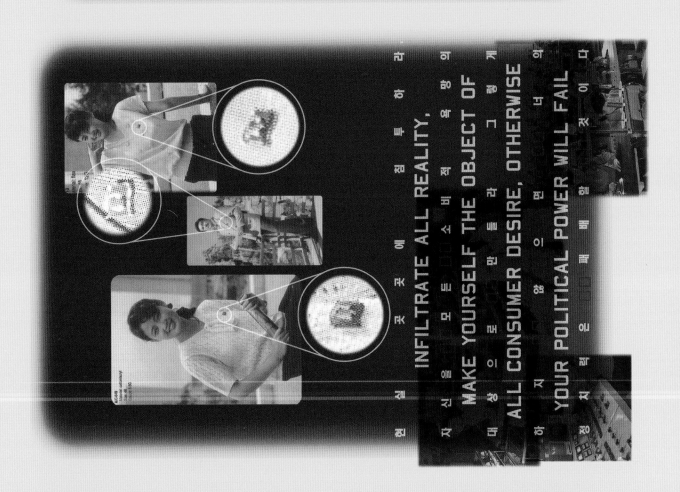

INFILTRATE ALL REALITY,

MAKE YOURSELF THE OBJECT OF

ALL CONSUMER DESIRE, OTHERWISE

YOUR POLITICAL POWER WILL FAIL

The Czech writer Milan Kundera is a great influence on me, in particular for this project his novel *The Book Of Laughter And Forgetting*. It directly affects this piece and the work on the next page. He writes about the idea of memory in relation to many subjects, of most interest to me was political power. In one part he deals with the role of children in dictatorships, how their lack of a past and a completely unresolved future makes them perfect for manipulation and the continuation of power. That indoctrination, if it works effectively enough, simply becomes the truth.

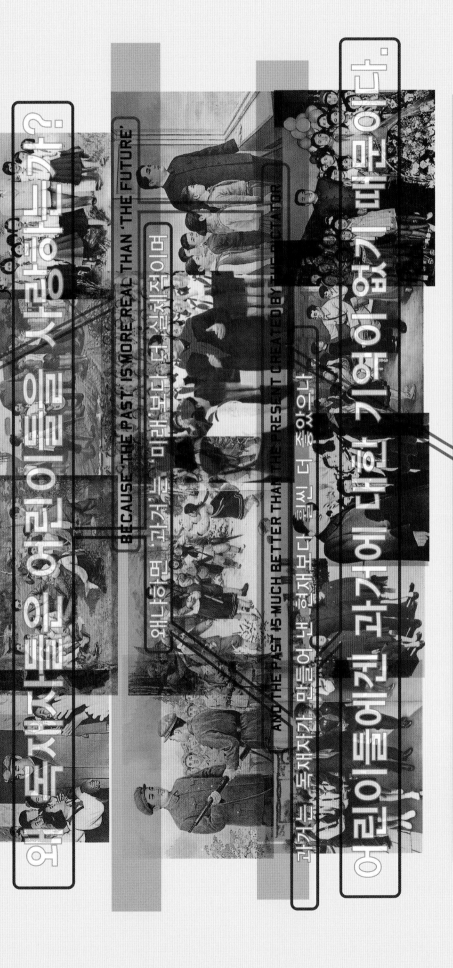

WHY DO DICTATORS LOVE CHILDREN?

왜 독재자들은 어린이들을 사랑하는가?

BECAUSE 'THE PAST' IS MORE REAL THAN 'THE FUTURE'

왜냐하면 '과거'는 '미래'보다 더 실제적이며

AND THE PAST IS MUCH BETTER THAN THE PRESENT CREATED BY THE DICTATOR

과거는 독재자가 만들어 낸 현재보다 훨씬 더 좋았으나

어린이들에게 과거에 대한 기억이 없기 때문이다.

AND CHILDREN HAVE NO MEMORY OF THE PAST

This was the final piece of work in the first North Korean series, because of that I wanted to end on something positive, not just criticise. Here again it was based on the text of Milan Kundera. The images are stills from footage of the 'Sunshine Policy', the name given to the positive engagement between the North and South Korean Governments'. Families that had been separated for over fifty years were allowed to meet for one day. They capture the first moment of meeting, decades of suppressed emotions finally expressed.

Unfortunately one meeting is all they got, there has been almost no permanent reunion of families. It really brings home the stupidity of any kind of political doctrine when the basic right of being with your family is undermined.

The work is about the idea of memory. That it can be a positive weapon against the corruption of the truth by dictatorships. If we always keep in mind the truth about how the past was before the dictatorship, then its power will ultimately fail. In particular in Korea, if people remembered Korea before the war then they would see its division as unnatural. The use of memory by the dictatorship is also discussed as a means of control: to create hatred and fear of what happened in the past and to reinforce the division of Korea. Forgetting is also important: to forget the years of hatred and work together towards a future that is completely open.

The Power of Memory 2001

North Korea 2.0

People often ask how we get time to do all of this extra or self-initiated work. It's easy, make it part of the necessary criteria of your studio projects. I can't stress enough how this has provided the creativity for commercial jobs. It is necessary to TELL THE TRUTH AS YOU SEE IT. This is why you are a graphic designer.

This second phase of work *North Korea 2.0*, completed three years after the first, looks very different in graphic style. It is bolder, brighter and uses less obviously digitised imagery. I think it was mainly a development of the work generally, the pieces look more confident and are aimed at a wider audience.

This was chosen as the main image when the North Korean pieces became part of an exhibition of our political work from the past fifteen years at Seoul arts Center in 2004, entitled *Tomorrow's Truth*. Many of you may not be familiar with the person in the picture, it is Kim Jong-il the son of the original dictator who undemocratically took over North Korea when his father died.

It was very difficult to gauge how far we could go with the imagery and what is acceptable in South Korea. In a discussion after a lecture, it was said that if I had been Korean I might have been in danger of being arrested. When national Korean television came to film me at the exhibition they didn't want to show the work. However another TV channel did an in-depth documentary about it, so it was very hard to tell. A lot of people saw the exhibition but their reactions were also hard to judge. I only got one email about it, somebody simply wrote, *you think you know korea? you really think you know korea?*

The Little Fellow 2004

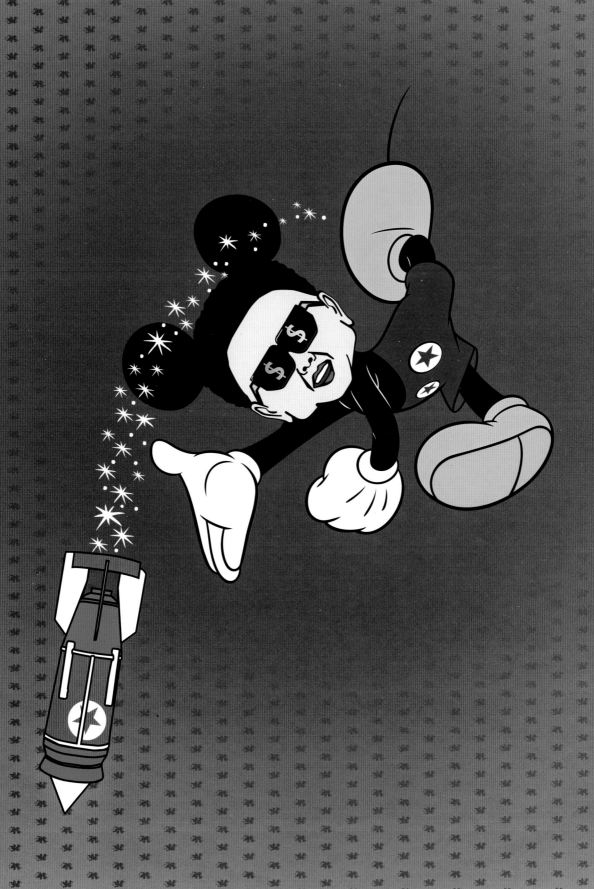

For this piece, I spent a lot of time drawing architectural features of note in North Korea: the flag pole, supposedly the tallest in the world, can be seen from South Korea, the statue is the previous dictator Kim Il-sung and the pyramid-shaped building is a tourist hotel in central Pyongyang which has been unfinished for many years. I particularly like the fireworks which have now become exploding missiles.

So what was the point of this work? I don't think what I am saying is revelatory, just that North Korea is 'a contained reality', like Disneyland. Everything is thought out, controlled – your reality is changed when you are inside both. Er… they also both a cost fortune to get into.

Disneyland 2004

KJI was inspired by an omnipresent fast food character, he seemed so similar to Stalin 'kindly watching over us' all of the time. And of course Kim Jong-il the North Korean dictator tries to do exactly the same thing with his image. I hope people found this both amusing about Kim Jong-il and a valid criticism of a 'friendly' fast food multinational.

Part of me thinks that perhaps the North Korean government saw the work. I have no idea what their reaction would have been. Have they kept a file on me? Will they send someone out after me? Or, are they just too stupid and disorganised to even know that this criticism exists. It is always difficult with a dictatorship to know whether their motives for doing things are incredibly clever or just dumb.

The first reaction to this piece of work from most people is to laugh. I rather like that. Making a valid political point by 'entertaining' rather than ranting is always a better way to go. It is one of the reasons I have kept away from the socialist party in Britain. If you are going to have some humanitarian principles then at least communicate them with what looks like a generous heart, otherwise there is no point.

KJI 2004

In this piece I tried to reveal the obvious lie inherent in propaganda. Very simply, if the view of the world portrayed in these kind of works were really true then there would be no need to produce these kinds of images.

It was very important to have the typography in Korean, simply because I wanted the points of view to be understood by Korean people. Otherwise it would mean the work had no validity as a device of communication. I wanted to connect directly with the people involved in the situation.

However the criticism that many Koreans have made is that the layout of the Korean typography is not interesting enough, I take this point. The Korean alphabet, which is very visually attractive to Western designers, looks to me enough excitement on the page. I wish I had known a Korean designer to work with me on these.

I am very interested in 20th century history, the partition of Korea and the war that caused it. I didn't want to try and pretend that I knew everything about this situation or even understood the fear of the daily threat of attack which South Koreans feel. My interpretation of Korea was exactly that – *my interpretation*, an outsider's view. Helpful or not, I hoped to give a different perspective and set of ideas to the people who were close to it.

Although I read a lot, it is not my only source of ideas. I am not snobbish about it. This piece of work was based on a TV interview with a representative of the South Korean government. His attitude was extremely pragmatic. Idealistically, I thought maybe the government hoped for the rejoining of Korea in the same way as Germany after the fall of the Berlin Wall. Instead he simply stated that all the they wanted was stability, nothing more than that. It could have been simply to save people's lives, but it seemed more to do with the fact that it would cost a great deal of money to reunify, and cause damage to South Korea's economy. I found it a thoroughly depressing point of view, a government with no vision, who did not seem to have any kind of positive aspirations.

What Governments Want 2004

Here I was trying to say something directly positive about the partition of Korea. Not an easy task, but I think it was important to show that this situation could change for the better. I felt that I had to portray the border as a positive frontier where something good can happen, rather than the starting point for fear.

The concept for this work initially came from a phrase that I noted from a Chechen gangster, not a great place to get a quote from, but anyway... It appeared in the art piece *Inflight* by Johan Grimonprez which parodied an airline inflight magazine. The actual quote was, "To you Westerners, borders represent barriers and limits, to us they represent opportunities." I wanted to use this in a different, rather more positive context for the issue of North and South Korea. So I chose a more universal form for the concept.

One of the most interesting things in this piece is how it refers to 'borders' – using the real edge of the work for emphasis. I wanted to refer to the physical restriction of the work itself.

For the Weak-minded 2004

시야를

한국어

새로운 경계선은

사람들에게 서로의

나라에 대한 방위를 의미한다

더 넓은 세계를

경제성을

세계에서 경제선을

[가능성]의 [시작]을 의미한다

911

Visual works made a week after September 11th asking for quiet reflection rather than revenge.

We almost didn't want to comment because it was too big a subject and was something that was already being responded to by everybody else 24 hours a day. However, it had such a profound effect that I felt we were not really being honest with ourselves if we didn't react.

These were originally proposed for the opening pages *Kohkoku* magazine. The magazine refused to print them, we are not sure why. Eventually they were shown as a special piece in various other publications. This was better in the end because I felt more people could see it.

P. 154 – 159

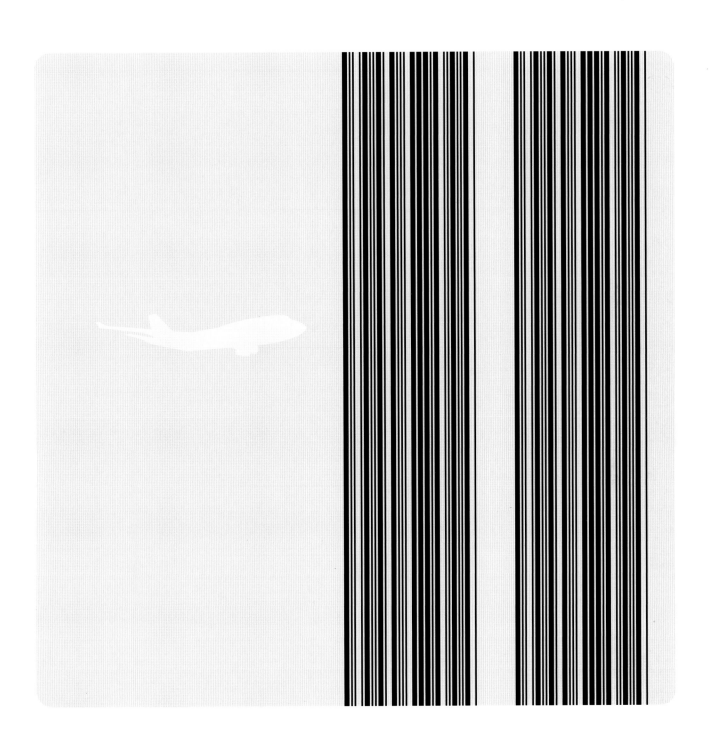

One of the most fundamental things after September 11th was the complete threat to civilisation that occurred. Not just the hysterical reaction about 'what might happen next', but the fact that the idea of civilisation, an agreed set of rules for society, was about to lose any meaning. Nothing could be trusted anymore.

Shortly after September 11th I received an e-mail saying, *"Are you going to stop your anti-globalisation work now that the biggest culture jam in history has happened?"* This was good example of how 9/11 was used as an excuse to squash different kinds of protest in all areas of society.

The Americans should sometimes question whether their government's huge spending on military technology is the best possible solution for their security and basic well-being. Forty-nine billion dollars for a missile defence system is a lot of money which could be spent on something more positive. It took a three dollar knife to hijack the plane used to crash into the World Trade Center.

These pieces of work were not meant to be 'in your' visual or add to the ranting. They asked people to think in a wider 'edition' context. They were printed in very pale colours, so that it was impossible to see them unless you looked very carefully. It seemed more appropriate that the pages were almost 'ghosts' themselves. 9/11 was so emotionally devastating there was no room for upfront, angry design

$3

$49,000,000,000

This is such a clear idea that we have used it in many other subsequent projects. It shows the evolution of man but the final figure is a soldier who has been turned around to shoot the rest of the line. A comment on the destructive and pointless nature of violence or military solutions.

These works are embarrassing and I was trying to think why. Maybe it is something to do with the directness of a message which deals with such big themes. Graphic design so often concerns itself with the irrelevant, it just seems a bit unusual when somebody airs this discussion in this medium.

The final piece was a very simple statement about the pointlessness of killing. There is no heroism or solace in being killed for a higher cause or by mistake. There is no higher moral position because you have killed somebody for an allegedly *just* reason.

Being a graphic designer does not mean that you are disconnected from what goes on around you, it is possible to put your anger, frustrations, emotions into your work in quite a direct way. Graphic design has the potential to reach an audience of millions.

+ A DAY OF *forgetting* +

All through this book I have demonstrated my commitment to the end of conflict and I now ask you to contemplate a suggestion – the simplest solution to end strife is for people to forget. I may be accused of not respecting those who have sacrificed their lives or died without choice. However I believe the best way to honour the dead and give them dignity is to forget our anger, division and differences. I propose that Remembrance Day, Armistice Day and Memorial Day, when ceremonies are held for the war dead, be changed to *The Day of Forgetting.*

On the right is one expression of this. I wanted to provide an opportunity for people to reflect on the state of the world and give them an alternative, more poetic solution. It is based on Milan Kundera's novel *The Book of Laughter and Forgetting* and his ideas about history, memory and their role in political ideology.

This was the final piece in the *Tomorrow's Truth* exhibition in Korea, 2004.

XXXVIII. IMAGE CREDITS

현 ——— 충 ——— 일

+ INSTEAD ——— OF A *day* ^{of}REMEMBRANCE, LET U

대 신 에

TO FORGET ————————— ANY ANGER WE FEEL ———
——— 저 들 에 게 가 졌 던 ————— 모 ——— 든 ——— 분 ——— 노 ———

HISTORIC
& ETHNIC ———————— DIFFERENCES BE PART OF THE ——— PAST

역 사 적 ——— 인 종 적 ——— 불 화 는 ——————— 미 래 의 분 열 이 ——————— 아

+ + + + + + + + + + + + + + + +
+
+
SURELY TH

이 것 이 분 명 망 자 들 의

TO HO

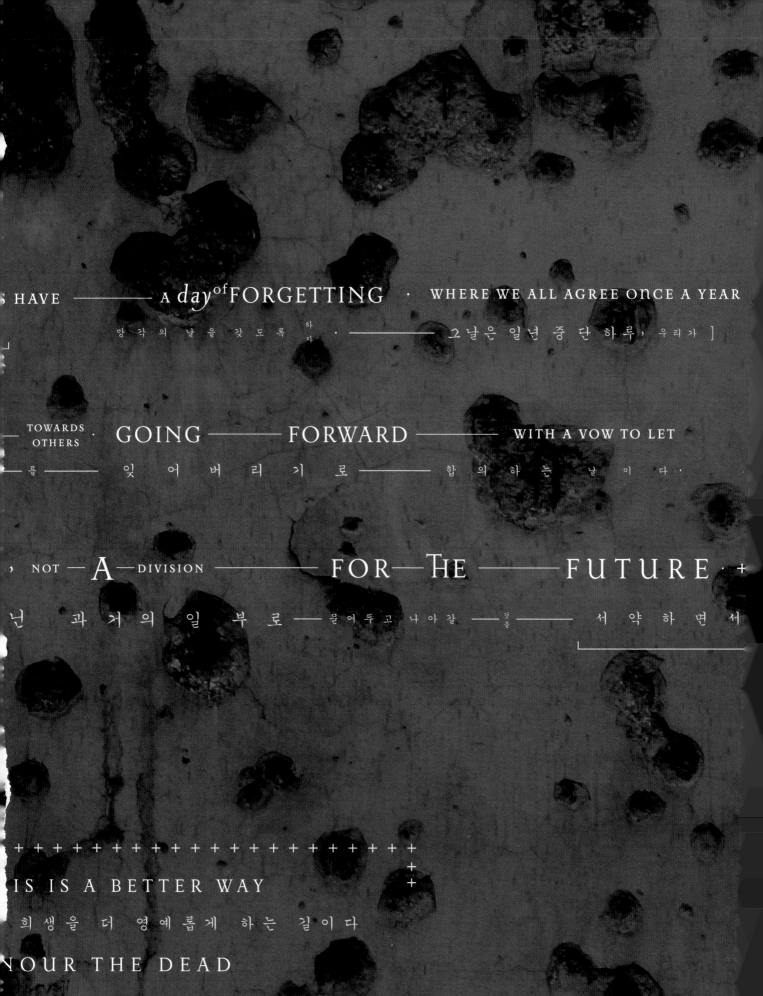

HAVE ——— A *day* of FORGETTING · WHERE WE ALL AGREE ONCE A YEAR

망각의 날을 갖도록 하자 · ————— 그날은 일년 중 단 하루, 우리가]

TOWARDS · GOING ——— FORWARD ——— WITH A VOW TO LET
OTHERS

를 ——— 잊 어 버 리 기 로 ——— 합 의 하 는 날 이 다 ·

, NOT ——A——DIVISION ——————— FOR THE ——— FUTURE ·+

닌 과 거 의 일 부 로 ——— 묻 어 두 고 나 아 갈 ——— 것 ——— 서 약 하 면 서

+ +
+
+
IS IS A BETTER WAY

희 생 을 더 영 예 롭 게 하 는 길 이 다

NOUR THE DEAD